UNITED ARROWS
STYLING EDITION

UNITED ARROWS
STYLING EDITION

2

151 Jacket
UNITED ARROWS
Black
XS/S/M/L
129,600yen

152 Shirt
ERRICO FORMICOLA
Light Blue
XS/S/M/L
24,840yen

153 Trousers
UNITED ARROWS
Navy
42/44/46/48/50/52
21,600yen

154 Gloves
UNITED ARROWS
Navy (PHOTO)/Black/Beige/Wine
M/L
15,120yen

gr.tif

Ski - Running

27 Georg Thoma 1960 Gold in der Nord. Kombination

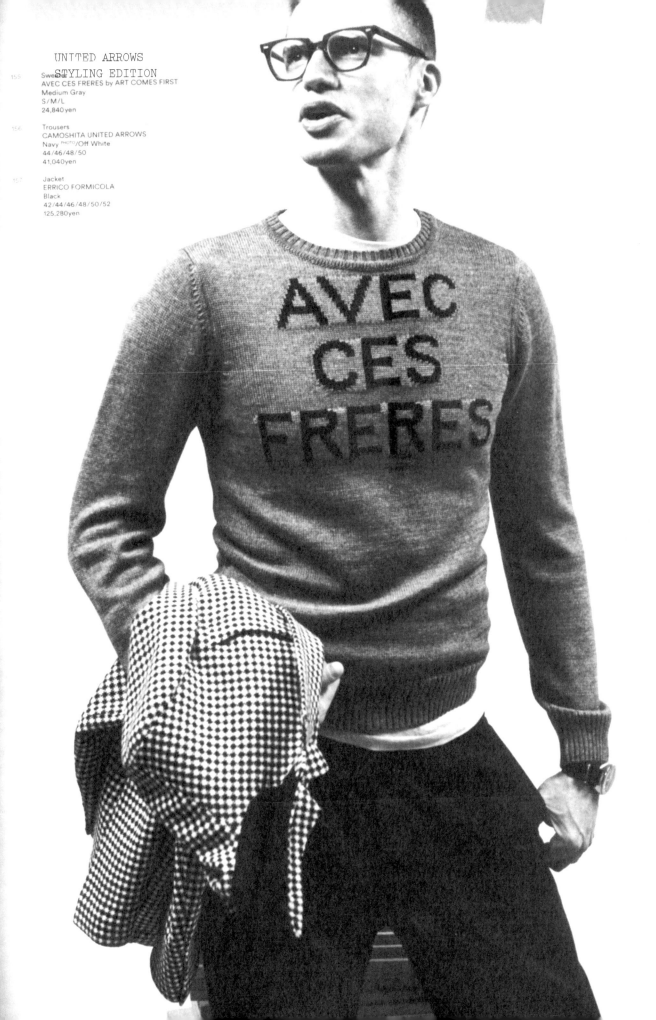

UNITED ARROWS
STYLING EDITION

155 Sweater
AVEC CES FRERES by ART COMES FIRST
Medium Gray
S/M/L
24,840yen

156 Trousers
CAMOSHITA UNITED ARROWS
Navy PHOTO/Off White
44/46/48/50
41,040yen

157 Jacket
ERRICO FORMICOLA
Black
42/44/46/48/50/52
125,280yen

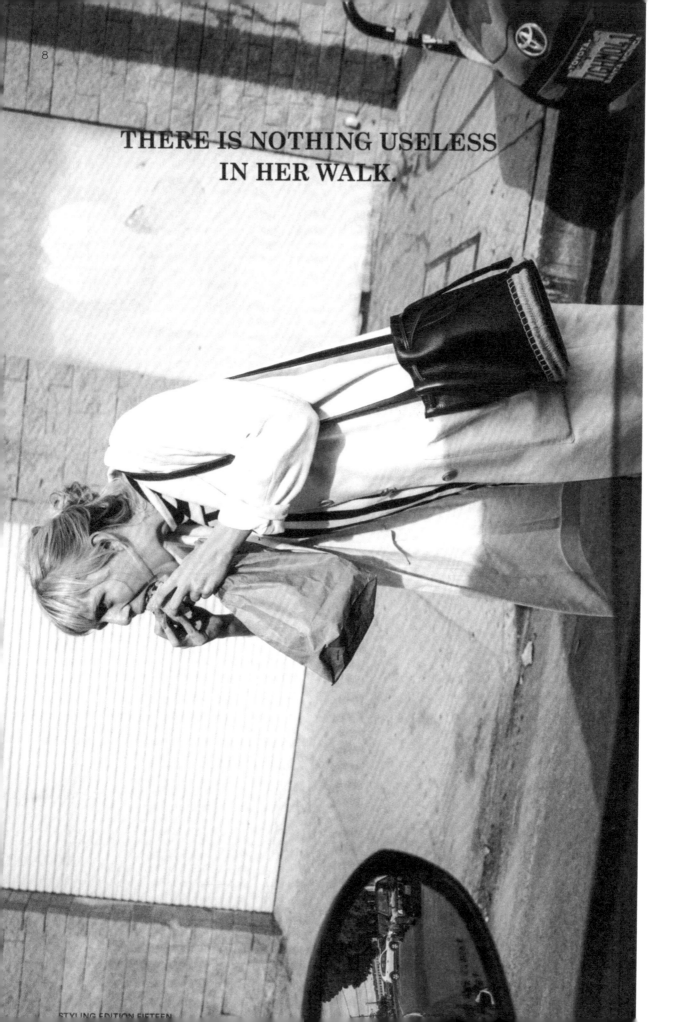

THERE IS NOTHING USELESS
IN HER WALK.

8

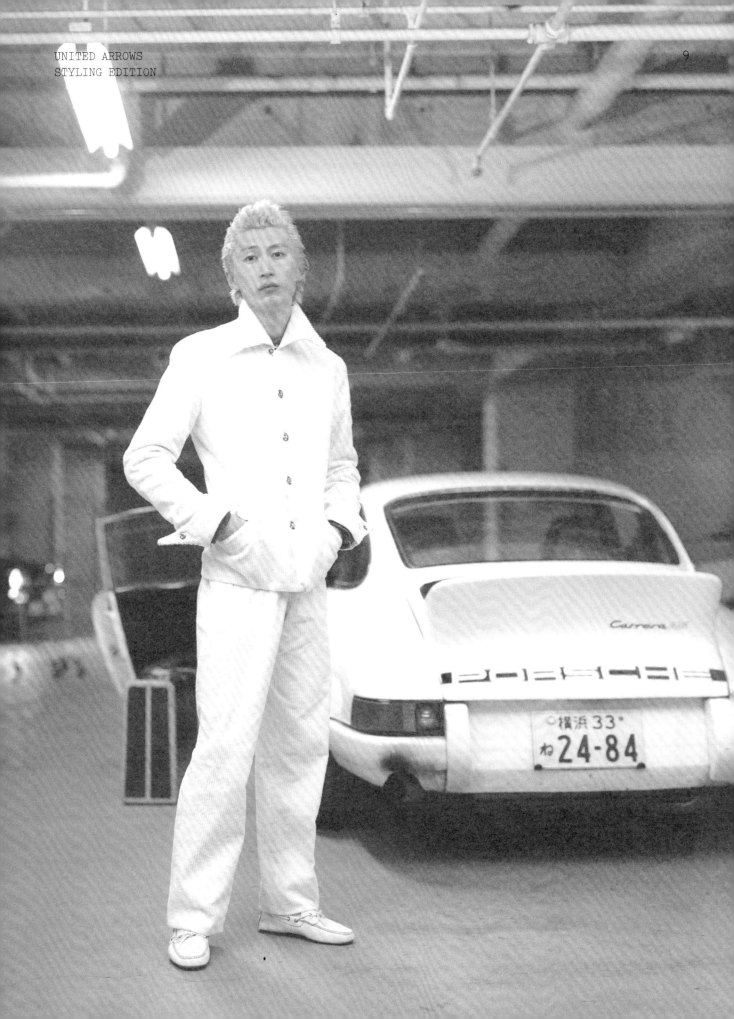

vivienne westwo

oguri ———————

prada

UNITED ARROWS STYLING EDITION 19 p. 107

_gr.tif

38
cket
UNITED ARROWS
Royal ^{PHOTO}/Beige
42/44/46/48/50/52
¥39,960

Sweater
UNITED ARROWS
Medium Brown ^{PHOTO}/
Off White/Black
XS/S/M/L/XL/XXL
¥19,440

246 T-Shirt
 Medium Brown ^{PHOTO}/
 Dark Gray
 XS/S/M/L/XL/XXL
 ¥12,960

247 Trousers
 UNITED ARROWS
 Royal ^{PHOTO}/Beige
 42/44/46/48/50/52
 ¥19,440

248 Scarf
 JOHNSTONS
 Medium Brown
 180×50 ᶜᴹ | ¥19,440

249 Scarf
 NICKY
 Cobalt ^{PHOTO}/Medium Brown/Navy
 70 × 180ᶜᴹ | ¥23,760

250 Handkerchief
 ERRICO FORMICOLA
 Orange ^{PHOTO}/Olive/Navy
 40 × 40 ᶜᴹ | ¥6,480

 P089

251 Jacket
 UNITED ARROWS
 Beige
 42/44/46/48/50
 ¥45,360

252 Sweater
 UNITED ARROWS
 Beige ^{PHOTO}/Black/Wine/Navy
 XS/S/M/L/XL/XXL
 ¥17,280

253 T-Shirt
 UNITED ARROWS
 White ^{PHOTO}/Black/Medium Gray/
 Beige/Navy
 XS/S/M/L/XL | ¥6,480

254 Trousers
 UNITED ARROWS
 Beige
 42/44/46/48/50
 ¥19,440

255 Stole
 ERMANNO GALLAMINI
 Cobalt
 80 × 250ᶜᴹ | ¥38,880

256 Necklace
 FLORIAN
 Natural
 Free | ¥35,640

257 Handkerchief
 NICKY
 Beige

256　Waist Coat
　　STELLA JEAN
　　Yellow
　　44/46/48
　　47.000yen

257　Shirt
　　STELLA JEAN
　　White
　　44/46/48
　　22,000yen

258　Trousers
　　STELLA JEAN
　　Olive
　　44/46/48
　　38,000yen

259　Shoes
　　CROCKETT & JONES
　　Red (etc.) / White
　　5h/6/6h/7/7h/8/8h/9/9h
　　64,000yen

260　Hat
　　SUPER DUPER
　　Wine
　　59 (cm)
　　28,000yen

261　Jacket
　　STELLA JEAN
　　Olive
　　44/46/48
　　75,000yen

262　Suit
　　SOVEREIGN
　　Beige
　　42/44/46/48/50/52/54
　　100,000yen

263　Shirt
　　UNITED ARROWS
　　Cobalt (etc.) / Kelly
　　36/37/38/39/40/41/42/43 (cm)
　　13,000yen

264　Tie
　　NICKY
　　Blue
　　16,000yen

265　Chief
　　NICKY
　　Natural
　　42 × 42 (cm)
　　7,500yen

266　Hose
　　SOVEREIGN
　　Dark Brown (etc.) / Dark Gray /
　　Cobalt / Navy
　　Free
　　3,600yen

267　Shoes
　　CROCKETT & JONES
　　Dark Brown (etc.) / Black
　　6/6h/7/7h/8/8h/9/9h/10
　　65,000yen

195 Suit | ERRICO FORMICOLA | Black | 42/44/46/48/50 | 117,000yen 196 Shirt | CHARVET | Cobalt PHOTO / White / Light Blue | 37/38/39/40/41/42 (cm) | 53,000yen 197 Tie | NICKY | Black | 20,000yen
196 Chief | NICKY | Natural | 42 × 42 cm | 7,500yen 199 Hose | SOVEREIGN | Navy PHOTO / Black / Dark Gray / Dark Brown | Free | 2,500yen 200 Shoes | UNITED ARROWS | Black PHOTO / Dark Brown | 6/6h/7/7h/8/8h/9/9h | 32,000yen

— Head straight from the office to the club and dance the night away,
suit and all. This casual suit style is current and on-point. The
springy seersucker will aid each step. Show everyone those moves!

— Dressing up may severely alter your state of mind.
Why not do it more often? Go all out and add a bit of
excitement to your life.

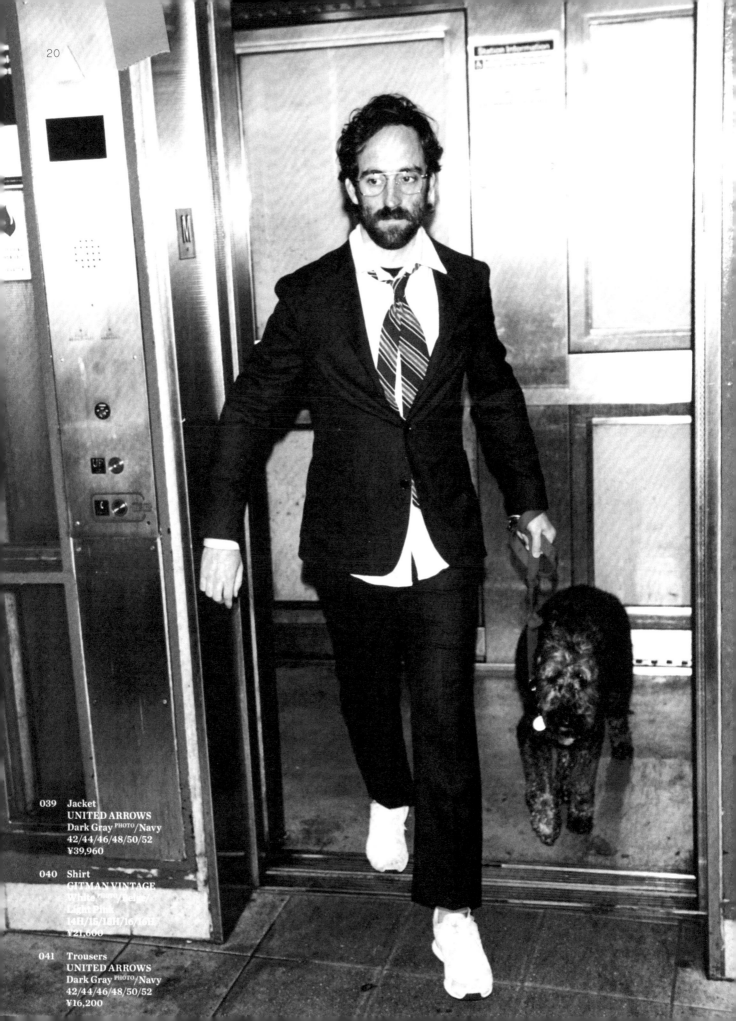

039 Jacket
UNITED ARROWS
Dark Gray PHOTO/Navy
42/44/46/48/50/52
¥39,960

040 Shirt
GITMAN VINTAGE
White PHOTO/Beige/
Light Pink
14H/15/15H/16/16H
¥21,600

041 Trousers
UNITED ARROWS
Dark Gray PHOTO/Navy
42/44/46/48/50/52
¥16,200

178 Sweatshirt
 UNITED ARROWS
 Black PHOTO/White
 S/M/L
 17,280yen

179 Jeans
 UNITED ARROWS
 White
 29/30/31/32/33 INCH
 19,440yen

180 Coat
TRADITIONAL WEATHERWEAR
Black
34/36
39,960yen

181 T-Shirt
UNITED ARROWS
Black PHOTO/ Off White
Free
17,280yen

UNITED ARROWS
STYLING EDITION

182 Shorts
KAON
White PHOTO/ Black
S/M
28,080yen

183 Sandals
UNITED ARROWS
Black PHOTO/ White
35/35h/36/36h/37/37h/38
19,440yen

25

MEN'S WOMEN'S ~~WORDS~~ ~~REFERENCES~~ 083

Jacket *MC RITCHIE* 47,250yen
Cut & Sewn *MONROW* 9,450yen
Shirt *UNITED ARROWS* 12,600yen
Trousers *CAMOSHITA UNITED ARROWS* 29,400yen
Stole *CAMOSHITA UNITED ARROWS* 16,800yen

27

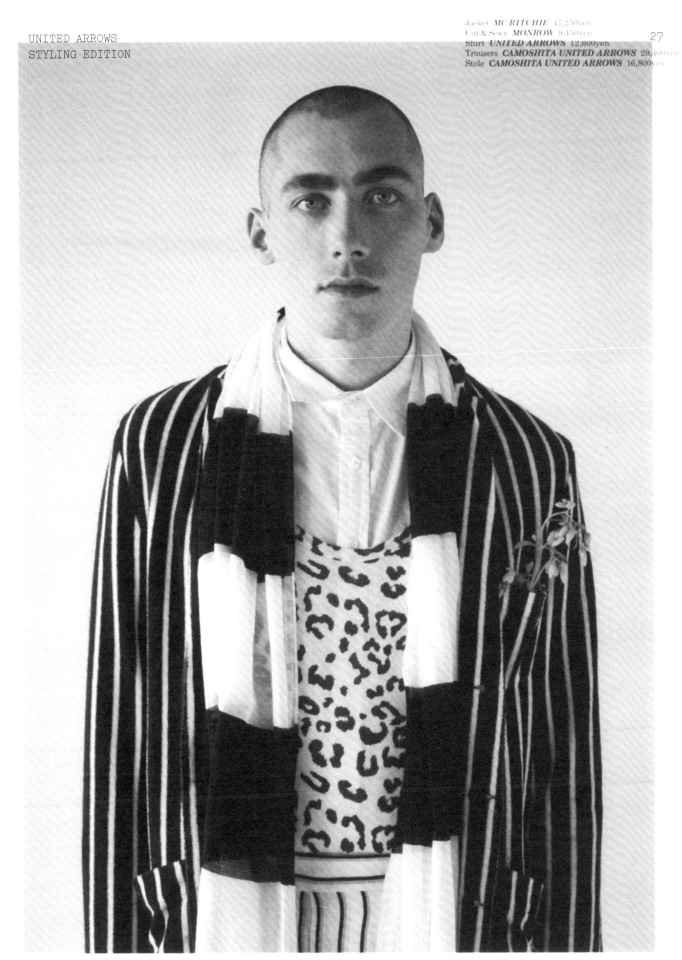

Will Tattersall

Origin ID: SOUA

73 NewSt

FedEx

Ship Date:

"N " ████████@plug-in.co uk>

████ UNITED ARROWS <█████████████████

styling edition

Shoes HIROSHI TSUBOUCHI 37,800yen

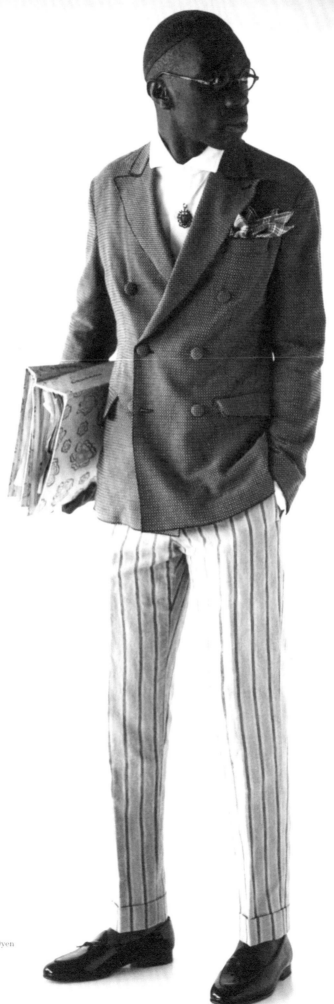

Jacket *LVCHINO* 58,800yen
Shirt *SALVATORE PICCOLO* 23,100yen
Trousers *GBS* 33,600yen
Pendant Head *VINTAGE* 26,250yen
Chief *FIORIO* 3,990yen
Shoes *BOW-TIE* 29,400yen

068

069

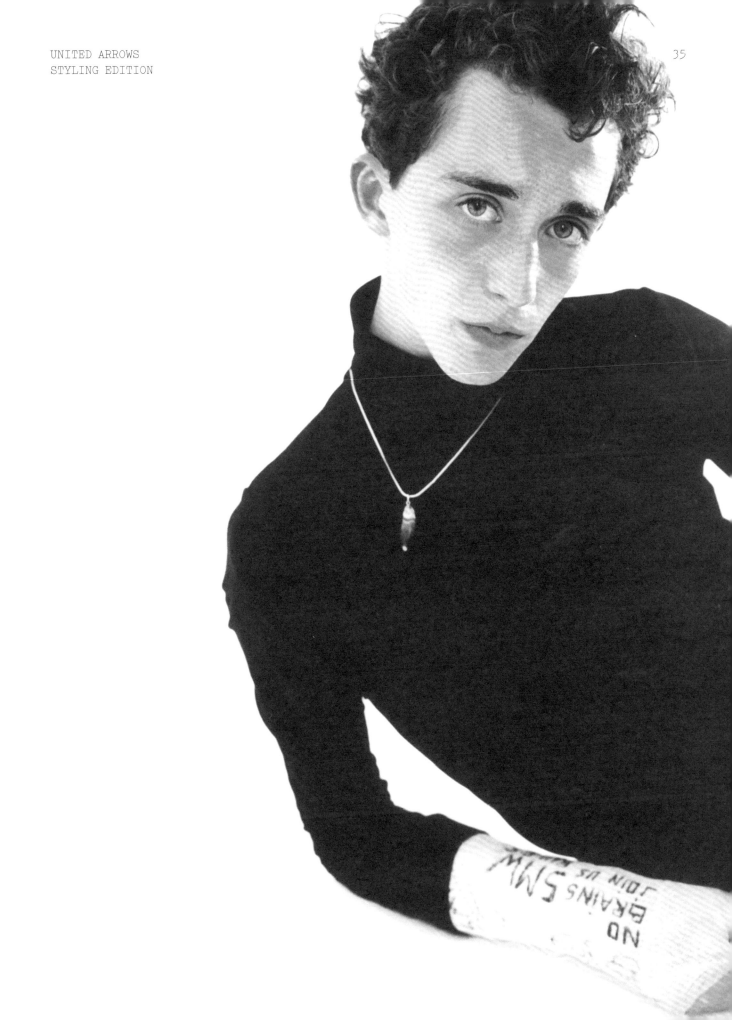

68220035.tif

68210016.tif

68090016.tif

68090009.tif

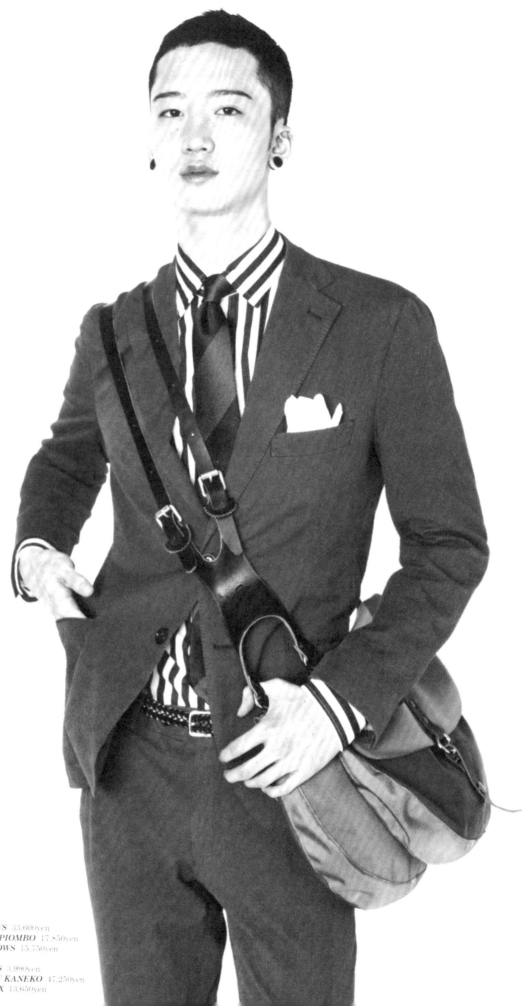

20
Jacket *UNITED ARROWS* 33,600yen
Shirt *MP DI MASSIMO PIOMBO* 17,850yen
Trousers *UNITED ARROWS* 15,750yen
Tie *NICKY* 12,600yen
Chief *UNITED ARROWS* 3,990yen
Bag *TASCHI BY KAORU KANEKO* 47,250yen
Belt *WHITEHOUSE COX* 13,650yen

39

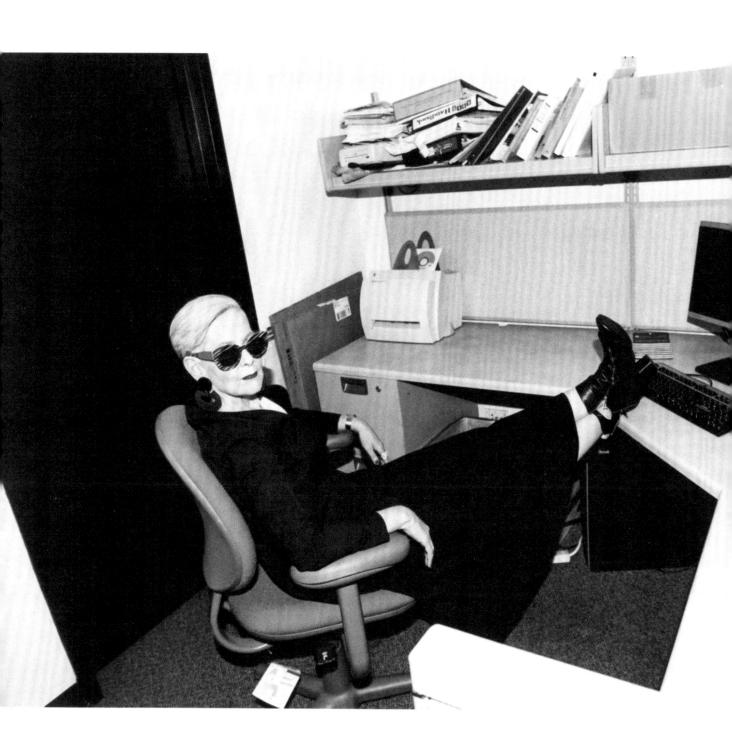

195 Jacket | UNITED ARROWS | Black PHOTO/Off White | 36/38/40 | ¥25,920
196 Ring | FALLON | Silver | ¥28,080

42

R.I.

215 Sweater | UNITED ARROWS & SONS | Natural PHOTO Wine | S/M/L, XL, ¥21,600

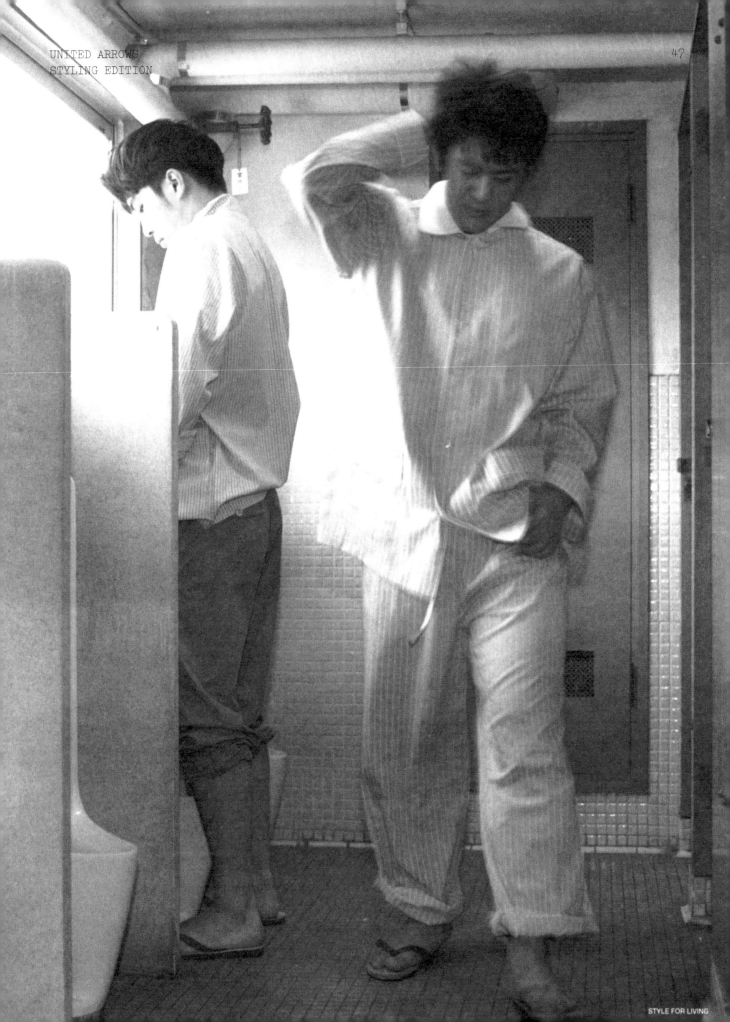

22_047_gr.tif

United Arrows

New York · Paris · London · Milan

Foreword: Letter from the Company CEO

Established in 1989, UNITED ARROWS LTD. marked its thirty-second anniversary this year.

For more than thirty years since our founding, we have faithfully followed the same management philosophy. Our mission statement: "With sincerity and a sense of beauty, we continually create new tomorrows for our customers, setting the standard for lifestyle culture."

Our services, products, and stores have all been designed with this ideal in mind: we want to help each of our customers to dress for the complex life they live today.

Integral to our mission is the creation of an indispensable lifestyle culture. To reach this ambitious goal, everyone at UNITED ARROWS focuses on our customers. Like many arrows, we fly toward this target, and are committed to enrich anyone who comes into contact with our brand—our customers, of course, but also our employees, business partners, and shareholders.

This book is the embodiment of this collective effort, from our founding to the present. It presents the progress we have achieved to date toward our declared mission.

We would not have been able to build this long, gratifying history without the generous support from all of our stakeholders. I take this opportunity to humbly express my heartfelt gratitude for this support.

We look forward to adding more chapters to our colorful history. We are thankful for your continued support in our many endeavors.

Mitsuhiro Takeda

Representative Director,
President, and Chief Executive Officer
UNITED ARROWS LTD.

Table of Contents

PART 3: 2010s

Our Labels

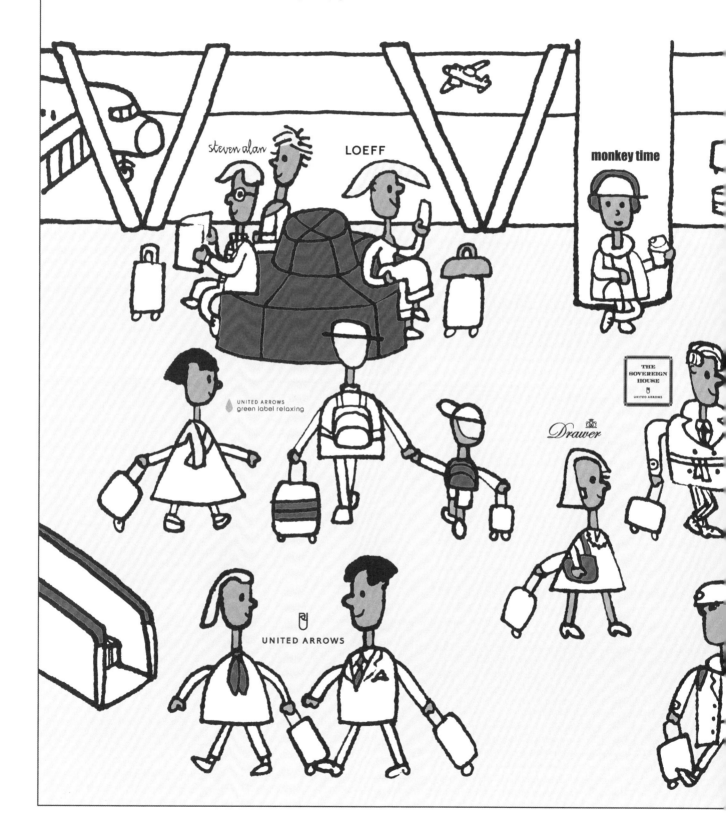

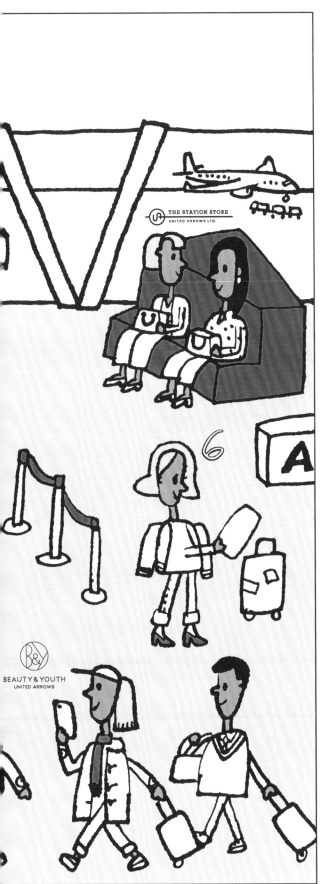

UNITED ARROWS
The original label of UNITED ARROWS LTD., the line proposes a lifestyle based on dressy, formal styles for adults, with a refined sensibility.

BEAUTY&YOUTH
BEAUTY&YOUTH offers casual wear that embodies the spirit of freedom, combined with what we refer to as our "standard": a quiet dignity, peace of mind, well-being, and a nod to tradition.

green label relaxing
Based on the concept of "Be happy," this label offers clothes and sundries that add color to the wearer's personal style.

THE SOVEREIGN HOUSE
A menswear line made in the image of a "smart" male, the label was launched with this kind of man in mind; someone who appreciates sophisticated fashion.

6 (ROKU)
The number "6" comes from the six elements the brand is envisioned to span: sports, military, ethnic, nautical, work, and school. These elements represent universal themes rooted in styles of vintage clothing.

THE STATION STORE
THE UNITED ARROWS STATION STORES, found in train stations, arose from a desire to make commuting more enjoyable, and certainly more fashionable.

DRAWER
This label offers an elegance that only a woman can achieve by adding a touch of high fashion to staple items that will be cherished for a long time.

monkey time
This label offers a unique Japanese mix of styles, the freedom of streetwear and the creative energy of the best in high fashion.

STEVEN ALAN
This label offers simple, comfortable items based on American traditional (*ametora*) and American casual (*amekaji*) styles, but adds a Japanese twist.

LOEFF
LOEFF clothes are all about simple designs that showcase perfectly selected materials sewn to the highest standards. With its roots in workwear and menswear, the label's philosophy revolves around strength, integrity, and quality.

AEWEN MATOPH
The brand name AEWEN MATOPH derives from the ancient
Japanese words: *iuen* (elegance) and *matou* (wear). This
label features couture, vintage, and basic items built
around contemporary trends. It is aimed at women who
know exactly what they like and prize originality.

Odette e Odile
Inspired by *Swan Lake*, this label's original shoes
feature a modern take on classic French chic. The
brand also offers select shoes and items from all
around the world. Each piece is engineered to bring a
rush of pleasure and confidence to its owner.

District United Arrows
District United Arrows is principally a menswear label
based on the theme of creativity and craftsmanship, and
strives for a high level of perfection, from design to
manufacturing.

H BEAUTY & YOUTH
Based on the concept of "City Man and City Woman" this
label offers a range of high-end sports and casual wear
and accessories, a Tokyo attitude intended for fashion-
forward adults.

UNITED ARROWS & SONS
A concept label for a culture born in the streets—with
a spirit that would endure, in items of such quality
that can be passed on to future generations.

ASTRAET
Taking its name from the Old English word for "street,"
this label offers updated styles in three categories—
new basic, heritage classic and street mix—for women
to match their current mood, alongside seasonal
collections that examine the latest trends through the
ASTRAET lens.

BLAMINK
Sincere in the belief that in these garments, the
wearer "will shine from within," this label pursues
a new form of luxury, with an emphasis on the finest
materials, from classic tweed jackets to accessories
in exotic leathers.

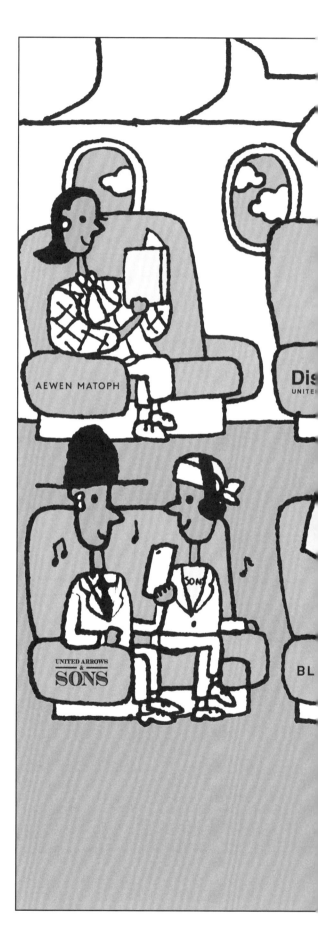

Where our home is

United Arrows Ltd. Store Maps

HOKURIKU

HOKKAIDO

TOHOKU

KANTO

TOKYO

TAIWAN

It all started in Tokyo on October 2, 1989

The year 1989 was right in the middle of the bubble era. United Arrows Ltd. was founded in October of that year, with the support of Hirotoshi Hatazaki, then CEO of World Co., Ltd.

By selling clothing from America, we introduced a new kind of culture to Japan. But over time, we gradually noticed that as exciting and appealing Western clothing was to us Japanese, it wasn't all an exact fit—literally and otherwise. We realized that we should incorporate into our collections cultural traditions fundamentally rooted in Japanese life. We would then take a further step: to propose a new lifestyle not limited just to clothing. These considerations were behind our decision to grow a different kind of business, one that would become a new standard in Japan.

When we started, we looked around and noticed the small number of existing shops that dealt with imported goods. Those shops sold only the imported items, and the service was generally hideous. Some shops would even warn potential customers away with signs saying "Don't touch!" or "Don't enter if you are not interested in fashion." This is why United Arrows has always emphasized the importance of customer service. To this end, we set out to create a modest and humble shop, committed to providing the highest level of customer satisfaction. Building on this direct contact with customers, we have directed every step in our operation toward the enhancement of customer satisfaction—from manufacturing to purchasing to sales promotion and even store building. We want to see our customers leave United Arrows with a feeling of gratitude for service well rendered. We want our customers to say "This is the best purchase I've ever made!" Doing everything for the customer has been our approach from the start. It has not changed for more than thirty years.

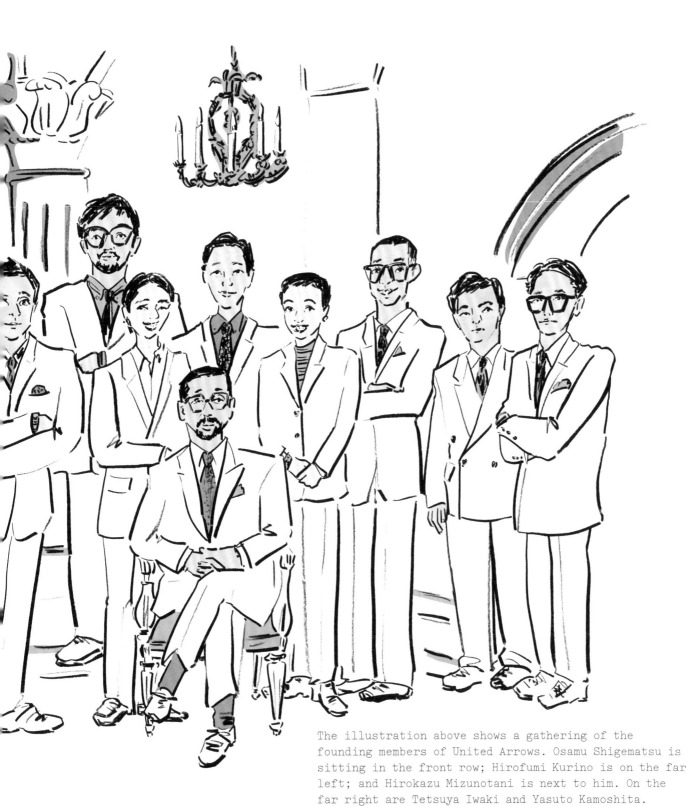

The illustration above shows a gathering of the
founding members of United Arrows. Osamu Shigematsu is
sitting in the front row; Hirofumi Kurino is on the far
left; and Hirokazu Mizunotani is next to him. On the
far right are Tetsuya Iwaki and Yasuto Kamoshita.

Why do we call ourselves a "Select Shop"?

The Japanese word for department store is *hyakkaten*, literally meaning
"stores selling one hundred types of goods." Under the influence of the
United States, such stores appeared in Japan in the early twentieth century.
United Arrows sought to update this conventional retailing concept.

In 1990, United Arrows opened its first store on Meiji-dori Avenue. At this
time, it unveiled the concept of *cho-senmon jyukka-ten*, literally meaning
"ultra-specialized stores selling ten types of goods." Whereas department
stores offer hundreds of types of goods, it was enough for United Arrows to
offer only about a tenth as many, that is, only those it really wanted to offer.

United Arrows determined to stock only a limited amount of carefully selected
products, and the first store carried out this policy of only having the best
in the world at the time. The buyers on our staff had a wealth of experience
and actually went to the sites of production to find merchandise. There, they
communicated with manufacturers, inspected textiles and other materials, and
selected products.

United Arrows was then conceived as a multi-brand store (called a "select
shop" in Japanese) that *selected* or curated what it sold. For example, buyers
selected Alden for leather shoes made in the United States, Edward Green for
those made in the England, and John Smedley for knitwear made in England.
They did not worry too much about the purchasing price, and only put together
an assortment of items that would meet our standards. The total purchasing
cost then easily exceeded 200 million yen (around 2 million dollars), but we
didn't think much about how we were going to recoup it… It goes without saying
that we were also particular about the store interior. Taking the art deco
style of the building and interior design as the keynote, we decorated the
walls with traditional ornaments made by Japanese craftsmen, and displayed
and sold Fornasetti tableware and furniture as interior decoration items.
We designed the space as well to express our eagerness to propose a standard
that fused Western and Eastern culture and was a cut above. Launched in this
manner, the United Arrows Shibuya store quickly won the praise of stylists
and other people in the fashion industry, including magazine editors and
managers of so-called DC (designer/character) brands, a unique subset of
Japanese fashion that catered to young consumers.

A Navy Blazer as a Uniform

This story is from a trip Hirofumi Kurino (Senior Adviser of United Arrows) made to Europe. He went for two weeks, visiting London, Florence, Milan, and Paris. This was a trip for pleasure, as opposed to business, and so he packed nothing but casual wear. Moreover, all of the items were of the mix-and-match type; he didn't have any jackets or suits along. However, in London, his first stop, a certain incident caught his attention: at a restaurant where a friend had made a reservation for him, all of the other male customers were wearing jackets or suits. Although the atmosphere inside was relatively relaxed, Kurino-san could sense an invisible logic that told him knitwear and regular shirts were too casual... This subtle out-of-place feeling was unbearable for him, and he immediately went to a long-standing menswear shop in Piccadilly and bought a six-button navy blue blazer. He also wore this blazer during his subsequent visits to Italy and France. And like magic, even when he appeared at the door without a reservation, and even at restaurants that seemed to be a little exclusive, he was ushered to a "good table." Kurino-san thinks the main reason was that six-button navy blue blazer he had on.

Partly because of this experience in Europe, the in-store staff at United Arrows all decided to wear a uniform of the same style. Needless to say, a six-button navy blue blazer was part of it. Kurino-san recalls they wore gray slacks with it. When serving customers, the staff act solely as *kuroko*—the black-clad "invisible" stagehands who assist actors in traditional Japanese theatre. This philosophy was manifested in the uniform.

The uniform itself is no longer worn, but our attitude in serving customers still remains completely unchanged.

When Harajuku Became Our Home

United Arrows Harajuku, our flagship store, has become a bit of a landmark; in fact, many people from both in and out of Japan have visited the store, often just to get a look at its architecture. In 1994, one of its passageways was used as the runway of a fashion show held by Maison Martin Margiela.

The Harajuku flagship store might not have existed without Hirotoshi Hatazaki. Back then, Hatazaki was the president of the apparel company World Co., Ltd. We wanted a new building, and we wanted Ricardo Bofill, who had already planned a structure for Harajuku, to design it. Hatazaki granted both requests. A Catalan-born architect, Bofill had previously authored the Espace d'Abraxas development in the eastern suburbs of Paris

in 1983, which was used as a set location for Terry Gilliam's *Brazil*. In Tokyo, Bofill would later design the famous red building housing Shiseido Ginza in 2001. The Harajuku store was built in 1989, and that was his first building in Japan.

The Harajuku store opened its doors on October 1, 1992, about three years after our founding and two years after the opening of the Shibuya store, our very first. The concept for Harajuku was a store with three floors aboveground and one lower level, with sales space on each floor. Combining tradition in the form of a classical colonnade and modern architecture with the use of glass facades, the architecture positively embodies the spirit of United Arrows.

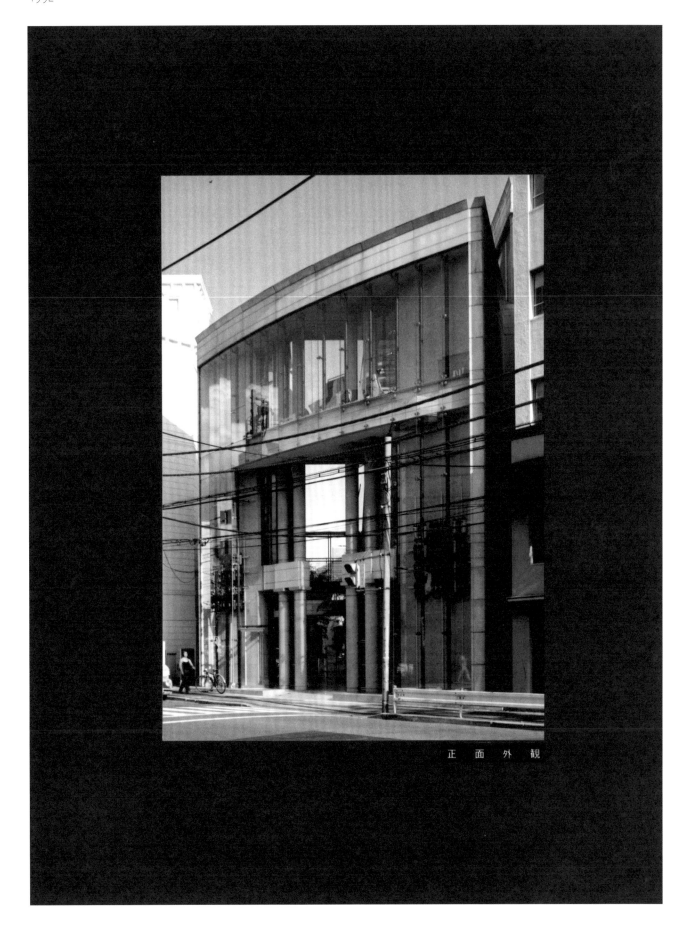

正 面 外 観

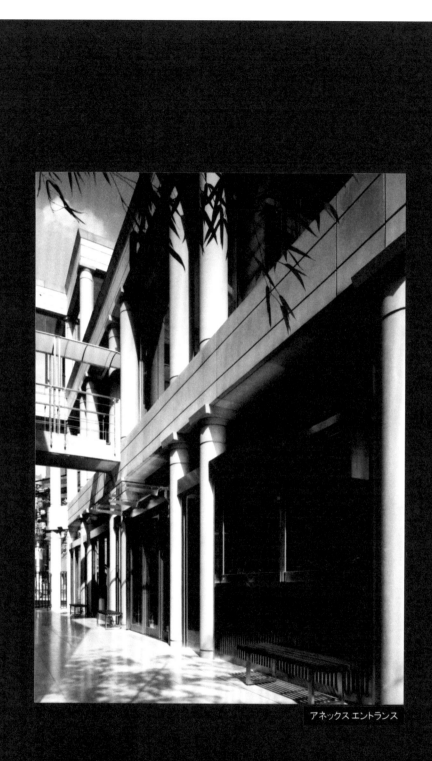

アネックス エントランス

Who Built Our Home

Interview with
Ricardo Bofill, Architect

Hi Ricardo, it's been a while. We got in
touch with you because we wanted to ask you
about the building that World Co., Ltd.
commissioned you to design in 1992.
The United Arrows Harajuku shop has become
a symbol of Harajuku, and it still welcomes
many customers to this day.
I believe that it was a challenge for you,
too, as it was your first project in Japan.
How was it back then?

Whenever I design, I always draw a connection
between the project and the territory,
a thread that aims to capture the *genius
loci*, the spirit of the place. This is very
important for me and it is the basis for my
work. However, the United Arrows Harajuku
shop was an exception. I was very influenced
by my approach and relationship to Japanese
culture.

The quality, the precision, the competence,
the way of doing things—I am always impressed
by the architecture that reflects Japanese
tradition and unique Japanese character. The
project in Japan takes place in a country with
a long-standing civilization and a developed,

advanced culture. My work is to create the
salient components of an ideal city that
I bear in my mind. However, that is not to
change Japanese architecture, or to propose
a new architectural style. My attempt was to
give my best to cherish this tradition, based
on all the knowledge I had.

This project, like the others I did in Tokyo,
can be seen as a contribution from my side to
an existing culture of architecture. Bringing
in the techniques and knowledge I personally
have, the space is a materialization of my
respect for the Japanese sensitivity for
space.

The constant seems to be your ability to draw
inspiration from the local environment in
each project. What sources of inspiration lie
at the foundations of the Harajuku shop?

Designing and building in Japan is not
the same as doing it in other developing
countries like in America or Europe. Japan
has a certain weight, for its history, and
the skills and expertise of its people. But
most of all, it is a country that has its

own, specific relationship with *ma* (void). If you bring this idea of the *ma* to other places, like in America or in Europe, it might cause confusion and anxiety, making people question: "What is this space for?" But we can see the sense of beauty that values the concept of *ma* in the gardens of Kyoto, and also in the city of Tokyo.

Within this cultural sensitivity that is rooted in the country itself, I wanted to create a space based on my own understanding of *ma*. The peculiarities of the Harajuku shop are certainly the inner passage between the two buildings and the presence of a distinct façade, but most of all the method of construction that I managed to bring to Japan at that time.

Certainly, the *ma* aesthetic is quite apparent at the United Arrows Harajuku shop. However, the building appears to be Western rather than Japanese, and it looks like it was built with reference to European matrix and their methods of construction. What is the story behind it?

No, it is not European—it is *Bofillian*, we may say.

As an architect I love drafting projects and it is an extremely important process for me. But at the same time, I am very passionate about the construction and the technology too. I am very interested in that aspect, how I used to say: "the project is the theory, but construction is the practice." The latter also makes you understand when you need to get back to the drawing board.

Mastering these two elements, I brought to Japan a specific way of designing and producing prefabricated concrete that I had developed myself in France. In 1980, after my projects in Algeria—under the request of the Algerian government—to build a village for agricultural workers in the semi-desert region of Abadla in Western Al Aria, I went back to Paris, to the factories that were producing these blocks of concrete. There I changed the design and the technology of production to fit my plans and wishes, enabling me to use architectonic concrete and artificial stone to give life to all the architecture I wanted. Not only concrete blocks, I also brought pieces for the column, the gate, the window etc. that were made from the factory in France.

It is true that the method was not Japanese.
However, the construction company, the
workers, my partner architects who worked in
Japan, and the materials all came from Japan.
That was extremely important for the success
of the project. Even though the location was
not too central at that moment in the urban
design of the city, the developer manifested
a strong will to build the shop there, and
the collaboration with Kajima and their elite
team, has been fundamental in the development
of the project for precision and dedication.
They were very good: I remember the ten-hour
sessions with forty technicians to illustrate
how that French technique of construction
was supposed to be executed. At that time, I
was extremely pleased that people in Japan
were getting to know about the innovative
technology I developed in France.

Speaking of the two peculiarities of the
United Arrows Harajuku shop that you told
us about just then. The first is the inner
passage that is sandwiched between the two
buildings. And the second element is the
façade. How did these ideas come to you and
what was the intention?

The façade is the result of two streams
of research I undertook in the past. One
was rethinking the Renaissance for the
contemporary age, thus making buildings that
have two distinct designs for the interior and
exterior. I tried to avoid designing a façade
for the United Arrows Harajuku shop that would
be a mere replication of the interior design.
The second branch of research was on the
compatibility of glass and concrete.

The inner passage is the most important
element of this building. The plot of land
was quite small in the end, about 1,200
square-meters, but I wanted a structure that
could host a number of different shops. I
thought that with having an indoor passage,
we could allocate the different boutiques
and retailers around it. There was a need to
compartmentalize the space somehow, so that
visitors would be able to walk through the
passage and the building. This central theme
makes most of the unique spatial concept of
the Harajuku shop.

I believe that the street is one of the
key elements to build a city. This is true

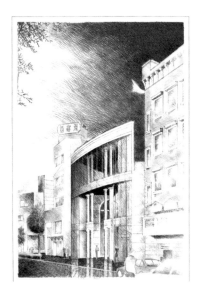

especially in Mediterranean cities, where I came from. The idea of a *passage*, which is indeed an alley between two streets, was an appropriate way to organize the space-time relationship in that specific context. To some extent, the passageway inside the shop is a different space separated from the city of Tokyo and Harajuku. This component allows the visitor to experience the space through different perceptions while walking. The materials, concrete and glass, are simple elements that, when mixed and rearranged, still provide a certain complexity to a building, even in its indoor sections. But this complexity here is measured, mediated by the same Japanese aptitude to humbleness and control that I respect so much. It is an admirable quality: Japanese architects are able to do amazing things with small spaces or just a few elements available. In the same way, I wanted to develop a vocabulary for the Harajuku shop, where nothing feels excessive, unnecessary, or out of place.

You've mentioned in a recent interview for the 17th Architectural Biennale in Venice that there is pleasure in the experience of space. How does that apply to the shop?

Partly in the way I just described, there are some commonalities with the design and architectural solutions that were implemented in the United Arrows Harajuku shop. However, here we are discussing a more general consideration that I have on the relationship between space and time, and architecture too. Architects establish links with the history and the culture of a place—both in understanding it, and also actively contributing to their making. For example, if you go to Chicago, you might not speak the language, but you grasp information about the economy, the social order, the law, just by looking at the buildings. However, these elements are somewhat external to the thought process of architecture. In the end, what I deeply enjoy and cherish is intelligence, beauty, space, and time. I say that there are people that can gaze and effectively understand this relationship, while others simply do not understand it. Understanding space means also understanding *ma*, the void. People who like and understand architecture are observers with a vision angle of 180° and can comprehend space. I think you can

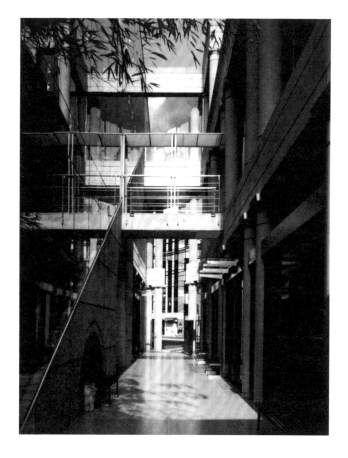

understand the space by observing it
like that.

The attempt and effort to control, govern,
and organize space in relation to time is
the fundamental element of architecture; its
driving principle. Those who can equally feel
and sense the space in a Baroque building,
or in a Gothic cathedral, or at sea with
the horizon all around—people with this
understanding are also those with a spatial
and architectural sensitivity.

You have worked on over a thousand projects
in over fifty countries around the world.
These projects have included private houses,
social housing, hotels, department stores,
city development, and urbanism. Do you have a
different approach for each type of project?

Of course, the approach is different. It
is important to be mindful of the different
cultural contexts in different countries.
This mindset is connected with the Harajuku
shop, as well as with other developments I did
in Japan and elsewhere.

Before the Harajuku shop, I had an admiration
for the distinctive minimalism in Japanese
culture. In Japan, there is a different
sensitivity in organizing and experiencing
space as compared to Europe, using a limited
number of elements and in a given, delimited
space. For example, you can see it in the
gardens of Kyoto. The Harajuku shop was the
first time I could do a project in Japan and I
adopted a very careful approach. I wanted to
make this inner passage with these materials
and techniques, and to have the cooperation of
a great builder such as Kajima because I knew
the project would be perfect.

How has Harajuku changed after that?

No matter how many changes there are, it was
only one of my architectural strategies.
Looking back, I see it as a moment of control,
discipline, discovery of a country and a place
in the project. It was one of the happiest
moments of my life to be able to take on a new
venture and new project. I feel like those
projects and the design process allow me to
reformulate parts of my personality. This is
because my whole life can be seen as a project
and a challenge. This moment of concentration,
of focusing on an idea and the methodology,
and then moving on to the construction—this
dynamism drives the happiest moments of my
life, it gives me pleasure.

With Margiela

We had heard about the existence of a fantastic designer named Martin
Margiela. We saw some of his work at Seed Shibuya at Seibu Department Store,
and wanted to add his products to the United Arrows assortment. At this
time, though, we didn't know anyone who could connect us with him. As it
happened, in 1994 he was planning to unveil his fall and winter collection
simultaneously at nine stores in six cities: New York, London, Paris,
Milan, Bonn, and Tokyo. The stores included Barneys New York, Corso Como
in Milan, Browns in London, and Maria Luisa and Bus Stop in Paris. Margiela
was wondering where to hold the show in Tokyo, and one of his consultants
suggested United Arrows. We were delighted to be placed on the same footing
as these iconic stores, and we soon forged a positive relationship with
Margiela. As we started to handle his merchandise, we also began planning the
Tokyo debut of his latest collection, which was to be held at our Harajuku
store. As it turned out, this was Margiela's first and last show in Japan.

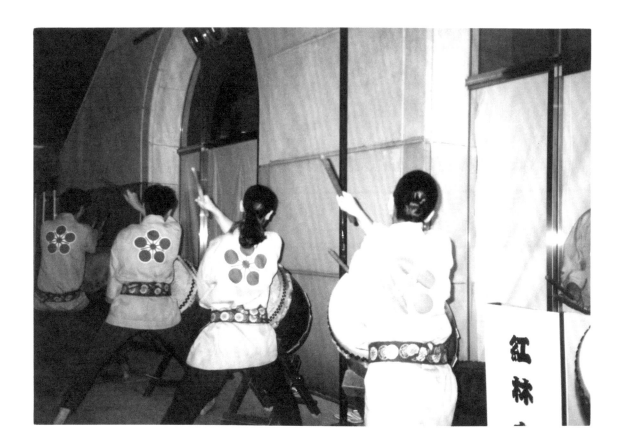

We dressed twelve models in Margiela for this show. Margiela himself wanted Mari Wagatsuma to be one of them, as she had been one of the top models in the modern Japanese fashion industry. Margiela insisted on Mari, but asked us to find the other women for the show. We sought models we thought would be suitable for his style, and we eventually put together a cast of a dozen distinctive women. For this particular season, Margiela featured items from his "Barbie" collection: life-sized doll outfits, 8.5 times larger than the originals. We transformed the passageway into a runway. For the sound design, we focused on traditional Japanese festival music, including *wadaiko* drumming, and carefully selected tracks in this style.

The show marked the beginning of a rewarding and valued relationship between United Arrows and Martin Margiela (and the present-day Maison Margiela) that has lasted for more than twenty-five years. Looking back, this event seems like a dream. We cherish it as one of the proudest achievements of United Arrows and the Harajuku store.

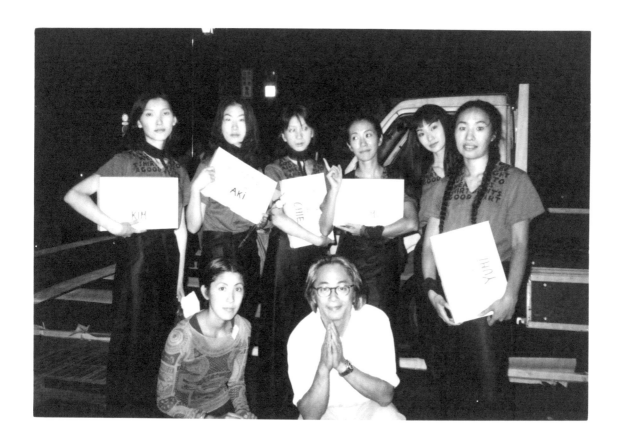

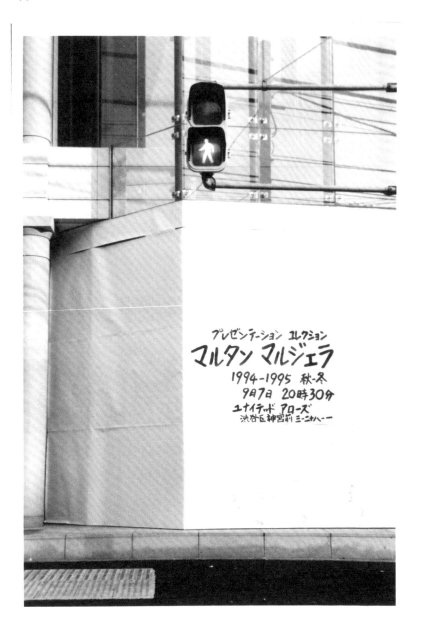

Hello Belgium! Hello, Antwerp!

Our relationship with Antwerp Six

Osamu Shigematsu, the current Honorary Chairman of United Arrows, was formerly a managing director and buyer for BEAMS. Back then, he was the first buyer in Japan to purchase Dirk Bikkembergs, Walter Van Beirendonck, and Dries Van Noten. In 1981, Shigematsu created a space in BEAMS called International Gallery, where he featured foreign designers' brands, and in 1987 he exhibited and sold clothes from these three designers. This pop-up shop approach was also the first ever of its kind in Japan. Walter Van Beirendonck was extremely pop, much as he continues to be today, and despite being a newcomer at the time, Dries Van Noten brought a sense of British style with a somewhat traditional feel. Dirk Bikkembergs had a modern aesthetic, one belied by a dedication to materials like leather. The actual sales were not easy at first, but Shigematsu had a dogged sense of duty as a buyer, firm in the belief that "these items really should be introduced to the Japanese market." Three years later, in 1989, United Arrows was founded, marking the brand's first encounter with the Antwerp designers. It was then that we started, through a Japanese agent, to import Dries Van Noten. Then we met Linda Loppa, who was the head of the fashion department of Antwerp's Royal Academy at the time, the institution that produced the Antwerp Six. In 1993 she gave us a tour of a retrospective exhibition on the Academy. This was an incredibly valuable experience, like having Salvador Dalí give a tour of a Surrealist exhibition. This is how we discovered the great talents of Antwerp, and decided to bring their products to United Arrows. After that, we had the opportunity to attend Walter Van Beirendonck's show. We were then able to meet the Belgian designers in short succession.

We developed a special relationship with Dries Van Noten. We could empathize with the inventiveness of his designs and at once reflect reality—a union of imagination and realism. At United Arrows, we select clothes with the mantra "clothes that can be worn rather than put on display." For close to three decades now, Dries Van Noten has been one of the most important brands for us and has been so closely aligned with our own vision.

A Message from Dries Van Noten

"It is a great achievement that United Arrows has reached this great milestone in the important role it has played in dressing the men of Tokyo and Japan. My relationship with the company; and Hirofumi Kurino-san in particular, over the years has been a treasured one. The mutual support and friendship we have enjoyed is a good example of what is great in our world of fashion. The dedicated following of the customers of United Arrows has also been a great encouragement to my team and myself in our lives as designers. Congratulations to you all and my best wishes for your next thirty years."

Dries Van Noten

My Neighbors
by Hirofumi Kurino,
Senior Adviser of United Arrows

First, I'd like to offer a few personal recollections. My family lived in Harajuku for approximately four years starting around 1954. The location was about seven minutes away from what is now that of United Arrows Harajuku, the brand's flagship store. I went to the local kindergarten but was compelled to stop attending when we moved overseas for my father's job before I graduated. My academic record therefore includes the entry "withdrawal from kindergarten." The things I most remember of the Harajuku of those days are the big *torii* gate that stood at the intersection of Omotesando and Aoyama avenues, the police box that was nearby (and is still there), and the store of a wonderful florist. It was a pleasant neighborhood with an ambience that could even be termed *shitamachi* (old downtown).

HARAJUKU HISTORY
I joined BEAMS, my employer before United Arrows, in 1978. Even before I started to work at BEAMS' Harajuku store, I'd been visiting the district for a while. That was in the early 1970s, at the dawn of contemporary Japanese fashion. New creators had taken up residence and opened offices there, and hung around *kissaten* (Japanese-style coffee houses) and other spots.

The name "Harajuku" was steadily gaining recognition around this time. The Harajuku Central Apartment Building (1958-1990) stood where Tokyu Plaza Omotesando Harajuku now stands. For its time, it was a state-of-the-art apartment building. It was equipped with central air conditioning, water-heating facilities, a telephone switchboard room, and rooftop laundry room. Many creators—illustrators, graphic designers, photographers, and other professionals—had offices there. The *kissaten* Leon, which was on the ground floor of the same building, was where they went to discuss projects and share information. As a twenty-year-old keen on fashion, I got up the nerve to frequent Leon and was thrilled to breathe the same air as its clientele, whose type could not be found at other establishments. Leon was followed by Penny Lane and Café de Ropé as the "in" places to be. In any case, these spots were thronged with youths sporting the latest apparel and hairstyles, and grown-ups who were part of the scene.

It was not that the district was home to many apparel stores as it is today; instead, its cafés and offices had an atmosphere that was rare for those times, and attracted a hip crowd. The stores that were around then included Goro's and Grass. Near Ito Hospital was the Harajuku Flea Market Help complex, where some newcomer brands had opened

stores. Among them was the first store of Comme des Garçons
(known simply in Japan as CDG). When David Bowie made his
initial visit to Japan in 1973, I of course went to Help to
look for something to wear at his show. I believe the only
brands that were there then and are still around now were
45 rpm and CDG. The Harajuku of around 1973 was *the* place to
go for showing off new looks and engaging in mutual people-
watching as opposed to shopping for apparel. Harajuku's big
transformation into a hub of fashion retailing was occasioned
by the birth of Laforet in 1978. Laforet brought together all
of Japan's designer brands, whose popularity was steadily
rising. Its existence consequently defined the character of
Harajuku as a district for buying clothes.

OUR NEIGHBORS
The first United Arrows store was on Meiji Avenue. Shortly
after its opening in July 1990, Paul Smith visited the store
and congratulated us. Smith is a friend of Osamu Shigematsu,
United Arrows' president and founder. In 1980, Shigematsu
became acquainted not only with Smith but also Margaret
Howell, Marcel Lassance, Browns, and Japan's Yoshida & Co.
(Porter) through the New York Designers Collective. Thanks
to these connections, we became the first in Japan to source
merchandise from almost all of them. Eventually, Smith opened
a store on Meiji Avenue not far from United Arrows.

In 1992, United Arrows opened the Harajuku flagship store
at its current location in the heart of the
district. I was behind the counter there,
together with Yasuto Kamoshita and Atsushi
Toida (who, as of this writing, is at the
Roppongi store). Harajuku was in the process of
solidifying its position as a center of Tokyo
fashion. Until recently, the Gap store occupied
what was the site of the former Harajuku Central
Apartment Building in the 1970s. Along with
the increase in the number of stores, Harajuku
heightened its profile as the district for
showing off very personal tastes in fashion.

Overlapping with these developments, the
photographer Shoichi Aoki brought out the
first issue of *Street* in 1985 and that of
Fruits in 1996. Pioneering bibles of street-
style portraiture in Japan, these two magazines
commanded a cult-like following for their photos
of trendily dressed individuals (both Japanese
and non-Japanese) promenading and posing on
the streets of Harajuku, as well as in other
districts. I believe Aoki's achievement will go
down in fashion history as an essential record
of a particular time and place.

It is in part because of the visual
documentation in *Fruits* that Japanese

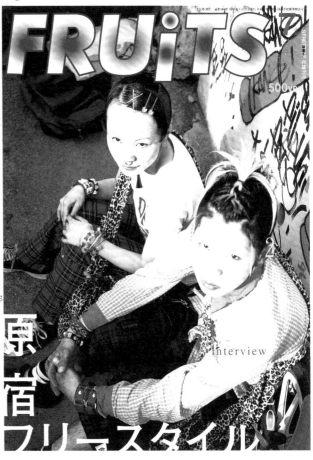

fashion is now celebrated around the world. In my interpretation, the key factors behind its uniqueness and appeal are the "classless" or egalitarian nature of Japanese society and its relative lack of "sex appeal." These attributes mean that what people wear does not indicate any social status or class to which they belong, and that they can freely choose clothing without worrying about whether it will make them look sexier. Gender-related constraints are also loose. The resulting freedom shaped the personality of Harajuku, which became a popular destination thanks to the aforementioned street photos.

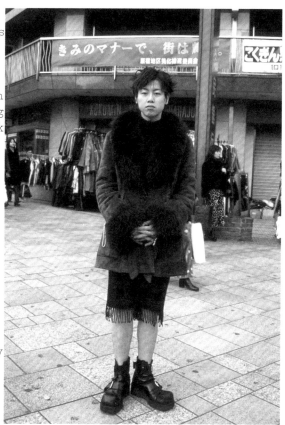

The few years after the opening of the United Arrows flagship store was also during a period that saw the genesis of independent Japanese brands. The successive emergence of brands such as Undercover, General Research (the current Mountain Research), and Mihara Yasuhiro coincided with 1994, the year in which grunge was born in the United States. Back then, "freedom and independence" were the cultural watchwords shared by youth around the world. A steady stream of new stores run by individuals also opened their doors in Harajuku. Examples are Made in World, ELT, Vandalize, and Bathing Ape.

United Arrows is a corporate enterprise that breathed the same air as these stores. I think it was precisely this coexistence of major and minor players in the same district that gave Harajuku its distinctive character. The 1990s was a decade in which United Arrows Harajuku advanced by leaps and bounds. At the very same store, customers could find clothing by the classic Italian brands Sartorio and Kiton; articles bearing the brands of Carpe Diem, Raf Simons, the initial line of Yves Saint-Laurent by Hedi Slimane, and the collection of Dries Van Noten. We sold all of this merchandise with the same enthusiasm and were staunchly supported by our fashion-conscious customers.

The brands and their products, which were to be themselves called "ura-Harajuku"—as they arose in the area to the rear (ura) of United Arrows and its vicinity—centered around specific items that became fixtures with youth and street culture beginning in the 1970s. The original lines of ura-Harajuku brands referenced Redwing work boots and Oshkosh chambray work shirts, for example. In my mind, they actually had a postmodern aesthetic. If the 1980s was a decade for hot, "coming-at-you" design as exemplified by CdG and Yohji Yamamoto, the 1990s could be characterized as one for reintroduction of past looks. This orientation found favor and support among customers who sensed a coolness in their reinterpretations. It could also perhaps be termed a transition from an age of "enthusiasm" to one of "participation," or from an emphasis on design to one on the products themselves.

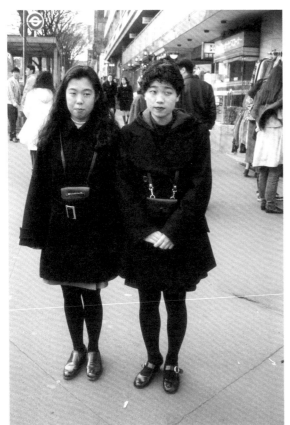 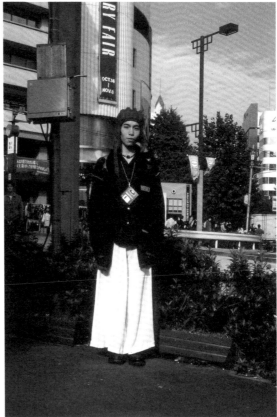

The movers behind the ura-Harajuku brands made their debuts
and opened stores without backing from big money. They
shared the idea of image re-consumption, which dovetailed
nicely with the new age, in which advances in computer
technology and design software made it possible for "anyone"
to become a "creator." This idea won deeper empathy and
backing from creators of a different generation, such as
Virgil Abloh, who watched it develop from the States. The
ura-Omotesando location and deliberately sterile interior
chosen for the new store that Abloh subsequently opened
for Off-White in Tokyo were said to have a 1990s, ura-
Harajuku feel.

With its origins in the 1970s, Harajuku grew into a district
where people could catch each other's eye, attired as they
were in free and uninhibited outfits. Even today, some forty
years later, it still radiates a special magic to Japan
and the rest of the world as a place where one can sense
the tone of the times, proudly manifested in clothing. It
is likewise a place where any fashion is accepted. But it
is also a place where purveyors of fast fashion, tied to a
global strategy, end up withdrawing, one after the other.

In the post-pandemic age, the people of Japan will
presumably make some resolute decisions—something which has
generally been hard for them to do. I have a hunch that,
from now on, fashion will be a both real and emotional
entity, and can assure everyone that we intend to keep our
flagship store in Harajuku well into the future as well.

Welcome to our family: The Sovereign House

Such a classic guy

To the present day, there has not been any real change in the image of a "smart" male adult. Often described as having his own aesthetic sense, he is a man who takes care of himself and values his free time. The Sovereign House was launched with this kind of man in mind; someone generally between twenty and sixty years old, who appreciates sophisticated fashion. When The Sovereign House was founded, the enthusiasm for Armani and other Italian-style brands had somewhat diminished. The market was beginning to shift toward a "classic Italian" style promoted by United Arrows: brands like ISAIA, Attolini, and Luigi Borrelli.

The existence of The Sovereign House undoubtedly drove the Japanese market into the golden age of classic Italian styles. However, when United Arrows began handling this kind of merchandise, the brand quickly came to be perceived colloquially as a "classic-oriented" store.

Of course, it's hardly a mistake to equate "classic" wear with items made with great patience, care, and effort. With this in mind, The Sovereign House carries a wide assortment of exclusive, premium items that have been thoughtfully chosen from manufacturers around the world. A visit to the store allows customers to fully experience the pleasure and luxury distinctive to men's fashion.

At United Arrows, we understand that while our customers wear suits, they might also want to have fun going outdoors, leisure activities, or going on holiday. To help them make the right choice, we provide a large selection of high-quality items from major brands inside and outside of Japan, along with makes one would not ordinarily find in multi-brand stores. For example, we might suggest a Liverano & Liverano sports jacket for a short trip, or straight tip or plain toe shoes by John Lobb for a party.

The Sovereign House began in 1997 with a store that opened on Namiki-dori Avenue in Ginza. It relocated to the Marunouchi district adjacent to Tokyo Station in 2003, and in 2021 will start offering its product line inside the United Arrows Roppongi Hills store. Because we believe that special moments are magnified when we enjoy them in great apparel, we intend to uphold our tradition of bespoke customer service, tailored to fit the occasion.

Exterior of The Sovereign House store in Marunouchi

Tatsuji Akashi, Sales Associate
United Arrows, Marunouchi Store

May I help you?

Lately, to my surprise I find that I've gotten older, and I sometimes find myself thinking about things like, "What can be done to create more respect and recognition for a skilled salesperson? What could make more young people want to serve in this capacity?" Of course, at United Arrows, "for the customer" is the very foundation of everything, but it would be nice if more people understood the importance of directly helping each customer in such a hands-on way. I say this because I have long stood at the ready in the sales space, poised and eager to help my customers.

I was certified as a sales master in 2014 and received the platinum rank, the highest for a sales master, in 2020. This was a great honor. Nevertheless, I don't follow the manual to a T when helping customers. And even though I've been a salesperson for more than thirty years, I never served customers in the same way twice. Because of this, it's hard to tell new salespersons that they should use such-and-such an approach at such-and-such a time. Ultimately, this comes down to how well you use your radar— your ability to sense the appropriate way to approach the person in front of you. Part of this is realizing that customers have diverse needs: some want a lot of attention and others simply stop by to take a look at something they saw on our website. Sometimes the best service is one that refrains from actively helping the customer. For customers who seem to be in a hurry to leave, it's better to help them quickly find what they want, rather than encouraging them to try on various items. As I see it, the best customer service in such situations is about adapting to each customer, as opposed to rigidly following any manual. The Japanese word for this is *omotenashi* (hospitality). I think the distinctiveness of United Arrows lies in the constant pursuit of this quality.

There are truly no detailed, set rules for serving customers, just as there are no clear-cut pass-or-fail guidelines. As such, I think customer service has a value that cannot be translated into numbers. At United Arrows, we call members of the sales staff "salespersons," but this term requires a little more finesse. Our guides do more than merely sell; they also provide counsel about apparel and propose ideas for ways to coordinate and complement items. Such insights are becoming indispensable skills in today's world. I would like to suggest a new name for this position, one that demonstrates an appreciation of this extra dimension: perhaps a better phrase would be "fashion doctor" or "fashion counselor." When a proper respect for the customer's space and a sense of trust is established, the essence of helping customers becomes clear. The respect and admiration of the position can then be better appreciated by everyone.

We're on TV!

The first television commercial for United Arrows aired in 1998. The catchphrase, which was also the title of the song used in the commercial, was "Cocoloni Utao" (Song for the Heart). This commercial was the production team's answer to a request: "Create something that encapsulates our love for our customers and clothing and that shares the simple joy of being alive, not to just sell clothes or make people look stylish." Even now, more than twenty years later, this commercial is still treasured by our employees as part of the history of United Arrows.

"Cocoloni Utao" (Song for the Heart)

You invited someone
Where are you taking that person?
Love is always looking for a way
Waiting for a signal

If you can, hold my hand
Cross the bridge, can you?
The windy slope, fallen leaves of light
It's a beautiful town here

I hope
Song for the heart
To your loved ones and also yourself
Sending love to the body

Again and again
Song for the heart
To your loved ones and also yourself
Sending love to the body

Letter from Bologna

In 1998, United Arrows ran a TV commercial called "Cocoloni Utao." The unique character of this commercial, which seemed like it wasn't even for a fashion brand, generated incredible excitement in the industry and among viewers at home. An Italian artist named Gianluigi Toccafondo created the animation for the commercial. Here is his letter from Bologna, written in 2020.

"Cocoloni Utao" for United Arrows, eh? Yes, that brings back memories. That animation was an important job for me that I'll never forget. I believe I was in Milan at the time. One day, the art director, Mr. Kasai, came all the way from Japan to ask me to work on an ad for the company United Arrows. The internet wasn't that popular then and he came directly to ask me that. When I think back to then, it was quite a different time. But, when I first heard about this I felt rather unsure of whether I could actually do a fashion-related job; I had no confidence at all. Mr. Kasai pointed at the picture of a pig's face I had and said that I could simply just draw a necktie on it. And in that instant, I realized the freedom I had; I knew that I could do it if it was as simple as that. It was thanks to Mr. Kasai that I was able to go about my work feeling giddy and without the slightest sense of constraint. I just wanted to create animation that would leave people with a pleasant feeling, that wasn't overly stiff, was exceptional, and full of playfulness. Toshio Nakagawa had composed the music early on and sent me a sketch of the song, so I recall drawing the animation in my workshop as I listened to the music. It was a place full of laughter. Many authors and manga writers often say that behind every ten sentences are a hundred more that need to be written; but the fewer words there are, the opposite actually occurs. And I think "Cocoloni Utao" is one example of that. I think that every ten frames actually communicates the message of a hundred in various ways.

I have since gone completely gray. I moved from Milan to Rome, and now I live a quiet life in the great natural surroundings of the countryside of Bologna. I still dress the same as I did before, but after completing that United Arrows job, I've come to look at fashion with more interest. I'm also working on opera costumes now. It's quite enjoyable. Gaining an interest in fashion has really helped me. I am grateful to Mr. Kasai and United Arrows for giving me a little push into this field. It's a rare and precious thing to learn from meeting different people and allow the world to teach you. When I'm in a position to teach, I learn from the perspective of the youth and the students. And it moves me when I see their eagerness to learn; I am reminded of myself back then.

Welcome to our family: Green Label Relaxing

UNITED ARROWS
Green Label
RELAXING

Let's Find a Little Happiness

It's always nice to observe the playful sensitivity of children, in their games and their approach to nature: collecting pebbles and stones, using clover leaves as bookmarks… Green Label Relaxing is a label that prizes this kind of effortless inspiration and resourcefulness.

Small pleasures can be experienced every day. Picking up a leaf with an interesting shape during a stroll, having a cup of freshly brewed coffee in the morning, discovering a new taste… These sensations can also be felt after a successful meeting at work, or a delightful date with that special person, or while wearing your favorite outfit.

Green Label Relaxing presents a simple yet refined lifestyle to people who see fashion as a hobby, as something that adds meaning to their lives. Based on the traditional values of United Arrows, this label offers products in categories ranging from business attire to casual wear, children's apparel, and even basic sundries, all at affordable prices. Following the watchwords "be happy," this premium on discovering and enjoying small pleasures is essential to the conception of every collection.

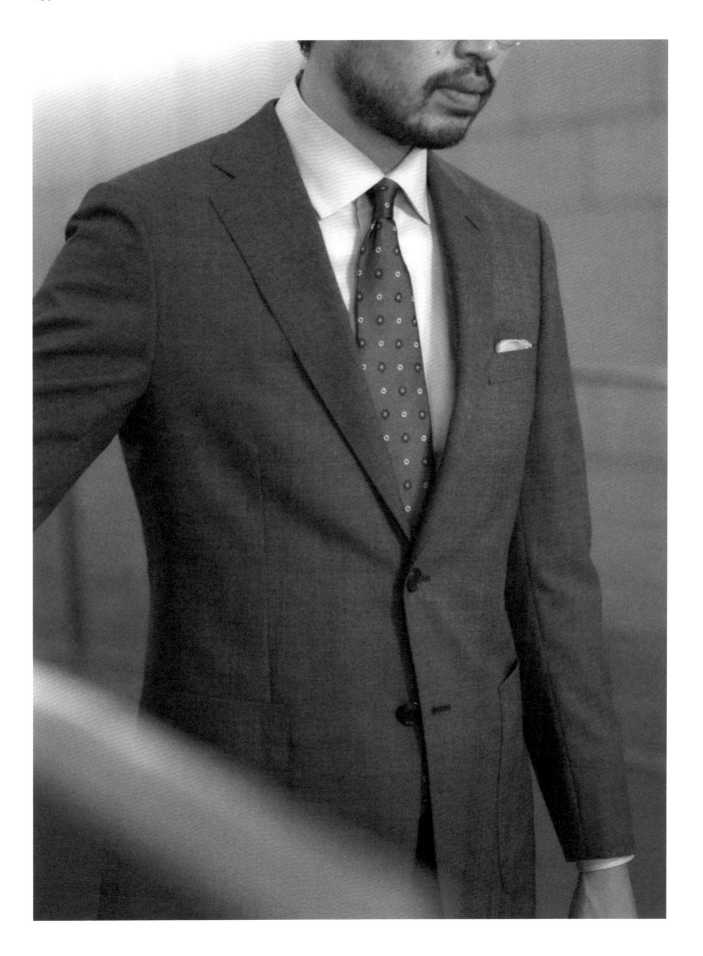

This is our wardrobe during the week...

In 1663, Vitale Barberis Canonico, generally known as "Canonico," founded his fabric company in Biella, Italy. The lightweight, soft, and beautifully colored fabrics from their looms are treasured the world over, and are proudly featured by Green Label Relaxing and other brands worldwide. Canonico's appeal is not merely defined by the high quality of its fabrics. Because the company carries out every step of the manufacturing process—from dyeing and spinning to weaving and finishing—they can also offer excellent prices. Therefore, affordable yet very high-quality suits can find their way to a much wider circle of connoisseurs.

Customers take pride in wearing suits made with Canonico fabrics. They must sense the history and craftsmanship of fine European dress clothing down through the ages. These suits are instant classics, works of art that play an important part of the Green Label Relaxing weekday wardrobe.

And this is our wardrobe on the weekend

What if you could change the global
environment for the better by the type
of clothes you choose? In their mission
statement, the brand Patagonia simply
explains: "We're in business to save our home
planet." They strive constantly to reduce any
adverse impact their materials and processes
may have on the environment by making
selections and choices that are gentle to the
earth. Sharing the same way of thinking, Green
Label Relaxing has been continuously carrying
authentic Patagonia items since 2012. Some of
our stores even have a space that is reserved
permanently for their products. While you
enjoy shopping for fashionable things to wear,
we hope you'll choose options that are also
good for the environment.

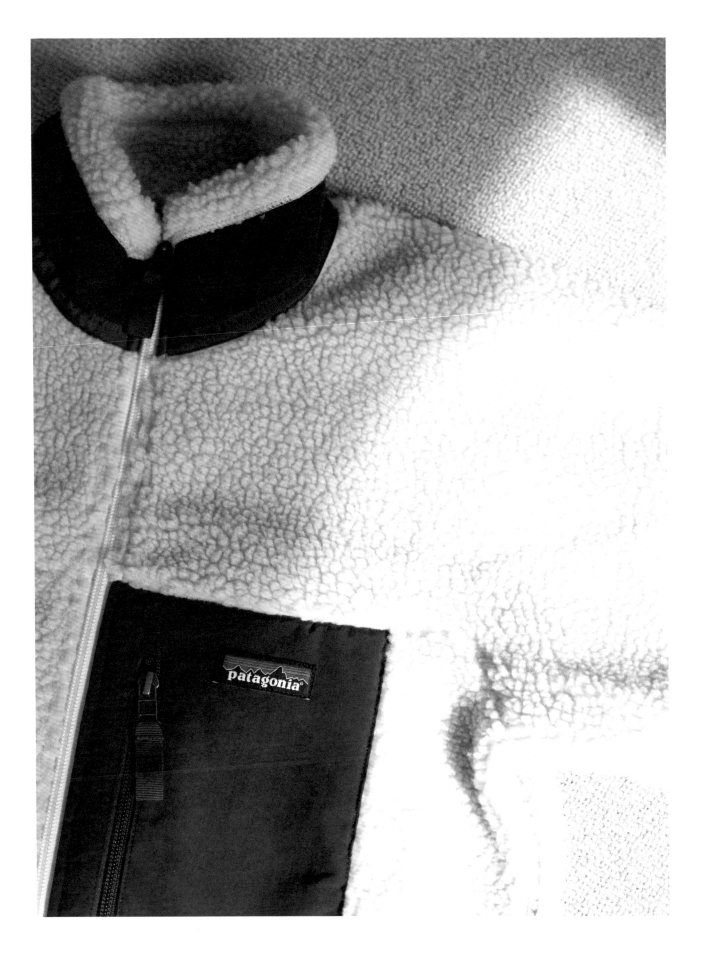

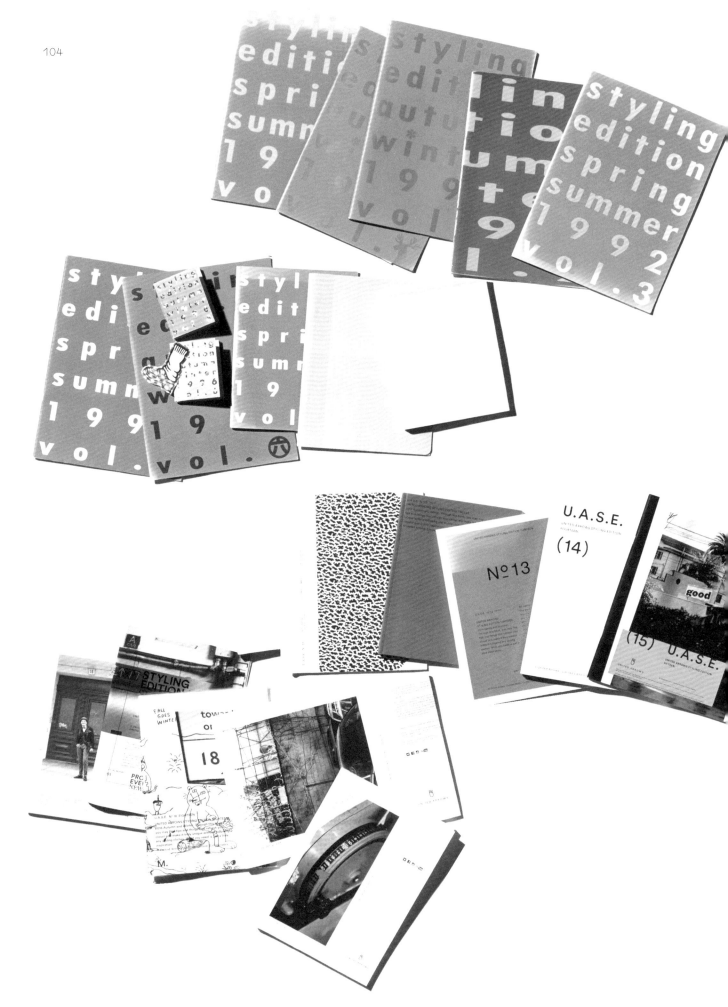

A New Standard

Is it a magazine, a catalog, or a lookbook? In 1990, United Arrows released its first *Styling Edition*, a unique publication that defied genre. This was a time before printed collateral from fashion brands were so clearly differentiated for each season. The first forty-eight pages of this book present a little remix of pages drawn from the *Styling Edition* series, which ran to twenty issues.

Koichiro Yamamoto oversaw the creative direction for *Styling Edition*, which came to be the face of United Arrows. He worked on all twenty issues and was credited as "Creative Director," but honestly, in the final analysis, it would be hard to describe his job in just a few words. Sometimes he would slip out of the office without saying anything and come back later, bringing news of some new photogenic spot, or a person he happened to meet on the street. Maybe what he did could be likened to jazz improvisation; he really, truly loved doing things in a haphazard, spontaneous way. That's why *Styling Edition* was put out without any advance specifications, on the number of pages, number of looks, physical size, format, and the *conté* or the "sketch" of the layout.

Yamamoto recalls: "There is so much to say about this that I wouldn't know where to start. But it boils down to the impression of a nice encounter of some sort, and not only as regards to apparel. This is precisely the kind of expression befitting a multi-brand store, which brings together and presents diverse brands from Japan and other countries. This is why I, too, have encountered various people, things, and places, and have striven to do so, even while producing *Styling Edition*. I wanted to squarely face any subject that made me feel "Wow, this is it!"—even though that undoubtedly made things harder for the art director and editor."

This outlook was also reflected in the way Yamamoto went about casting models. On the pages of *Styling Edition*, you find photos of university students taken in the dormitories where they actually lived; a teen working in an art gallery; an Iranian man working in a filling station; a newspaper reporter; and young women sporting the heavily made-up *garu* or "gal" look that dominated the street scene in the 1990s. By boldly deciding not to use professional models, Yamamoto made the reader think about why the people in the photos were wearing that particular apparel, instead of being taken by convention. *Styling Edition* proposed a more organic standard of looking good.

"With what types of narrative can we convey these personalized ways of looking good and the types of personal appeal we bring together? That will become our 'originality.' After doing all sorts of work, I have come to think that originality cannot come from any source but people. Originality is not in the apparel made by people, but in the people who wear it. When they wear the apparel, they engender the particular atmosphere and silhouette only they can bring to it. I think that's what I have been seeking while puttering and running around all this time."

The visuals that Yamamoto created dovetail with the "styling" that United Arrows has always cherished. In Japan, the terms "coordination" and "styling" are used in different ways. The former indicates combinations of articles of apparel, for example, the kind of slacks that go well with a particular jacket. The latter, though, concerns the kind of place or occasion in which to wear the particular jacket, including tips extending to the color of the handkerchief and how to fold it when placing it in the pocket. As suggested by its title, *Styling Edition* is full of such visuals.

Yamamoto concludes: "I wouldn't talk about it as a 'new standard,' but it comes close to the feeling you get when you find a pen, for example, of a kind that you have never seen before. There is a feeling of both surprise and excitement. Because I think this is precisely what the job of a multi-brand store should be. With *Styling Edition*, I had absolutely no intention of trying to make something wild or extraordinary using our creative energies. Perhaps what was constantly in my mind was a new ordinary."

Welcome to Our Family: Chrome Hearts

Questions

Q1. When did you start wearing the items in this photo session?

Q2. Of all the available items from Chrome Hearts, why did you choose this particular one?

Q3. If you have an anecdote about the item or items shown here, please share it with us.

Q4. Do you wear or use any Chrome Hearts items other than those shown here?

Q5. What was the first Chrome Hearts item you purchased?

Q6. How would you define the appeal of Chrome Hearts?

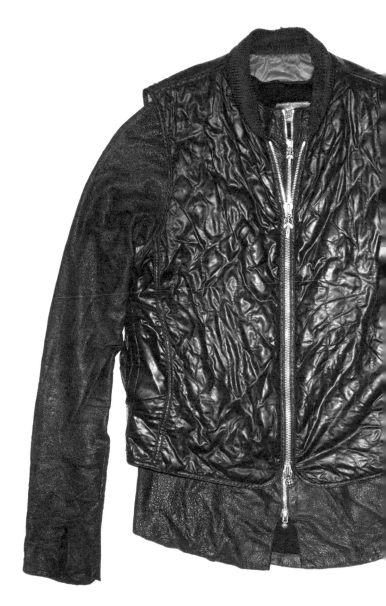

Name: Richard Stark
Occupation: Founder of Chrome Hearts

A1: 1988… Actually, way before that.
A2: The motorcycle gear was designed to ride the world at 100
miles an hour. And the rings—I've been wearing since the day
I made 'em.

Name: Osamu Shigematsu
Occupation: Founder of United Arrows Ltd.

A1. I'm not sure, but I think it was around 2005.
A2. Because of the buckle design, which I like, and the
leather material, which I also like. It is not ordinarily
sold with such a buckle.
A4. A vest, jacket, chain, and bag.
A5. A belt.
A6. Its unique, unparalleled style.

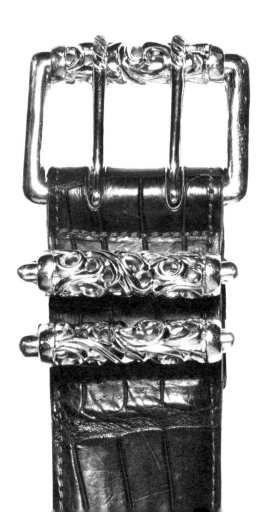

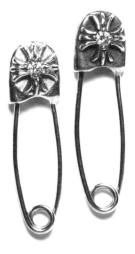

Name: Mitsuhiro Takeda
Occupation: CEO of United Arrows Ltd.

A1. I started wearing the jacket in 2001 and the safety pin in 2012.

A2. Because the tailored jacket is a rare item, even in the assortment of Chrome Hearts. It can express the versatility of the brand in all sorts of scenes, both public and private. The safety pin is an iconic item used as a lapel pin on suits.

A3. As we worked on developing this jacket, we first had a Japanese craftsman make patterns after taking apart a tailored fabric jacket we regarded as ideal, and then we converted it to leather. The jacket was then perfected after repeated production of samples at the factory. In those days, the jackets made by Chrome Hearts were mainly riders' jackets; the brand did not have any European-style tailored jackets. It was in this context that we created this one. And now I can finally say that I had high hopes we would create a jacket that I personally would want to wear someday, even on formal occasions. I was involved in its development, and put my whole heart and soul into it.

A4. Eyewear, a belt, bag, wallet, ring, key chain, notebook, and other such items. I also wear articles such as a leather vest and leather coat.

A5. A ring with a floral cross motif.

A6. Because it produces virtually all merchandise at their factory in Los Angeles. The list includes silver and 22-karat gold jewelry, leather and fabric apparel, and furniture.

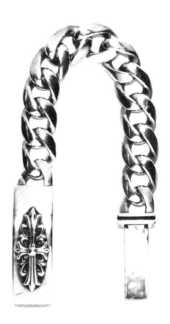

Yoichi Yasuda (signature)

Name: Yoichi Yasuda
Occupation: General Manager, Chrome Hearts Division

A1. I have been wearing the bracelet since 1993 and using the shoulder bag since 1998.
A2. The classic, timeless design.
A3. Around 1991, the actor Jeff Goldblum appeared in an issue of *L'Uomo Vogue* in a black suit and barefoot—wearing a Chrome Hearts bracelet, belt, and chain. I was stunned by this look. I remember being riveted to the screen as I watched Chrome Hearts receive an award at the CFDA Fashion Awards in 1992. It was for this bracelet. At the time, it was not in the stores, and I didn't even know its name. I therefore made a blown-up copy of this page and faxed it to the United States to place an order. I have been wearing it every day for the last roughly thirty years. As for the shoulder bag, I discovered one that had long been in use when I paid a visit to the factory in LA. It was love at first sight, and I bought it from the owner on the spot.
A4. My favorite item other than those appearing here is a leather jacket that I ordered around 1998. The leather is tanned with a vegetable tannin.
A5. The bracelet shown here.
A6. At times, this brand feels like a punk antithesis: nineteenth-century European influences with Native American influences, all together with cultural references from Africa and Asia. The brand's biggest appeal is its well-balanced blend of all these things. To use a word that has now become very familiar, it has a borderless feel.

Q&A with Richard Stark,
Founder of Chrome Hearts

What have you learned from your relationship
with United Arrows?

I learned to pay attention to every detail,
because United Arrows absolutely pays
attention to every single detail. This has
always motivated me to raise the bar higher.

Many of United Arrows staff wear Chrome
Hearts. Among them, we see less wearing it
in the standard T-shirt and leather pants
combination. Instead, they are incorporating
Chrome Hearts items into a variety of
creative styles of their own. When you
visit Japan and meet with people from United
Arrows—wearing a suit and tie, with a Chrome
Hearts wallet chain with suit slacks, for
example—what do you think of that?

In the early years, when I had made maybe
only three belt buckles, I said "I want a
Chrome Hearts belt on every businessman."
Now, it is one of my favorite things I could
ever see—businesspeople in suits wearing
Chrome Hearts.

SLITZ

'04

SUIT ¥48,000 SHIRT ¥11,000 TIE ¥3,800 SHOES ¥7,800

FICATION UNITED ARROWS HARAJUKU

裏地がファー使いの"ビーアール オブ"のジャケットに、"ミッソーニ"のニットとワイトなトラウザース。今シーズンのUAのテーマ ロマンスは
こんな新鮮なニュアンスから始まります。エレガントでふくよかなイメージですが、ロックテイストが感じられるところがイマっぽい。原宿本店なら
ではの新しい解釈のトレスタウン、カジュアルアップをお楽しみください。 稲川智久

ジャケット ¥220,500［ビーアール オブ］、ニット ¥89,250、トラウザース ¥57,750、マフラー ¥84,000［すべてミッソーニ］、
シューズ ¥183,750［サンダーラ］

原宿本店スペシャルの"ビーアール オブ"のレザーブルゾンに、今シーズン期待の"メニケ ティー"のトラウサース ブーツ ベルトをコオ
ティネート 原宿本店らしい「エレカンスを超えたワイルド」さ加減が スタイリングの幅を広けます 今シーズンの"メニケ ティー"はハイカース
アイテムをはじめ、多彩なアイテムを備えて、どれも刺激に属ちています 稲川智久

ライダース ¥220,500［ビーアール オブ］ サングラス ¥35,700［アルピナ］ ベルト ¥11,550 トラウサース ¥36,750

松尾　スーツ　コーディネート：未春ものシックで一番の注目、2つボタンテーラーの登場

UAオリジナルでフォーマルにもいけるウィンドウペンのスーツを気品ある　シャープ感のあるプリティ　フェスタイルウカ　コロン

スーツ¥68,000　ユナイテッドアローズ　シャツ¥16,000　ブラウン　ネクタイ¥11,000　ニッキー　ネクタイバー¥1,800　ユナイテッドアローズ　シューズ¥45,000　プレミア

太田　スーツ　コーディネート：オートンのシングルブレートは、銀座のサ・ソブリンのスタイルの流し
30　40年代のハウン　トスターのスタイルを手本。趣味性の高い高感度を備える
スーツ ¥428,000　キートン　シャツ ¥28,000 ルイジ・ボレリ　タイ ¥11,000 ＝　キートン　スーツ ¥120,000 シャ・ボ・ 117

9 350.SOVEREIGN; Shirt ¥30,450.SALVATORE PICCOLO; Tie ¥12,600.NICKY, Chief ¥2,700.UNITED ARROWS; Trousers ¥25,200.GBS; Necklace ¥12,600.MEGAN PARK; Bracelet ¥ 350.MEGAN PARK.

UNITED ARROWS
2000s

122

bag
hat 400

JACKET : BEAUTY&YOUTH ¥25,200
SHIRT : Gambert Custom Shirt ¥18,690
SHORTS : BEAUTY&YOUTH ¥12,600
SCARF : NATIC ¥3,990
TIE : the Hill-side ¥9,240
BELT : BEAUTY&YOUTH ¥9,450

Jacket FWK by Engineered Garments ¥36,750
cut&sewn YUGE ¥12,600
overali BURFITT ¥56,700

necklace
(from the top)

Nashelle ¥9,450
Marley B Parker ¥6,090
ORNER ¥16,800
MARJORAM ¥38,850
Enasoluna ¥20,475

🔹 Tシャツ ¥5,145　パンツ ¥3,990　ハット ¥1,995　ウォッチ ¥5,040　シューズ　スタイリスト私物

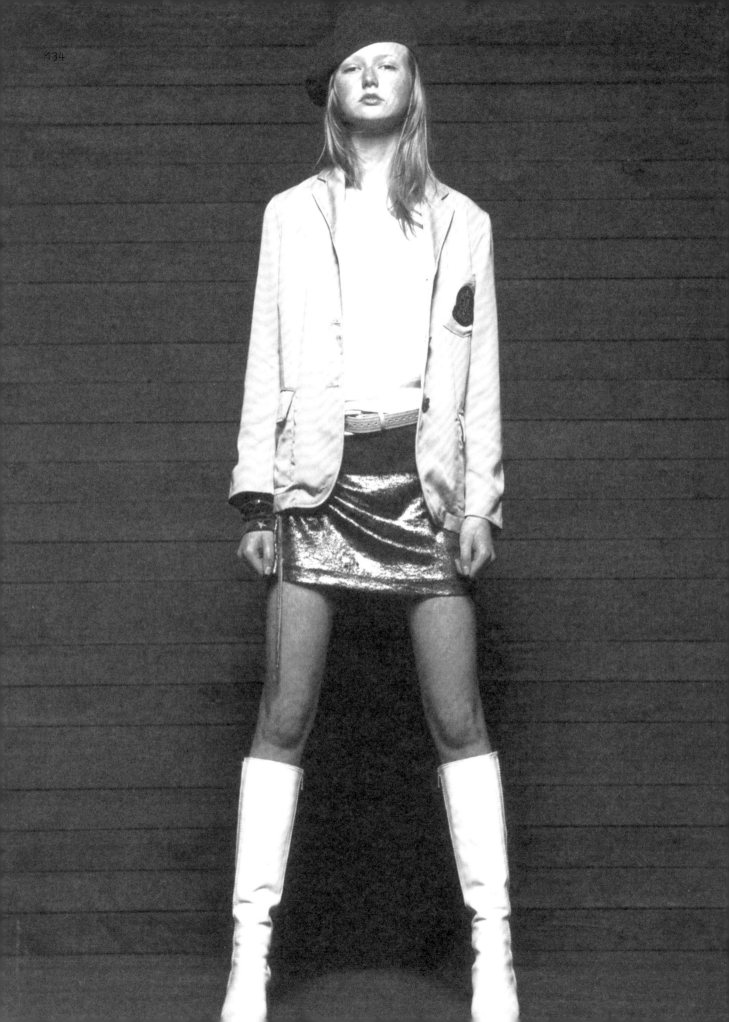

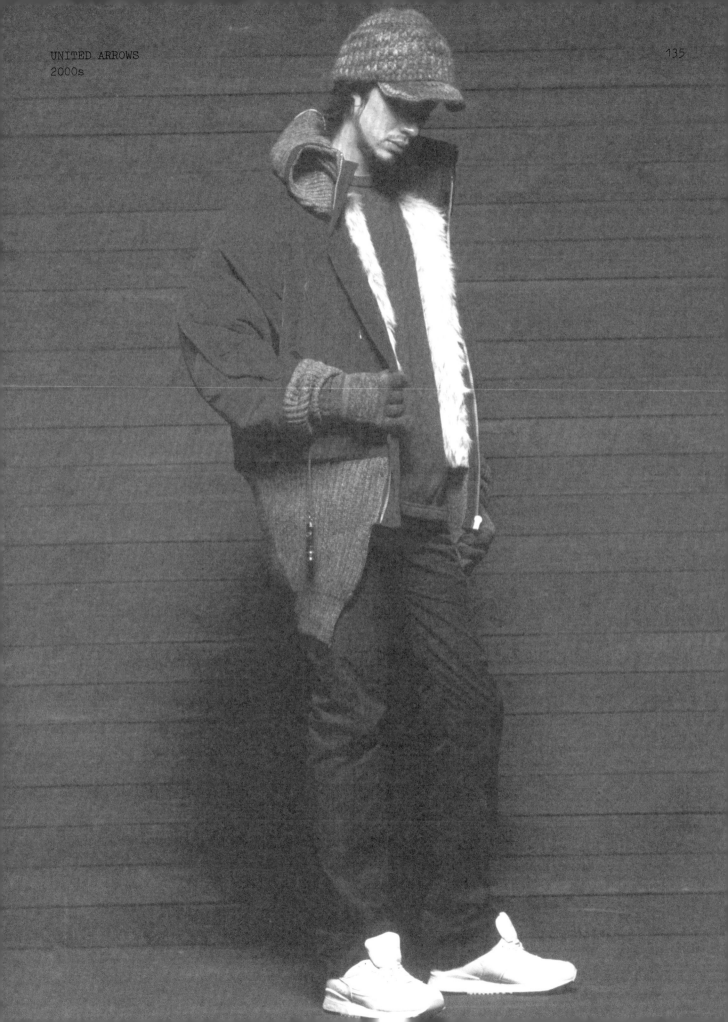

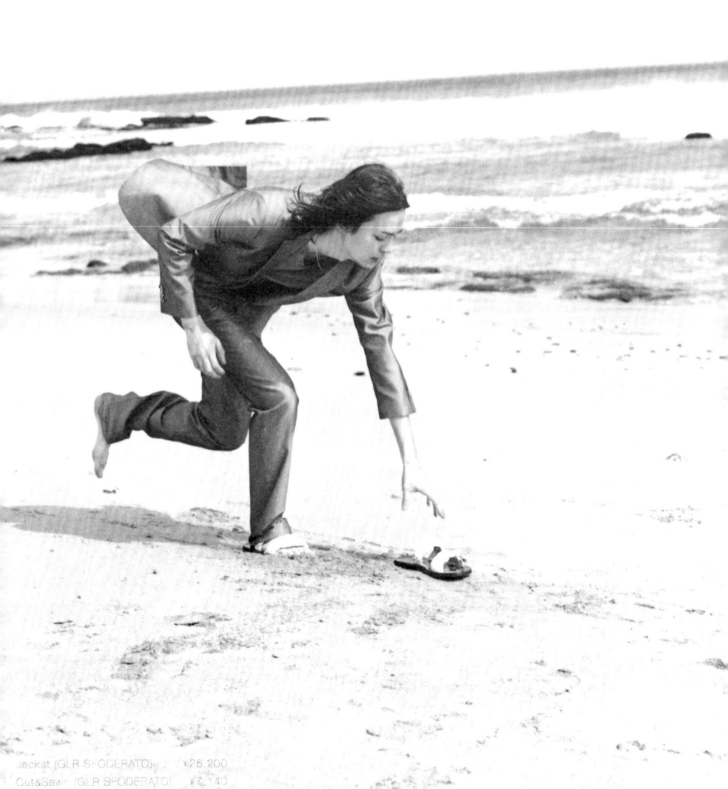

Jacket (GLR SFODERATO) ¥25,200
Cut&Sewn (GLR SFODERATO) ¥7,140
Pants (GLR SFODERATO) ¥11,550
Shoes (GLR SFODERATO) ¥15,540
Necklace (GLR SFODERATO) ¥11,550

Let's take a day trip!

We all have fond memories of special trips with family
and friends, visiting local stores and discovering unique
products in them. This is the real pleasure of shopping and
fashion: whenever we wear one of those special purchases,
these warm memories come back to life.

United Arrows stores in outlet malls hope
to create such fond, treasured memories,
while also offering the enticement of
bargain prices.

Outlet malls are generally large complexes
in suburban areas, far from the city center.
Partly because of their location, families
and couples enjoy visiting the outlet as a
day trip in itself. This day trip might be
part of a journey to local sightseeing, a
stop on the way home with relaxing shopping,
and even a good meal.

United Arrows established its business model
for outlet stores in 2000 and has grown to
include thirty outlet stores across Japan.
Unlike urban stores, outlet shops display
products without much regard to labels and

brands. Besides men's and women's wear,
shoppers can easily find everything from
dresswear to casual and kids clothing, along
with bags and other accessories. They might
even be pleasantly surprised by something
completely unexpected; such serendipitous
finds being part of visiting outlets.

United Arrows has also taken this sort of
thrill beyond Japan. In 2016 we opened a
store in a new outlet park in Taiwan, and
customers from this location taught us that
our brand philosophy travels well.

We want all our customers, inside or outside
of Japan, to have memorable, high-quality
experiences. We'd like them to come away
thinking, "That was fun. I'd like to go back
there again sometime!"

**Saori Morimoto
United Arrows
Ltd., Kobe-Sanda
Outlet**

May I help you?

Before coming to United Arrows Ltd. Outlet Kobe Sanda, the
United Arrows store in Kobe-Sanda Premium Outlets, I worked
at another outlet store. Every day I was busy with tasks like
stocking shelves or managing inventory. I was disappointed to
discover that I had no opportunity at all to help customers
directly. Gradually I started to feel dissatisfied with this
work. After seriously considering quitting, I decided to
approach my manager. My manager suggested that I set my sights
on the position of a sales master. "If you become a sales master
you can concentrate more on customer service, which is what
you really care about. Remember, you have control in making
this happen." Thanks to the thoughtful support, and that of
my coworkers, I was eventually awarded the position of sales
master. Now I'm doing the job I truly love—helping customers.

My attraction to customer service goes back to an experience
I had when I was in high school. At the Kobe Motomachi store,
which no longer exists, one of the salespersons was extremely
kind to me. I just couldn't decide whether or not to buy an item
that was on sale for about 10,000 yen ($100). The salesperson
supported me as I went back and forth, offering me advice about
how I might wear the item. He gave me perfect service without
being overbearing, right down to the adjustment of the hem. I
was thankful for such meticulous and thoughtful assistance,
something I had never encountered. After that, I began to think
about working in apparel.

As a United Arrows salesperson, I want my customers to purchase
only the products worthy of their highest esteem. Otherwise,
their purchases might be destined to just hang in their closets
for years. Recently, I've also started thinking that doing what
little we each can to break the cycle of excessive consumption
and waste can also be part of our role as responsible
salespersons.

My current wish is to work at an outlet store specializing in
accessories and footwear, perhaps in the Kansai region. I see
footwear, bags, and accessories as a special class of items;
they enable you to alter your whole look just by switching out
any one of them. It's a shame that many of these unsold items
are ultimately thrown away because the prices can't be lowered
anymore. In outlet stores, items are often displayed off in
a corner. I'd like to think that accessories would be better
served if we displayed them where customers can more easily
appreciate their merits and potential.

Welcome to the family: District United Arrows

District United Arrows is a conceptual label for which Hirofumi Kurino works as director. Items for the brand have been carefully chosen based on the key concepts of creativity, craftsmanship, and freestyling (our take on improvisation). Most importantly, the brand continuously conveys the joy of fashion that goes beyond the simple act of wearing clothes.

What is creativity?
This is the power to create
clothes that make a human
shine. Specifically, this
includes clothes like Comme
des Garçons Homme Plus, Dries
Van Noten, and Walter Van
Beirendonck.

What is craftsmanship?
This is an indispensable
element to producing clothes,
shoes, and accessories that
aim for perfection. This is
the lasting impression of the
human hand, not visible in
mass-produced goods.

What is freestyling?
This is about using your
own ideas to mix and match
clothes and shoes that have
the values of creativity
and craftsmanship mentioned
previously. Freestyling is
being able to freely choose
your own style and wear the
clothes you want, without
worrying about trends or
tradition. It exemplifies and
embodies the joy of living
creatively.

Jin Hamamoto,
District United Arrows

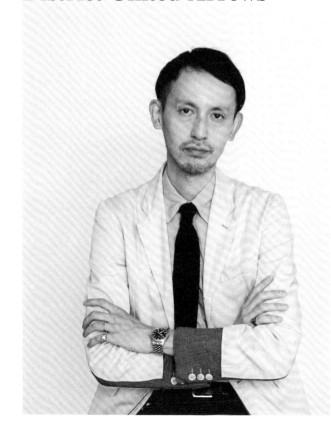

May I help you?

It isn't very common in everyday life for someone to give you a suggestion about something. When you go to the supermarket, for example, you would not usually seek advice about which vegetables to choose. We go about a lot of tasks this way, gathering information and making purchases quite well of our own accord. Adhering entirely to this approach, though, is unlikely to yield new discoveries, turn our attention to new things, or change our preferences. And that's a shame, especially for anyone in the fashion business.

Indeed, to be alive is to exercise flexibility and adapt to change; we can even choose to enjoy changes and still retain our full individuality. Though it might seem hyperbolic, I think that taking a new, objective look at something and sharing unbiased comments could potentially change a person's life. For me, this is one of the most gratifying aspects of working in customer service.

Making meaningful suggestions may not necessarily lead to immediate sales. And it won't serve the customer if I let myself fall prey to some of my own prepackaged ideas or assumptions. At District, we carry merchandise by Comme des Garçons, Dries Van Noten, kolor, Maison Margiela, and other international brands, as well as TÉGÊ United Arrows, an ethical fashion brand. The concepts tying these labels together are "creativity," "craftsmanship," and "freestyling," terms that underpin a contemporary, global approach to fashion.

The *raison d'être* of a multi-brand store is to help customers make choices aligned with their lifestyle. A basic part of this is sharing information about a product's designer and origin, but beyond that we have to bring the product to life for the customer. Because District is a firmly client-oriented store, the first thing a customer will notice is how closely they are listened to and how their concerns and priorities are respected.

In order to give this kind of attention to my customers, I have to invest in myself, too. I enjoy developing and expanding my personal knowledge about culture and I love to share my ideas about movies, music, and art with my co-workers, and sometimes with my customers. This gives me an opportunity to make a deeper, more meaningful connection with those around me.

While customer service has many different objectives, at District we are especially pleased when a customer leaves with the memory of an experience that may have little to do with apparel. Did the shopper enjoy the experience of just being in the store itself? Did they feel a bit of that excitement and energy one gets simply from being in a bustling business district? We should not underestimate the value of a customer's essential enjoyment of our carefully crafted and welcoming space.

It's Time for a Change

On the first page of an ad insert in the March 1, 2002, edition of *The Asahi Shimbun*, readers encountered two simple graphics, a triangle and a leaf-like shape, and words that translate to "It happened one day." When they turned the page, they would find many little stories. Here are a few:

*

I saw something beautiful.
An aged couple, holding hands as they walked,
Very naturally.
And then I had a thought:
To be successful in life
Must mean something like this.

Where should we go tomorrow?
Let's go shopping.

*

I like computers,
But I don't think they differ that much
From telephones and letters.
There is someone
On the other side.
There is no one
On the other side
Of washing machines and refrigerators.

Are you free tomorrow?
Come on, let's go shopping!

*

Pages 2 and 5 of the advertisement contained seventeen short texts. They were brief messages of "happiness," born from little things one might notice in the course of an average day—landscapes that happen to enter the field of vision or unexpected thoughts. These vignettes spoke to many people, businessmen included, who felt the pleasure of words spoken gently and casually.

A Visit with Art Director Kaoru Kasai

There is no one in Japan's design industry who doesn't know the name of Kaoru Kasai. Born in 1949 in the city of Sapporo, Hokkaido, Kasai joined the production company SUN-AD, after working at a printing company and a design research institute. His signature works include a series of ads for Suntory Oolong Tea; space and package design for Toraya, the renowned purveyor of yokan, a sweet bean jelly; and advertising for United Arrows Ltd. More specifically, in collaboration with Gianluigi Toccafondo, he produced a United Arrows commercial in 1997, as well as a number of memorable posters. In 2001 we again requested his services for the rebranding of Green Label Relaxing.

Nevertheless, Kasai confided that he regarded fashion-related jobs as the hardest or scariest for him, the ones that consequently made him the most nervous. This was a surprising comment coming from him, as it would be no exaggeration to call him one of the "mentors" of United Arrows. The place where we were to meet Kasai for the interview was a room in a certain condominium, his secret studio…

While you have produced ads and other materials for United Arrows and Green Label Relaxing, we somewhat brazenly asked you to let us interview and photograph you in a private space, because we also wanted to get closer to Kaoru Kasai, the person.

This is sort of my secret workplace. Almost all people, not just graphic designers, definitely want to have a modern lifestyle, don't you think? A clean white-walled interior and shelving where everything can be stowed out of sight, for example. But this space is the exact opposite, isn't it? And this is after I cleaned it up a little [laughs]. I feel relaxed in an old-fashioned space, where it's cluttered and everything is within reach. I also like the feeling of just about drowning inside it. Although I haven't done so recently, I used to spend the night here and do book cover designs while drinking. That was a lot of fun.

Book cover designs can be done by one person working alone, right?

Yes, if you have a copy machine. I had loads

of those good old cassette tapes. I listened to some of my favorite songs; they went so far back I couldn't play them with other family members around. I put them on with the volume turned way up [laughs].

You mentioned earlier that when you started doing work for United Arrows, you were fearful of the fashion world. What did you mean by that?

At the time, the fashion world seemed distant to me; I didn't know how to deal with it. Designers are liable to think that they have to make so-called "stylish" things. I felt such a thing was the most difficult to do. When I first did work with United Arrows, they said they wanted me to make a corporate commercial. They told me to create the commercial freely, because it was not about a product. I was really put out by this request. I mean, it was my first job for a fashion brand. The first thing that came to mind was a group photo of young men and women of various races from around the world, all wearing United Arrows clothes. But as it turned out, I proposed something that was already being done by other brands.

So you began from that kind of idea! But what we saw was something completely different. You made a commercial with a very humorous streak together with Gianluigi Toccafondo. How did you actually feel after finishing your first job in this field?

If you merely skim the surface of the word "fashion," you inevitably end up with a tension that somehow puts people on their guard—with something apt to be regarded as relating only to certain people. That is not my way, and so I felt daunted. Of course, like everyone else I wear clothes every day. People at United Arrows would remark, "Mr. Kasai, that's a nice shirt you're wearing today!" Hearing such compliments, I realized that I didn't even have to think about what was or was not stylish.

After the commercial for United Arrows, in 2001 you became involved in the renewal project for Green Label Relaxing. Please tell us about the production of the logo in the shape of a leaf. Actually, on our way here, we looked for a leaf resembling the logo in

the nearby park, but had trouble finding one. It is an unusual shape.

Ordinarily, when you draw a leaf, you end up with a shape like this [gestures]. However, that was uninteresting, and I couldn't be satisfied with it. For example, suppose this is a kite; with one vertical stick and another crossing it horizontally, the shape would bulge outward like this. It has just a little more tension than the ordinary leaf shape, don't you agree? The impression changes completely just by moving the bulge downward. Then it can look like a flame, too…

It also looks like a drop of water.

Put many together, and it looks like rain. The leaf shape per se is concrete, but the design is basically abstract, and the imagination therefore runs free. The kernel idea is a leaf, but there is no indication that says "this is a leaf." People are free to have their own idea of what it resembles.

And in the advertising for Green Label Relaxing, you didn't include any products;

there were only words from novels, for example, and the graphics. You took up the challenge of exploring modes of expression that would be hard to use these days.

I simply wanted to make something that I wanted to make, something that I wanted to see. When I was working on the United Arrows commercial, I was told that their stores were not selling clothes so much as the ideas and feelings surrounding clothes. This was also true for the rebranding of Green Label Relaxing. In producing that advertising, I proceeded from the question of how to present the lifestyle vision behind the products and services. I asked Hiroshi Ichikura, who also worked with us on the United Arrows commercial, to do the copy writing for the Green Label Relaxing project. I think this was also the first time he had done a fashion job. Whatever the assignment, Ichikura always comes up with distinctive and heart-warming copy. I felt certain that something interesting would result from his Green Label Relaxing collaboration. To a considerable degree, I was depending on his copy as vital to the design. The objective was not so-called "catchphrase copy"; I asked him to write a little story or account of a happening.

When creating advertising, what is the moment when you are glad you took the job on?

In the case of posters, for example, it is when they are actually seen amid the hustle and bustle. I made the Green Label Relaxing posters with the hope that they would become part of the landscape. I wanted people to get a good impression of the place or community that was linked to the posters in the railway stations and elsewhere.

When the text is this long, the poster, oddly enough, may be harder to ignore or seem to be speaking out to the passersby.

Posters usually are thought of as yelling "Look at me!" But our posters, on the contrary, seem to be merely keeping a close eye on the folks passing by, without especially calling out to them. It is as if they are saying, "I am watching you. If you like, come closer and take a look at me." While I didn't think about it in advance-

and this is true of the advertising I did with Toccafondo, too—I wanted the posters to depict something about the "cuteness" distinctive to human beings. That's why I developed a perspective that says, "What you are doing now is just fine, and you can be sure we are carefully watching." I wanted this attitude to be the hallmark of United Arrows. Perhaps the reason is because I am also lonely [laughs]. Many times, I would be relieved to know that someone is there, watching over me, a reassuring presence. I'm hoping for the emergence in society of this kind of altruistic, thoughtful orientation. But I've gotten old, and lately I find myself saying such noble things before I even know it!

I would like to ask you a question precisely because you know both United Arrows and Green Label Relaxing: if United Arrows were likened to a parent, what would the position of Green Label Relaxing be?

It might be close to a nephew or niece. It's not the child; it's related and shares the same blood, but it's a little distant, like the child of a sibling. I'm just talking off the top of my hat. I would like Green Label Relaxing to be the kind of presence that makes people think there must be lots of fun artistic types all around us.

What character traits do you think United Arrows and Green Label Relaxing share?

As I see it, United Arrows is characterized by the fact that it's accepted and trusted by all kinds of people, both men and women, from individualistic youth to middle-aged people whose wardrobe is fairly set. It is a select shop, but not the kind where the products are "stylish" in an aggressive sense. The feeling and products are more mellow, offering to complement the personality of the wearer. The clothes don't try to play the leading role; instead, they will accompany the lifestyle of the wearer. I think Green Label Relaxing is a more local and down-to-earth version of this lineage.

And so we have a good correspondence between the posters that become part of the community landscape you mentioned earlier and fashion that becomes a part of the lifestyle.

I wondered if I could make advertising solely with graphic design, without using any photos or illustrations. I was really happy when United Arrows gave me the chance to make this kind of advertising, because I didn't have to over-reach or strain myself to do it. That reminds me, I was recently part of a dialogue with Akira Minagawa, at a talk coinciding with the Minä Perhonen exhibition at the Museum of Contemporary Art, Tokyo. Something he said really made sense to me. He stated unequivocally, "I make clothes for good memories." This resonated with me, because I think I also have a sense of doing work for the production of good memories.

Relax is our school

Relax was a really good magazine. MOS Burger, Pepsi Cola, T-shirts, Winning Eleven, Spike Jonze, reggae, and Doraemon. A glance at the typical subjects of feature articles alone suggests a certain lack of coherence. Such a characterization would indeed be on the mark. *Relax* was not a magazine that could be easily categorized. It was a kind of playground, and the style of play was extremely free. It had everything from art and food to movies, music, and fashion. Just as children start from play in the process of growing and learning, it is likewise through play that adults soften views that are becoming overly rigid, or even revert to a child-like state and re-experience its joys.

Our world today is a very convenient one in which we can search for virtually anything on the internet. Nevertheless, the output received for our input on the search screen is full of items with fairly clear-cut causal connections. *Relax*, in contrast, led us to fortuitous encounters. "A fixed-gear bike and messenger bag—cool!" "Come to think of it, I'd really like to have a G-Shock watch." *Relax* brought new discoveries and realizations of this type, time after time.

Taking "Be happy" as its main concept, Green Label Relaxing was also a big fan of *Relax*. We put together our ads for each issue while engaging in dialogue with Hitoshi Okamoto, who became its chief editor in 2000. We did not hire a super photographer or cast a supermodel. Instead, the ads had photos that seemed like glimpses of someone's everyday life and were permeated with our desire to treasure those moments when we find happiness in ordinary, unremarkable sights and scenes.

Saki Kawamura
Green Label Relaxing, Shinjuku Lumine

May I help you?

I would like to be friends with the customer. Of course, because I'm a member of the sales staff, I mean friendship at a proper distance, not crossing any personal boundaries. I want to be someone customers feel they can trust and consult without hesitation. I think of the times I've gone shopping with friends and gotten personal comments like, "You don't wear this color, do you?" or, "You bought something just like this last time and haven't even worn it!" But truly, a friend who tells you things like this is someone you can rely on, who makes you feel secure. I think this is one of the reasons we go shopping with friends, instead of always going alone. In my own way, I do what I can to be a friend to the customer, offering my best knowledge, sympathizing with their feelings, and sharing my honest opinions.

Although I'm now a recognized sales master, I wasn't always so keenly interested in fashion. To be honest, I began looking for a part-time job in apparel sales with a slightly conceited attitude, thinking there was something "cool" about it. But seeing how veteran salespersons interacted with customers, I noticed that it was less about "selling" than about discerning how customers felt, and talking with them as if shopping together. That's when I started to

think that helping customers might be more interesting than I originally thought, and that I might be well-suited for this kind of work. My Green Label Relaxing store is in Lumine Shinjuku, next to Shinjuku Station, which is said to rank first in the world for the number of passengers passing through it every day. The store is in the station building, and it's surrounded by other apparel stores on both sides, as well as on the floors above and below it. These stores might normally be seen as rivals, but we see them as allies and friends. Sometimes I even point customers to one of these stores, saying "If you're looking for that kind of thing, I would recommend a visit to the store on the XX floor." Although customers can obviously make a search themselves, I started doing this because I thought it was very helpful and honest advice, especially considering all the stores in the station building. It was the kind of suggestion I myself would appreciate getting from someone. Because of this supportive atmosphere, there are also customers who come to Green Label Relaxing on the recommendation of staff at other stores. The shared feeling of helping each other in the station building is really nice. For me, this is part of sending the message, "Be happy," which is also the concept behind our label.

Welcome to our family: Beauty&Youth

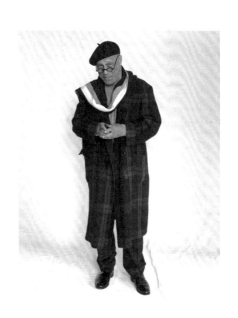

Another way to define United Arrows would be: "an evolving, long-established store." It means that we must constantly better our stores, day after day, based on improvements in both the staffing and service aspects, in order to reach and maintain a level befitting the status of a long-established store in the eyes of customers.

"Evolving" is key: fashion is constantly changing. Our Blue Label store was born in 1998. It specialized in our own take on casual fashion. Inheriting the DNA of Blue Label Beauty&Youth was founded in 2006. Its intention is to bring fun into fashion—whether through work or casual wear.

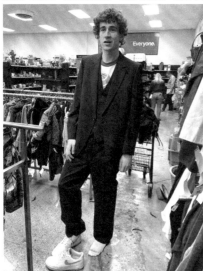
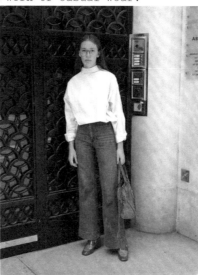

BEAUTY&YOUTH
UNITED ARROWS

Beauty&Youth is imbued with the spirit of freedom, that is, to think freely and have a playful heart regardless of age, to be yourself, and retain an intellectual curiosity. This attitude is combined with what we refer to as our "standard": a quiet dignity, peace of mind, well-being, and a nod to tradition. The "beauty" and "youth" in our name still reflect this association of ideas.

And this is his wardrobe…

C.E

In 2011, some of Tokyo's leading
graphic designers and illustrators,
Sk8thing, Toby Feltwell and Yutaka
Hishiyama, created the C.E brand. As a
cultural phenomenon with connections
to fashion and music, C.E is now
inseparable from the current Tokyo
fashion scene. We have worked with the
group since its inception, developing
several custom-made collections and
even opening a temporary shop called
"CAV EMPT SHORT TERM RETAIL EXPERIMENT
AT BEAUTY&YOUTH UNITED ARROWS." The
outfit in the picture is a bespoke
item made for Spring/Summer 2018.
Its distinctive color comes from
bleaching black denim white, a rare
look that resonates with the concept
of Beauty&Youth, incorporating C.E's
interpretation of a standard item.

And this is
his wardrobe…

Alden

Founded in Middleborough, Massachusetts, Alden is a traditional shoemaker of classic American shoes. In the 1970s, they brought innovation to the market with specially designed orthopedic shoes that were both comfortable and highly fashionable. Alden leather shoes have become a key item for Beauty&Youth. Renowned for their functionality and style, they bring the comfort of sneakers to a dress shoe. Beauty&Youth offers Alden shoes that can be worn with a suit or casually with a T-shirt or shorts.

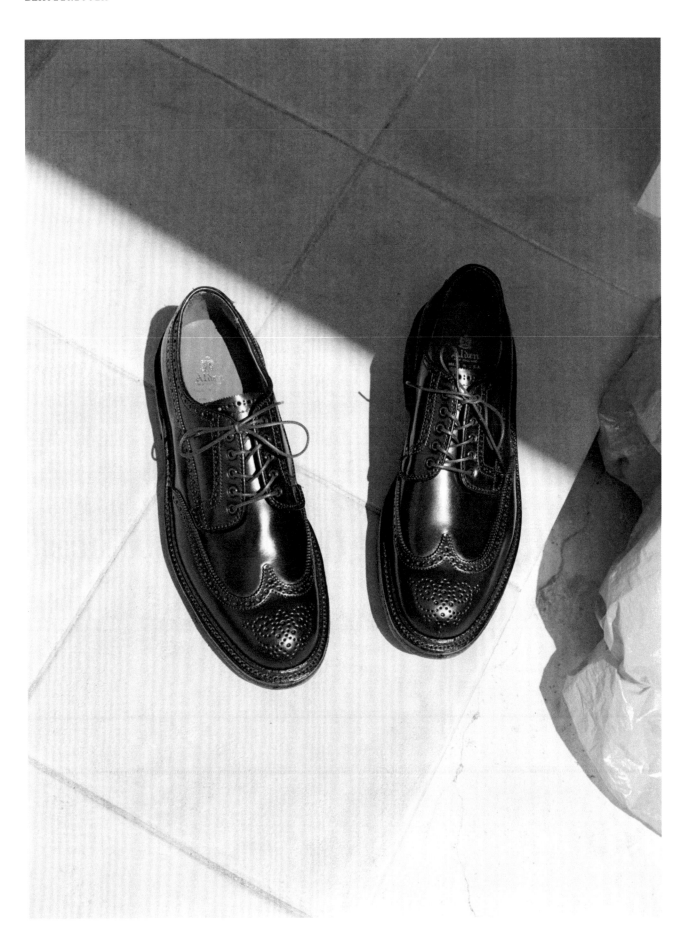

And this is his wardrobe…

GRAMICCI

Gramicci

At Beauty&Youth, the selection of products is
determined by their quality, not their price. A worthy
item might be expensive or inexpensive. For example,
an ensemble could include a C.E or Comme des Garçons
T-shirt and shoes from Alden, Clarks, or Vans. We mix
high fashion brands with streetwear, contemporary with
traditional styles. A good item is good, independent of
its cost. As the name indicates, the values of "beauty"
and "youth" include flexibility, a sensitivity to
style, and freedom from rules. We find these qualities
in the climbing pants made by outdoor brand, Gramicci,
featured in the photo. They're made from a stretch-
nylon material created by the world-famous Japanese
fabric maker, Komatsu Matere. The cotton-like texture
and the high-performance functionality feature an
inseam crotch gusset and a waving belt that can be
adjusted with one hand.

True to Nature

Green Label Relaxing
ECO BAG, helping to grow forests

Since 2008, Green Label Relaxing has been encouraging customers to use eco
bags, the same time that we also started a project to grow forests. The idea
for this project was to pay-forward our customers' good intentions to be
eco-friendly when they chose to use their own bag. We would build on this
positive impulse by donating to a forest conservation organization. Later on,
this project also spread to other stores. When we started doing this at Green
Label Relaxing, we also sold the eco bag in the picture, made from linen. The
bag features the phrase "Be happy," intimating a small, hopeful step toward
creating a better environment for everyone.

Green Label Relaxing
FOOD TEXTILE SHIRT

This cotton shirt from Green Label Relaxing is characterized by its soft
but deep and exquisite hues. Vegetables and fruits are used in the dyes,
but not just any produce; these dyes are extracted from food slated for
disposal. The increasing level of food waste has become a global problem.
It is estimated that around 28 million tons of food are disposed of annually
in Japan, and approximately 1.3 billion tons of food are being thrown away
annually worldwide. Much of this includes food that could have been consumed.
By transforming trash to versatile and distinctive dyes, Green Label
Relaxing has embraced the use of food in textiles, a worthy project that is
influencing the fashion industry.

Green Label Relaxing
Shirts and skirts made from Kortrijk Linnen

The one-piece dress featured here utilizes Kortrijk Linnen from Jos Vanneste,
a company registered with the European Confederation of Linen and Hemp (CELC).
This fine linen is famous for its strength, elasticity, and versatility and can
be worn year-round. Kortrijk, a city in Belgium, has been the center of linen
production in Europe going back to the Middle Ages. Today, Kortrijk Linnen
focuses on sustainable, eco-friendly materials of the highest quality.

Items incorporating Kortrijk Linnen are a staple at Green Label Relaxing.
Customers can relax in these clothes and find comfort in knowing that their
fine linen comes from processes and materials that are earth-friendly.

United Arrows
TÉGÊ United Arrows Jacket

TÉGÊ United Arrows debuted in Spring/Summer 2014. The label is a
collaborative venture with a United Nations project called the Ethical
Fashion Initiative (EFI), whose motto is "Not Charity. Just Work." TÉGÊ means
"hand" in Bambara, the language spoken in Mali and parts of Burkina Faso, and
its sound echoes the word *tegei* (handcraft) in Japanese. Every colored fabric
and piece of beadwork here is made individually by African artisans. We named
this label TÉGÊ United Arrows because of its association with the background
of the products—their unique, handmade quality. This special product label
aims "to connect creators and users, and to share their richness and value
through the product."

093
25TH Anniv.
Dress
SACAI
Black PHOTO
Free | 51.8

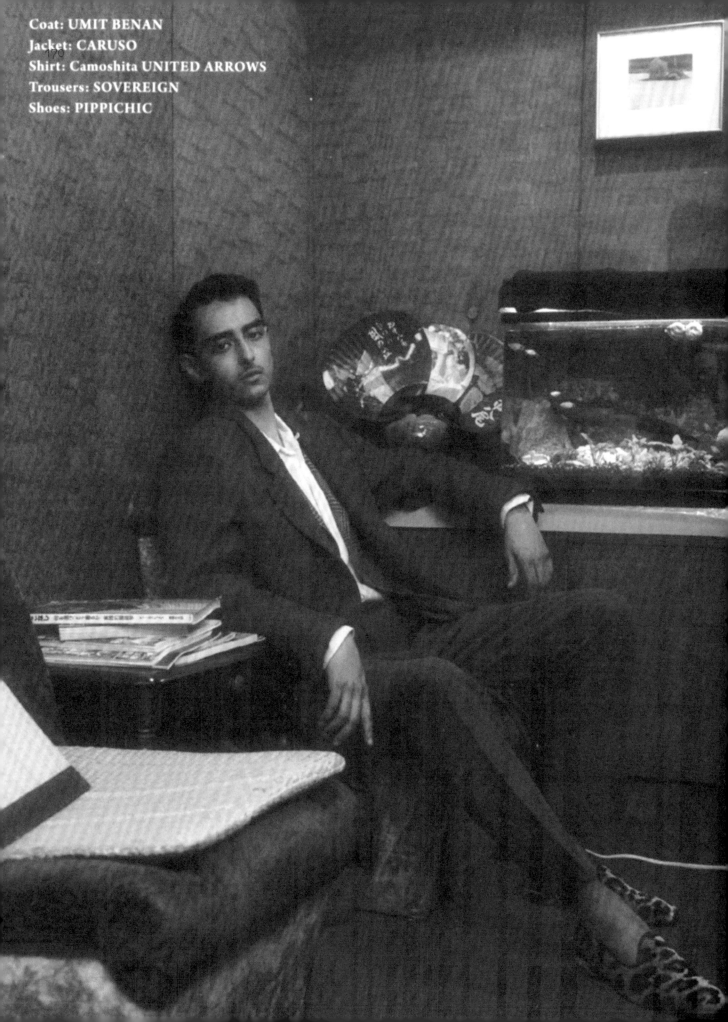

Coat: UMIT BENAN
Jacket: CARUSO
Shirt: Camoshita UNITED ARROWS
Trousers: SOVEREIGN
Shoes: PIPPICHIC

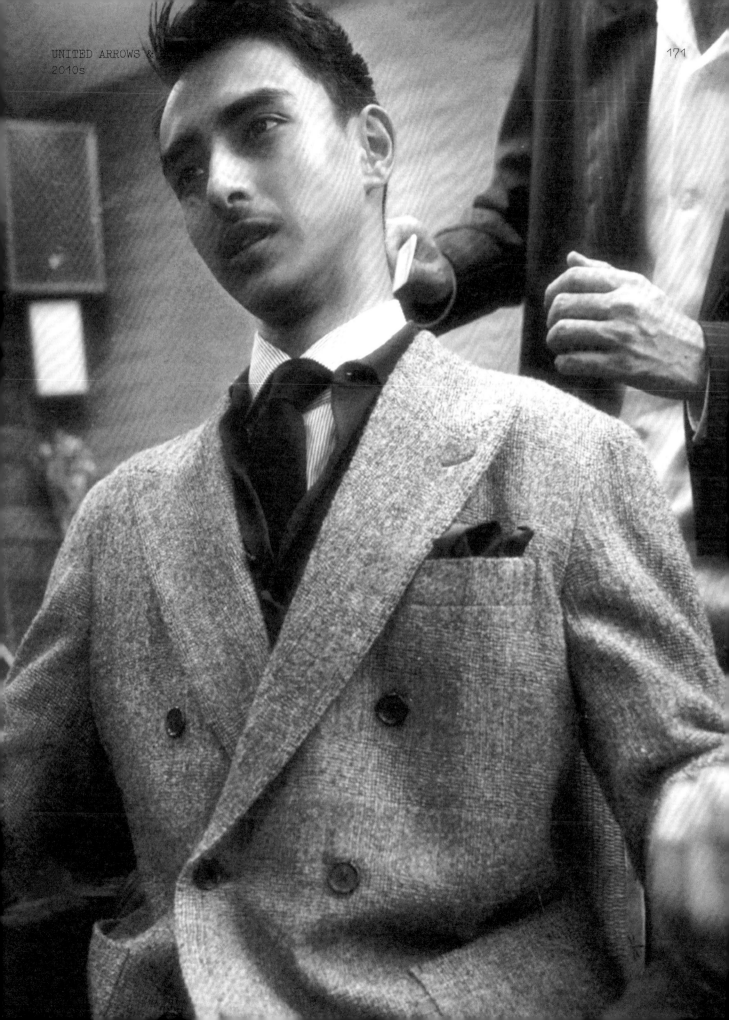

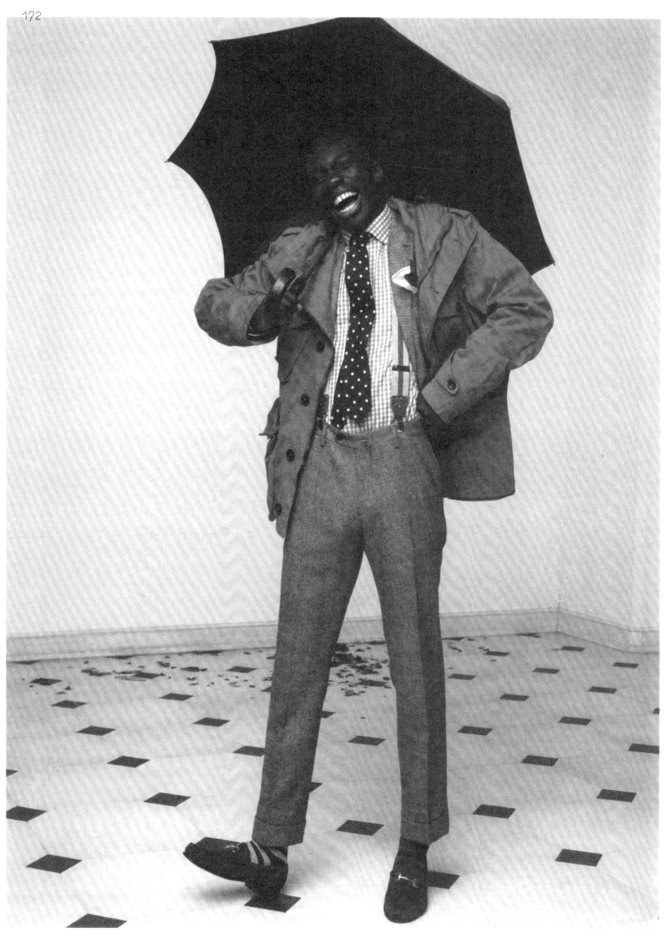

Coat ¥115 500(TEN C. Suit ¥71 400(UNITED ARROWS), Shirt ¥13 650(UNITED ARROWS), Tie ¥14 700(FIORIO), Tie Pin ¥8 925(UNITED ARROWS), Chief ¥3 990 (UNITED ARROWS), Chief ¥5 040(FIORIO),
Braces ¥15 750(ALBERT THURSTON), Shoes ¥35 700(RENATO PAGNANINI)

Jacket ¥37,800 UNITED ARROWS. Shirt ¥12,600 UNITED ARROWS. Trousers ¥15,750 UNITED ARROWS. Scarf ¥15,750 CAMOSHITA UNITED ARROWS.

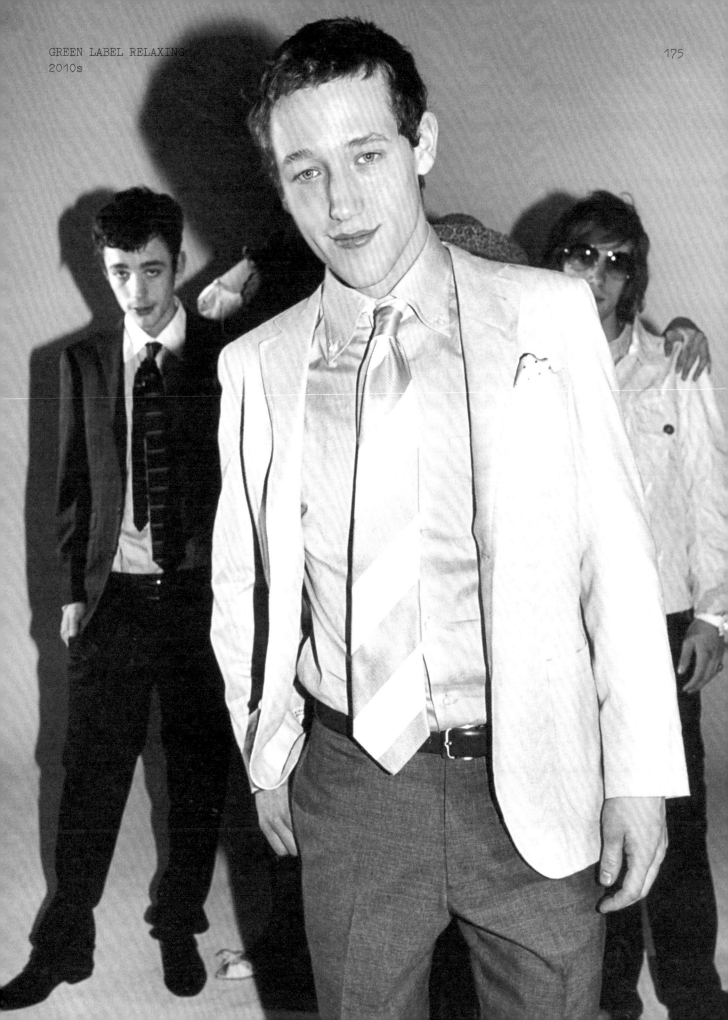

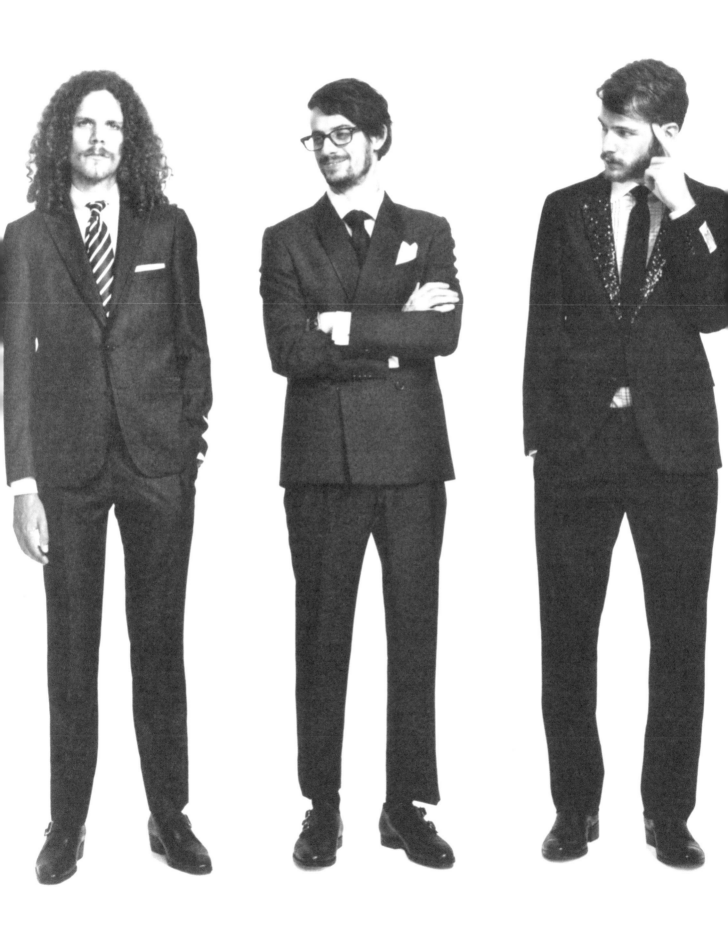

OPPOSITE
Suit_ UNITED ARROWS [Navy] 42,44,46,48,50,52,54 ¥99,360
Shirt_ SOVEREIGN [White] 37,38,39,40,41,42,43(cm) ¥29,160
Bow-tie & Cummerbund_ UNITED ARROWS [Kelly] Free ¥17,280
Cufflinks & Studs_ ELIZABETH PARKER [Black] Free ¥17,280
Handkerchief_ FIORIO [Off White/Beige] 32×32(cm) ¥4,320
Shoes_ CROCKETT & JONES [Black] 6,6h,7,7h,8,8h,9,9h ¥96,120

Suit_ UNITED ARROWS [Medium Gray] 42,44,46,48,50,52 ¥84,240
Shirt_ SOVEREIGN [Light Blue] 37,38,39,40,41,42,43(cm) ¥23,760
Tie_ FRANCO BASSI [Beige] Free ¥17,280
Handkerchief_ UNITED ARROWS [Medium Gray/Navy/White] 38×38(cm) ¥4,536
Socks_ SOVEREIGN [Navy/Black/Dark Brown/Medium Gray] Free ¥2,160
Shoes_ CARMINA [Black] 6,6h,7,7h,8,8h,9,9h ¥69,120

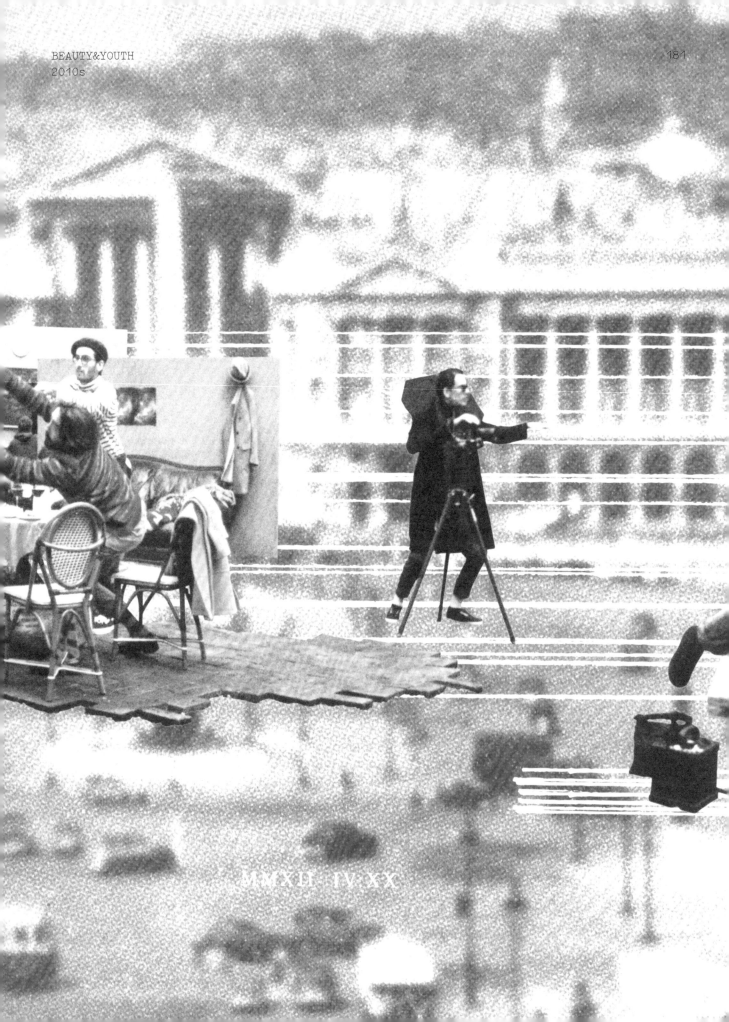

MMXII·IV·XX

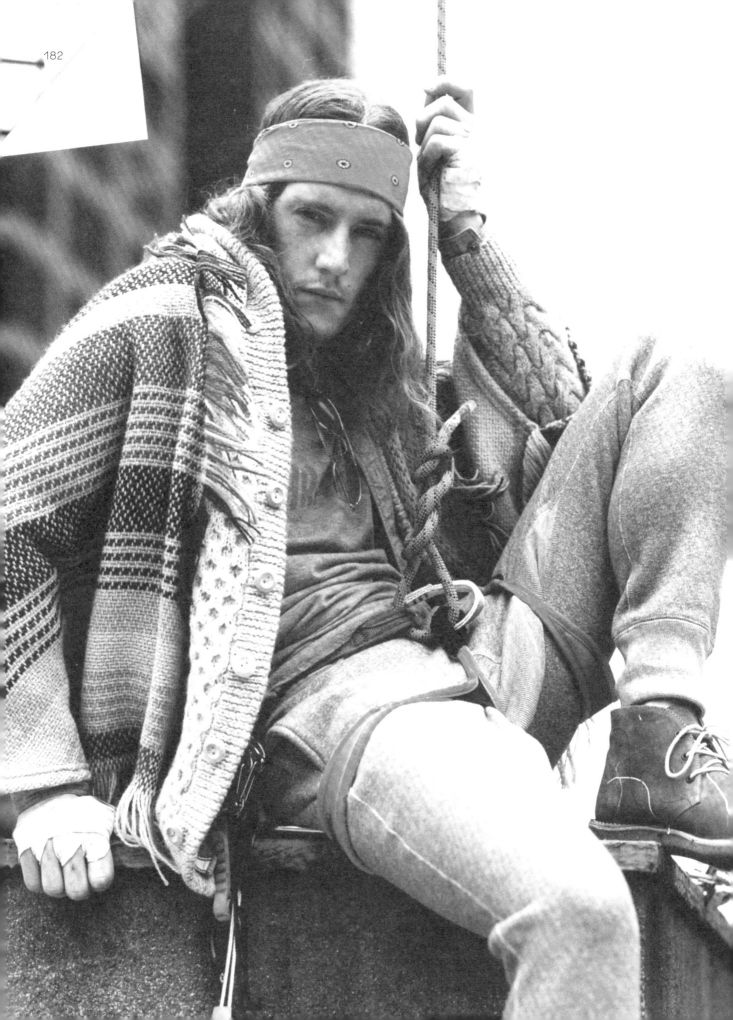

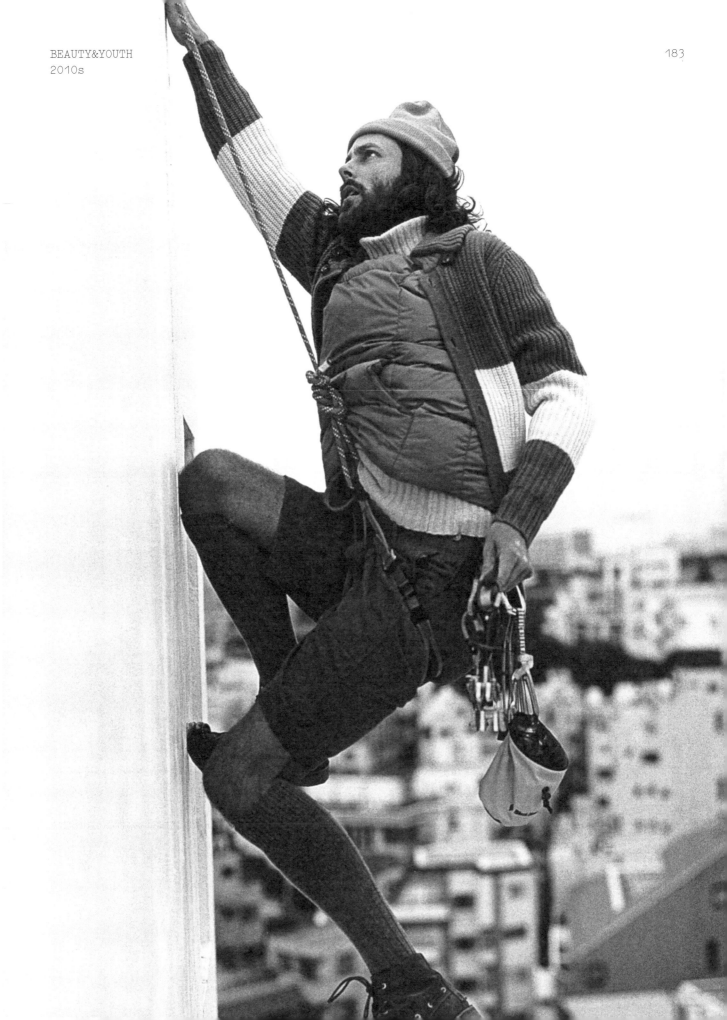

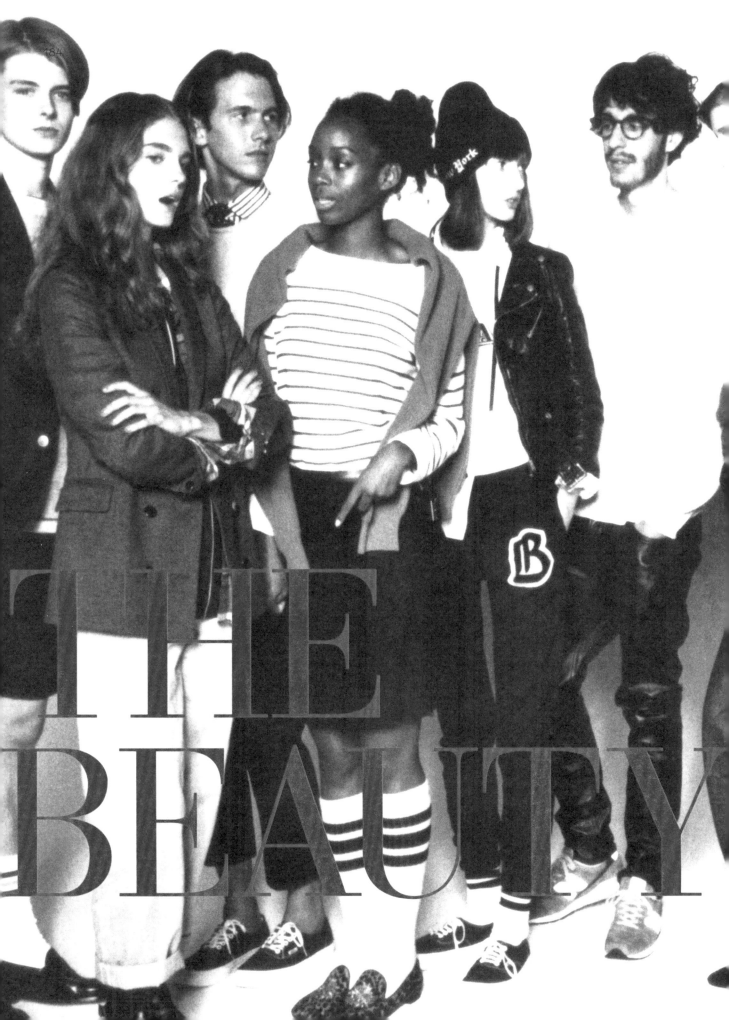

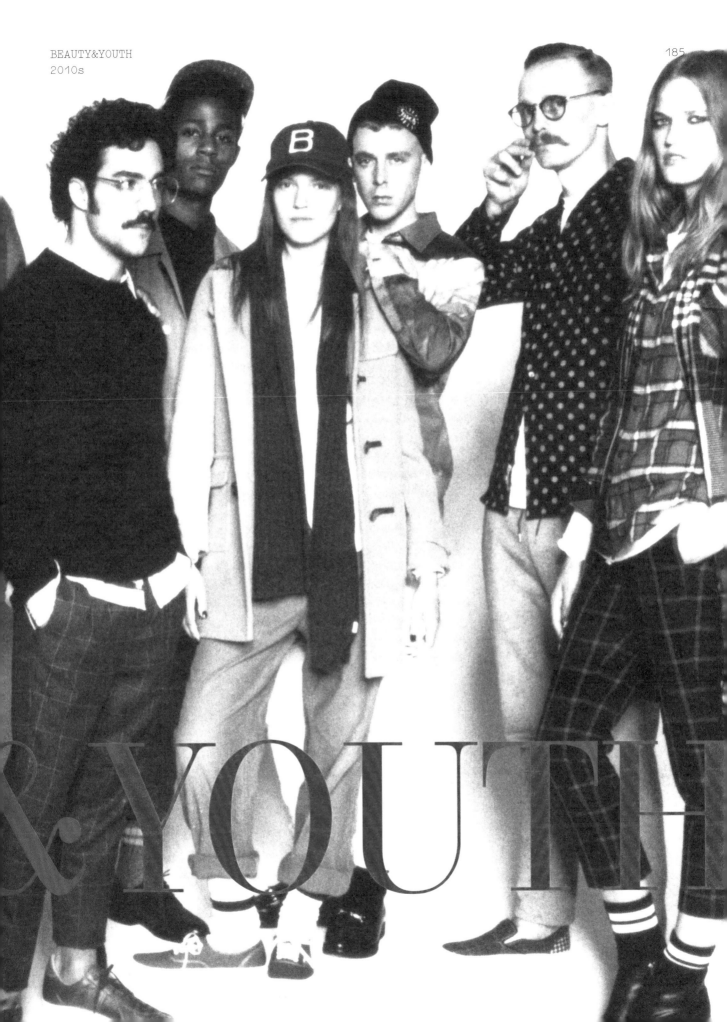

&YOUTH

ロングジャケット [*]
1577-343-5960
DESIGNERS REMIX
ミディアムグレー
32. 34
¥54,000

アスコットブラウス [*]
1578-599-5732
THE IRON
オフホワイト
S
¥30,240

フリーツスカート [*]
1578-599-5748
THE IRON
ブラック
S, M
¥48,600

ピアス [*]
1733-343-4295
AUDEN
ゴールド
フリー
¥34,560

magazine

2014　Autumn&Winter　vol. 05

WOMEN

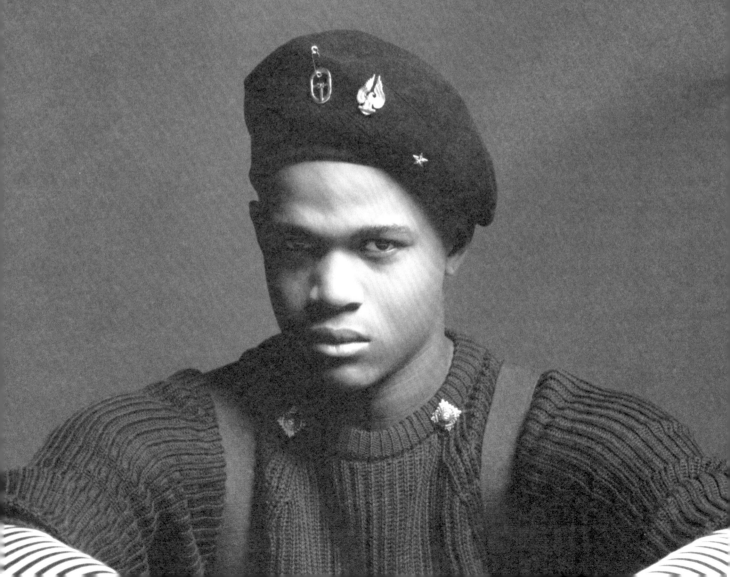

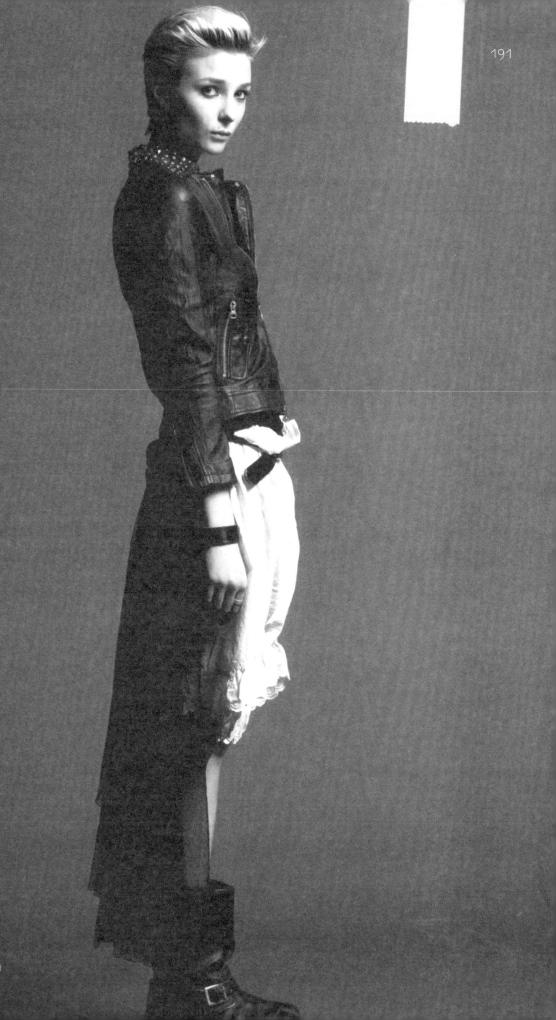

opposite page.
KNIT：BEAUTY&YOUTH　¥12,600 (top)
KNIT：BEAUTY&YOUTH　¥10,500 (under)

BLOUSON：BEAUTY&YOUTH　¥39,900
BOOTS：USED　¥46,295

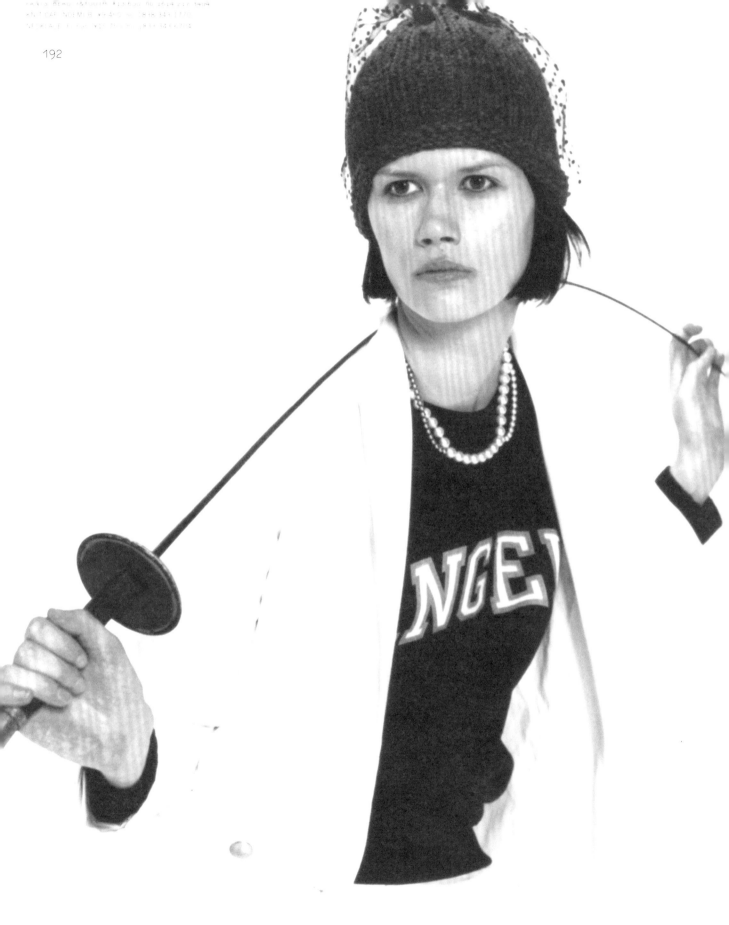

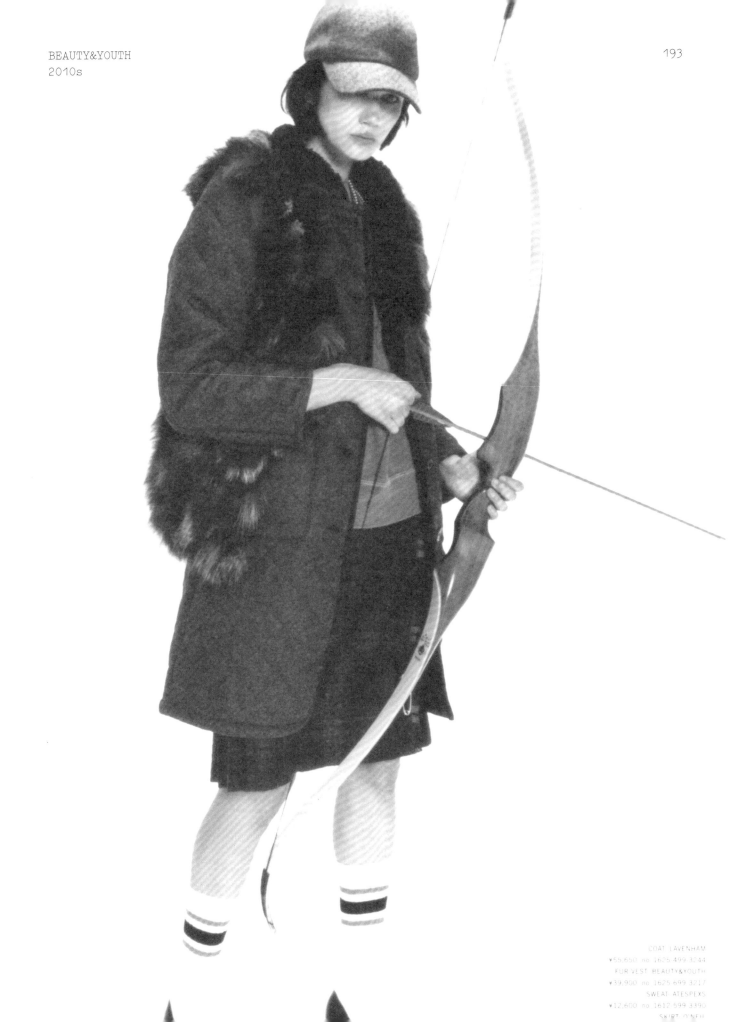

COAT LAVENHAM
¥55,650 no 1625-499-3244
FUR VEST BEAUTY&YOUTH
¥39,900 no 1625-699-3217
SWEAT ATESPEXS
¥12,600 no 1612-699-3390
SKIRT O'NEIL

denim jacket 8,190yen, camisole 3,045yen, skirt 5,145yen Grin Kids shoes model's own

GREEN LABEL RELAXING
2010s

Welcome to our family: & Sons

The year 2006 saw seminal cultural developments that suggested new and potential values in fashion that had been absent from the Japanese market to that point, and forecasted trends and currents over the horizon. It was an age in which music and fashion became truly inseparable, and hip-hop and R&B artists commanded undisputed, worldwide acclaim. The "image label" boutique Liquor, Woman & Tears (2006-2010) in Minami-Aoyama was the first in Japan to focus on the look and feel of this generation of musicians and offered original clothing and accessories that evoked the era. Following this influential concept, the B1 floor of United Arrows Harajuku underwent a total makeover and was reborn as United Arrows & Sons. Motofumi "Poggy" Kogi, was picked to handle the buying and managing director roles, as he did for Liquor, Woman & Tears. Tapping the very essence of United Arrows, United Arrows & Sons proposes suits as extensions of casual wear. Besides offering fashion a step ahead of the times, the store regularly stages a variety of events in keeping with its role as a hub transmitting cultural information.

In 2020, Shinsaku Masuda, who had long been involved in press activities and buying for United Arrows & Sons, was appointed as new director. Under his leadership, the brand is proposing new and diverse directions as it carries on with Kogi's original vision.

Dr. Martens ×
United Arrows & Sons

Based on an archival model of the British boots and shoes brand, Dr. Martens, we adopted a colorful green suede for this collaborative item. It is produced at the Wollaston factory of Dr. Martens, known to be one of the best shoemaking sites in the UK. Retaining the classic handmade silhouette and fringe design, the silver bit is replaced by a gold one, and for finishing touches the classic tassel loafer was greatly modernized by integrating Dr. Martens' iconic yellow welt stitches.

HUMAN MADE® for United Arrows & Sons

The sheepskin jacket by HUMAN MADE®, designed by NIGO® for United Arrows & Sons, was made in celebration of the thirtieth anniversary of United Arrows. Based on the 2-button jacket—an iconic United Arrows item— signature HUMAN MADE® graphics decorate the whole jacket from the front to the back and the sleeves. On the left chest of the leather jacket is the classic spot-billed duck mascot of HUMAN MADE®, and polar bears with their upper bodies pop out from the two pockets on either side.

Our partner in crime NIGO®, Fashion Designer

From the 1990s to the early 2000s, a
distinctive fashion style that was quite
different from other mass fashion trends
was born in the area called Ura-Harajuku.
It focused on street culture such as
punk music, hip-hop, motorcycles, and
skateboards, and it came to be known as the
"Ura-hara" style. (Later on, in the 2010s,
it came to have a huge influence on people
like Kim Jones and Virgil Abloh.)

One of the key people who created and
supported the Ura-hara movement was NIGO®.

The birth of & Sons triggered the deep
relationship between NIGO® and United
Arrows Ltd.

& Sons launched in 2010 as a new label from United Arrows, with Motofumi "Poggy" Kogi as the brand's director. Located on the first floor of the flagship store in Harajuku, the label offers high-quality items worthy of being passed down over time, combined with a cultural vibe from the street. The brand that embodied this concept the most is MR. BATHING APE® by United Arrows, a collaborative brand between NIGO® and United Arrows.

Chairman Osamu Shigematsu was a big influence. I had started to make suits with Savile Row for four or five years, and I wanted to start a new suit collection. However, it didn't seem appropriate to do it with A BATHING APE®… I thought that it would be interesting and worthwhile to collaborate with United Arrows on this project. Around that time, I wore a Savile Row suit to an awards ceremony for a prize I received from *GQ Magazine*. No one really noted the type of suits that attendees wore to the ceremony, but a few days later I happened to meet Mr. Shigematsu and he asked me, "Where did you get that suit made?" I was very impressed with his exceptional aesthetic sense and knowledge.

In those days, MR. BATHING APE® concentrated primarily on basic items like suits, shoes, and neckties. But these staples were augmented with NIGO®'s unique characteristics to create a fresh kind of mismatch—for example, using camouflage patterns for a suit.

It wasn't just an impulsive idea. I started by ordering lots of suits from Savile Row and learning about it in my own way. In that sense, a lot of the items were approached with the aim of creating a totally unconventional mismatch. As a category, suits belong to a genre that is already quite saturated. I wanted to create a design that put emphasis on bringing out the "likeness" of a suit.

MR. BATHING APE® evolved to become NIGOLD® by United Arrows. It follows the classical styles found in British and American fashion, but also encompasses a much more contemporary mood. Because of NIGO®'s unique creative approach, NIGOLD® brings new meaning to what might appear "old-fashioned" at first glance.

What I'm saying is not only limited to suits; for example, the ultimate form for denim was achieved when the Levi's 501® came out. It is not old-fashioned or anything like that, but it already had achieved a perfect, finished form and there was nothing else you could do with that except for changing the materials.

You must reconsider the term "old-fashioned" too. I tried, and it resulted in "destroying the dress code." After all, many places today allow denim in their dress code. This is just a matter of moving with the changing times. But no matter how expensive the clothes of other luxury brands might become, you cannot replace suits. Suits will never go out of fashion, even though there are problems in the world like global warming, and even though remote work has become mainstream.

Creation through destruction. NIGO®'s creative approach, which began in the town of Harajuku in the 1990s, remains unmatched.

I think that we shaped the fashion and culture of that era by constantly improving ourselves through friendly competition. Rather than saying that the city has changed, it seems more truthful to say that the people have changed. In our case, that change was the "Ura-Hara" movement. I started going to Harajuku when I was sixteen—it was where I met new people, shopped, and started a business. If I was a bit sloppy at times, it was in a good way. Harajuku was a place where anyone has a chance. I know I succeeded because of Harajuku.

The first United Arrows opened in Harajuku in 1992. It is somewhat far away from Jingumae Crossing and Takeshita Street, which are the most well-known areas in Harajuku. What did the presence of the United Arrows Harajuku Store mean to NIGO® back then?

I opened a shop called NOWHERE in 1993, and at that time I felt United Arrows had a very high threshold, in a good way. It wasn't a place where kids like me would go. It had a hardcore status and had a certain coolness that kept some people away; all the staff and customers were fashionable and everything was perfect. I think the energy of the shop created a new customer flow in an area that originally had no other shops. The fact that it is still there today is absolutely amazing.

Today's Harajuku changed dramatically due to the intervention of many major brands and the construction of numerous commercial facilities.

For a long time, Harajuku has had a history as part of a fashion trend, along with the stories of those who made it that way. So, we can't just make a quick generalization and claim that "it became boring." In reality, the Harajuku that I belonged to has indeed gone away. But today I see a place where young people continue to create and enjoy what Harajuku has to offer. We and our predecessors are the people who left Harajuku, and it feels slightly awkward to still call us the "symbols of Harajuku."

What do you think the future of Harajuku looks like?

While I want Harajuku to change and become more "Harajuku-like," I also want to pursue youth culture there. In fact, the reason why I opened HUMAN MADE® on the first floor of Laforet Harajuku was to perpetually seek out the 1980s Harajuku style. However, precisely because so many things are changing all the time, I'd like United Arrows to stay the same. I think that perhaps the building should be designated as a cultural property of Harajuku. I still feel a sense of relief every time I go there.

Our Son's Styling Guide Book

Interview with Motofumi "Poggy" Kogi, Founder and Former Director of United Arrows & Sons

I joined United Arrows in 1997. I came to Tokyo from Sapporo when I was twenty years old and was posted to the United Arrows Yurakucho store. I honestly didn't think I would be hired. At the time of the interview, everyone else was dressed in a suit, but I was wearing something from Undercover or Supreme [laughs].

From the late 1990s to the early 2000s, it was the age of magazines. *BOON*, a street fashion magazine, exerted a particularly great influence. As one of its regular features, it ran snapshots of the staff at fashion stores, and sometimes there were photos of salespersons at United Arrows. But of course, United Arrows had a somewhat serious streak, and the staff seemed to dress a little more neatly than normal when they were going to be photographed for the magazine. This bothered me slightly. I thought, why not show staff members holding skateboards or projecting their individuality in some other way? I broached this idea with the press people, who gave me the green light and said, "Sounds okay to us. Go ahead and do it." From then on, I was frequently given the call for staff snapshots.

When I went from being a salesperson to working in the press department, I had more opportunities to talk with fashion designers, magazine editors, stylists, and other people involved in the production of apparel. I worked with magazines instead of customers. I increasingly had interactions with creators and was given advice by many press people who were my senior. It was a time when musicians such as Kanye West, Pharrell Williams, and André 3000 rapped in outfits designed by Ralph Lauren, for example. Meanwhile, in Japan, street was street, and luxury was luxury; there was a clear separation between the two. However, there was one store that foresaw the arrival of an era when rappers and street artists would go shopping at multi-label specialty stores; it proposed an outlook that could be termed "luxury-street." That store was Liquor, Woman & Tears, on the basement floor of From First in Tokyo's Minami-Aoyama district. Following the idea that "polishing leather shoes is the same as polishing sneakers" as their core concept, they offered a new style that elegantly blended hip-hop aesthetics with apparel that had a traditional, clean look.

We established United Arrows & Sons in 2010 in order to transmit this vision of Liquor, Woman & Tears, that is, the "trad" mindset and suit style behind United Arrows, to the next generation. Just then, NIGO® and Osamu Shigematsu were getting to specifics in their dialogue for the collaborative brand MR. BATHING APE®. When I was assigned to this project, I felt that we could come up with an interesting new direction in suits. The idea was to combine a simple and refined style grounded in United Arrows with an approach incorporating street, art, music, and other culture right into the suits. This is the story behind the birth of United Arrows & Sons, the brand's prodigal son.

I got this perspective from breakbeat music. Regarding styles of apparel, I have heard that "classic" style is a point and a "trad" style is a line. However excellent it may be, a specific style may end with its times. When a style that may otherwise end as a point is passed on as something of value to the next generation by the previous one or, on the other hand, is studied by the next generation to learn about valuable things of the past, a new point is born. In this theory, the line connecting these two points is "trad." Breakbeat music arose in the 1970s at outdoor block parties held by African-Americans. It was created by people who were unable to go to discos, which were then at the height of their popularity. They brought their turntables into parks and held their own parties. This was before the term "hip-hop" was coined, and the DJs did not play any hip-hop music. Their mix instead centered around old funk numbers, soul tunes, and even tracks from completely different genres, by artists such as Kraftwerk. Between the tracks were breaks filled only with drum and bass parts. Noticing that the dancers became even more inspired during these breaks, the DJs got the idea of playing the same record on two turntables and looping the break part. This was the start of breakbeat. It was from here that hip-hop culture was born.

As I see it, this was a case of taking old, pre-existing music to generate a new culture in the form of hip-hop, by drawing a line in a slightly different way. I believe United Arrows & Sons is in the process of drawing the line for the next style.

Why? Because we are busy, busy, busy!

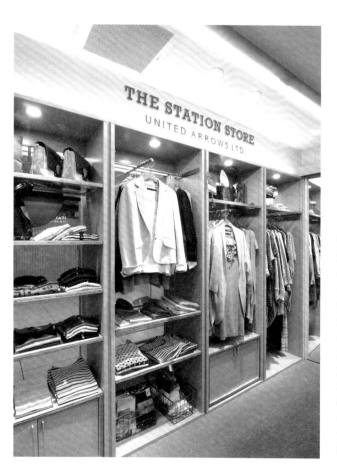

The United Arrows Transportation Stores,
found in airports and train stations,
arose from a desire to make commuting and
international travel more enjoyable, and
certainly more fashionable. The Airport Store
and The Station Store feature a number of
original items available exclusively at these
locations. The idea is to offer products
perfectly suited to a traveler's needs or
fancies. They offer a fun, useful place to
drop in at the metro station or the airport,
on your daily commute or on an important
trip, where you can add a little dose of
excitement to your travel.

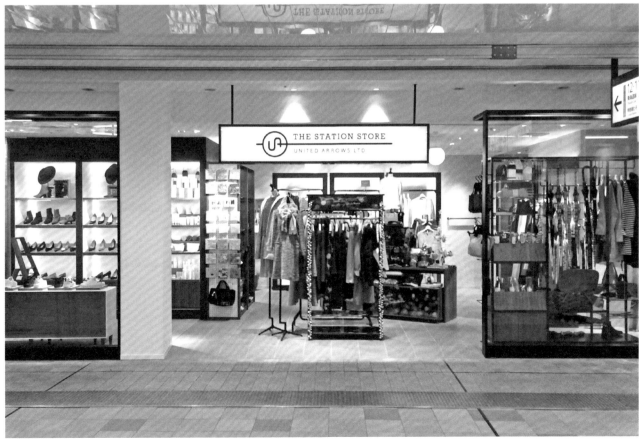

In 2012, we fell in love with a couple of marionettes

Have you ever felt touched by the hand of
fate? Perhaps in relation to a lover, a
friend, or a family member? No doubt everyone
has experienced a magical moment that moves
and thrills them. This rare kind of emotional
encounter was provided by a participation-
oriented installation in a display window
titled "Marionettes in Love" at the Green
Label Relaxing store in Shibuya Mark City in
2012. Two marionettes hung from the ceiling
in the display window. But when a person
stood in front of the window, a sensor would
instantly catch any bodily movement and have
the marionettes reproduce it in a realistic
manner. Mannequins that had never before
moved were suddenly and skillfully mirroring
the motions made by the viewer.

それは だれかに つづく 恋の糸

GREEN LABEL RELAXING
2012

209

The two marionettes could also assess a
couple's mutual compatibility through
simultaneous operation by each partner.
For the approximately one month the display
was up, the area in front of the window was
thronged by people who came just to see the
marionettes. The movie made for the related
ad campaign told a touching story; in it,
the marionette couple stepped out of the
display window in the middle of the night and
fell in love, as destiny directed them. This
short film attracted a lot of attention; in
the following year it was nominated for the
Cannes Lions Awards, one of the world's most
prestigious honors for advertising
and communication.

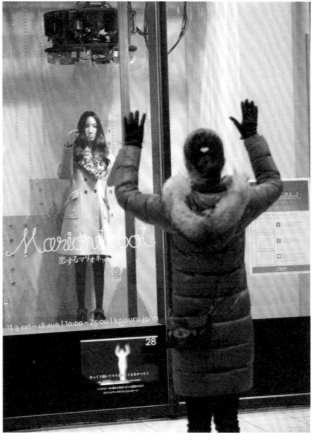

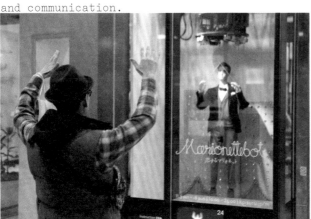

Jamboree Comes to Our Town

Green Label Relaxing does not sponsor many events. One of the few is the Good Neighbors Jamboree, an annual summer get-together dedicated to all things that bring joy into people's lives. Attendees have the opportunity to discover new and delightful foods, view unique crafts, hear good music, enjoy fashion, or make connections. The Jamboree is a cultural festival for the people. It's held at the end of summer in Kagoshima Prefecture, in a forest landscape, on the site of a former school in Minami-Kyushu City. Booths serve curated food and beverages from across Japan, local Kagoshima craftspeople offer a slew of workshops, and there are endless opportunities for children and adults to romp in the great outdoors or dive into rich cultural experiences. Presiding over all the activity—but also enjoying himself just as much as any festivalgoer—is Shuichiro Sakaguchi. We sat down to talk with him.

A talk with our good neighbor, musician Shuichiro Sakaguchi

Tell us how Good Neighbors Jamboree first got started.

It all dates back to when I was involved in a band called Double Famous. We played at Fuji Rock Festival, Rising Sun Rock Festival, that whole circuit. That was when I started to get a vague idea like, "Wouldn't it be cool if I could put on my own event somehow?" Jumping back to an earlier point in time, the whole reason I got into music in the first place was that when I was a kid, I had this uncle who would take me along with him to jazz cafes. For me, jazz cafes were a place where adults drank coffee, kids drank melon soda, and music that I didn't quite get was played. When I started thinking about what an event should be, I found myself reminiscing about those formative experiences. My ideal event was not just a concert, but a gathering harking back to that combination I first experienced in jazz cafes: you get to listen to great music as you drink great coffee, eat a great meal—and it's even better if you're eating and drinking with some nice tableware. That line of thinking led me to the concept of the Good Neighbors Jamboree, an event that everyone can enjoy, one that's not limited to just one genre of the good life.

And there's a certain DIY element to it as well, right? That sounds fun.

DIY and BYO. Do it yourself, bring your own. So, people bring something they've made, and swap it with something that somebody else made and brought. That's been part of the concept since the very first Good Neighbors Jamboree. This event is not based on some people standing up on an elevated stage;

it's "flat"—everyone is on the same level. People who are good at music play music; people who are good cooks cook; people who can make clothes lead workshops on making clothes. There are all kinds of ways to express yourself. And this is a place where all those things come together on an equal footing; that's what I mean by a flat event. The name "Good Neighbors" comes from this idea that everyone in attendance is relating to each other as neighbor to neighbor, not as performers/producers and audience. There is no "audience" at Good Neighbors Jamboree. No one is a "customer," and we don't offer a "customer service"-style experience. Everyone who shows up is part of putting on the show.

There seem to be a lot of parallels between the "neighbors" concept of Good Neighbors Jamboree and the "think local" theme. This theme is part of Green Label Relaxing's identity as a brand that promotes local-mindedness (giving out maps that highlight neighborhood attractions, and so on).

I know that Green Label Relaxing staff really look forward to the Good Neighbors Jamboree every year. A few years back we wanted to offer a workshop on the practice of *dorozome* (mud-dyeing) from Amami Oshima, an island in southern Japan. The printed area of the fabric would be tied off with rubber bands, keeping that part undyed during the dyeing process, so the graphic would still be visible. Obviously, whoever would be running that workshop would have to put in a lot of effort, and a lot of money, frankly. But we received two replies from Green Label Relaxing, volunteering to take it on. It showed me that they are really in sync with our approach to people taking ownership of the event.

You also put a lot of effort into making the event eco-friendly. You're reusing a former school campus… You sort rubbish and recyclables into twenty different waste streams… It's quite impressive.

The only way to reduce our ecological footprint is by making one choice at a time. But if we get into a mindset of jamming this down people's throats, and enforcing a bunch of rules, it's inevitable that some people will feel like it all just becomes a hassle.

And then they definitely won't make a habit of eco-friendly practices down the road. That's why at the Good Neighbors Jamboree we try to make sustainability fit in with having fun. People love to carry around an eco-bag, if it's one they really like. They will wear their favorite T-shirt for years and years. We opt for organic cotton wherever possible in the products sold at the event. In daily life, there are a million situations where people have to make a choice between more and less eco options. I hope that people who have taken part in the Good Neighbors Jamboree will be inspired to make that choice for organic cotton next time without a second thought. Because they associate it with "that awesome T-shirt I bought at the Jamboree."

Sustainability, when it's treated as just "an issue," can become a really left-brain thing, right? But maybe real sustainability thinking should come from a more intuitive place.

Exactly. When we brought up the idea of creating a T-shirt with Green Label Relaxing, the response right off the bat was, "Let's use organic cotton." We didn't have to make a detailed case for doing it; the people at Green Label Relaxing just intuitively understood where we were coming from. Nothing makes me happier than conversations like that. This is how we build neighborly relationships organically.

May I help you?

My main goal is to share the love I have for fashion with
United Arrows customers. I don't think that goal will ever
change. I am extremely committed to my look on the sales
floor: I always wear a jacket, whatever the season.

As a student I mostly wore black skinny pants and vintage
T-shirts. Then one day, on a whim, I dropped into a little
store and the staff suggested I try on a Franklin Tailored
jacket. I pushed back against the suggestion. Hardly any
of my friends ever wore jackets like this and I wasn't
interested. Still, the person who worked there carefully
went over every detail of the jacket and all its charms.
They pointed out the jacket's crisp lines on the hanger.
They turned it inside out and explained the lining and the
differences between machine and hand stitches. That one
conversation forever changed the way I look at clothes.
"Whoa, jackets are so cool!" I was hooked. I've worn jackets
ever since.

By this point, I think I've probably achieved "geek" status,
and I'm happy with that. That status feels fitting being that
the people I admire and follow in this industry are all geeks
in their own field.

Some people feel that jackets are relics of a bygone era, but
I tend to disagree. It is so easy to incorporate them into a
variety of outfits that I consider them to be both economical
and eco-friendly. Just throwing one over your shoulders is
such a chic look. Swapping out what's underneath the jacket
totally changes the ensemble. There is no other clothing item
that is more convenient! I believe it's my calling to help
people become more familiar with this indispensable piece by
working at Green Label Relaxing. I'm delighted to lead the
way, dressed in my very own jacket.

Ryo Katsumata,
Green Label Relaxing, Yokohama Lumine

At Home with Fashion

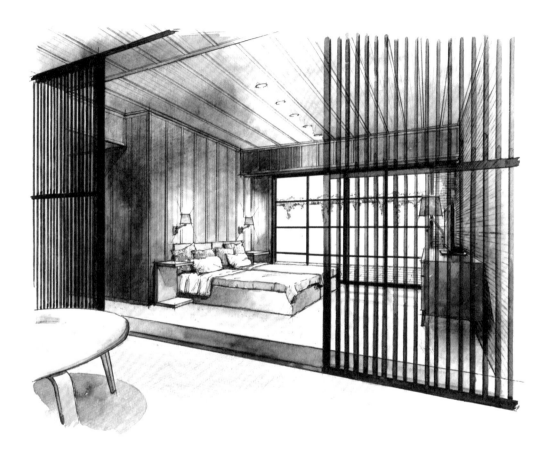

Nomura Real Estate Development's housing brand, PROUD, and United Arrows collaborated on a project focused on the future of housing, based on the concept of "a comfortable home."

A home is meant to be a treasure trove of precious moments. It should delight the eye, comfort the body, and become even more beautiful over time. In 2012 we created a home that embodied all of these elements, and then in 2015 we collaborated with PROUD again and produced furniture.

United Arrows took the same approach to this endeavor as it does to clothing. Take an Oxford button-down shirt. It's a classic that you always want on hand; one you fall deeper in love with every time you wear it. It's the same with furniture. The gentle weathering of wood, and the gradual wear of fabric. The quality of a material changes over a decade of use, settling into its personality and increasing in value. Traditional forms and design elements interpreted through a modern lens offer a new standard for stylish living. PROUD and United Arrows have created beautiful furniture that meets the many needs of a modern lifestyle.

TYPE-PA001

TYPE-PA001 takes the simple, modern lines
of antique Scandinavian furniture but adds
a twist of nostalgia. The items all share
the same slim leg ends, which are wide
enough to provide stability but chiseled
down to provide the user with maximum floor
space. The extendable dining table and other
furniture items in the collection pair
functionality with structural performance,
offering a design that fits in any setting.

TYPE-PA002

TYPE-PA002 pairs the warmth of Scandinavian
furniture with classic Japanese design
elements. Detailed woodworking and a
traditional Japanese framework combine to
create pieces that showcase both quality
and weight. Instead of sharing a uniform leg
shape, each piece has a clean, simple form
that suits its function. Tables and cabinets
are designed to emphasize their thicker lines
and large surface area. The sofa has weight,
but the combination of fabric and oiled
leather creates a softer feeling. The chairs
are light and easy to move, yet the materials
ensure that they are substantial enough to
pair seamlessly with the other furniture in
this set.

A trip to the farm

Consider an utterly simple cotton top with no clever twist or edge. How could such a simple item carry an enormous significance?

The earthquake and tsunami that struck Japan on March 11, 2011, caused unprecedented damage across the country and in the Tohoku region in particular. Farming was hit especially hard. The fashion industry sprang into action, thinking of how to reinvigorate farming, as well as how to provide stable employment going forward. In that same year, the Tohoku Cotton Project was formed when over eighty companies and groups banded together with the aim of resurrecting farming in the region, focusing especially on families directly affected by the disaster. Farmland destroyed by the tsunami could no longer grow rice, so cotton was planted instead. The cotton was spun, woven, and turned into clothes, and the customers who purchased the results were part of the team supporting the devastated areas. As one of the original founders, Green Label Relaxing was part of the Tohoku Cotton Project from the beginning. The project succeeded in growing cotton in the far north of Japan, and, together with local farmers, it has created Japan's largest cotton fields in Miyagi Prefecture, creating employment for many people.

With the tenth anniversary of the disaster approaching, Green Label Relaxing took part in "Tohoku Cotton Festival 2019," a hands-on event where local farmers and the general public came together in celebration of the cotton harvest. Visitors enjoyed the beautiful fields as they tried their hand at picking cotton; they participated in workshops that showed the process of turning cotton into clothes; they listened to musical performances, and they enjoyed local food and beverages showcased in on-site booths. Green Label Relaxing held a workshop on cotton spinning and sold distinctive striped cotton tops. These items hold a special meaning and connection to this region; wearing them helps support Tohoku farmers.

A wardrobe that takes us places

Jalan Sriwijaya

Jalan Sriwijaya is an Indonesian leather shoe brand that was established in 1919 as a maker of military shoes. After Indonesia gained its independence, the brand started branching out internationally by sending staff to Britain, where they learned from master shoemakers.

Under the helm of the current owner, who has strong ties with French exporters of premium quality leather, the brand has become known for its production of high-end leather shoes. The shoes are hand-sewn from the sole up, leaving only the outsole to be Goodyear welted. This technique makes the shoes supple and comfortable even after a long day at work.

Green Label Relaxing is proud to present Jalan Sriwijaya as one of its leading business shoe brands. The elegant closed-laced Oxford shoe offers comfort and durability along with a thoughtful touch of style, making it a perfect business shoe for today's modern lifestyle.

Signature Denim

New Basic, Green Label Relaxing signature denim line, offers jeans that are smart, flattering, and well-tailored. Created in 2018, this line focuses on women who want a casual but well-put-together look.

From the height of the waistband to the length of the inseam, every inch of the silhouette is the result of careful thought. The simple styles and colors go with a wide range of tops and can be comfortably worn year-round.

Yusuke Fukuzawa,
United Arrows Ltd.,
Iruma Outlet

May I help you?

At United Arrows, we have something called our "Thank-You Notebook." It is a compilation of the thank you letters that we've received from our customers. We had the honor to receive these words from one customer: "I had many bad experiences with different shops when I visited the Mitsui Outlet Park at Iruma, but at United Arrows—the last shop I entered—I was served by Mr. Fukuzawa. Thanks to him, the bitter memories went away and it turned out to be a wonderful day." We were very happy with those words. It is true that the staff at the outlet stores are usually overwhelmed with shelf stacking and working at the register because of the larger number of products they have. Despite this, we always aim to create an environment where our customers can enjoy shopping.

Many outlets are located in the suburbs, far from the city center, and customers come with different purposes—as a side trip after visiting other tourist attractions, or to eat local food. Compared to many other businesses, we believe that we should put more importance on providing the highest level of satisfaction to our customers in the shortest span of time. Of course, each of us also takes pride in being a salesperson. We should always take into consideration our manners and behavior or the clothes that we wear, as well as each and every word we say. Just like the letter that I mentioned previously, I hope our customers become our fans based on the added-value service we provide, so that our products are worth more than the actual retail price.

As a salesperson based at an outlet store, my main concern is to focus on how we can minimize the number of products that will eventually be returned or disposed of. That is why it is necessary to create an environment where our customers can easily access our products, while we control the inventory through data collation. As a salesperson at United Arrows, I take this responsibility to send off our products till the very end quite seriously.

Please give us ten minutes of your time

When shopping for clothes, it is important to try out colors and silhouettes that you wouldn't normally reach for. Trying something new can make you look at the world from a totally different perspective. We at United Arrows make it our utmost priority to find items that work best for our customers.

This commitment is at the heart of our *Jounetsu Sekkyaku* (Passionate Service) campaign, which helps to push customers out of their fashion comfort zone.

The process is easy. First, pay a visit to one of our stores and entrust yourself to the capable hands of a salesperson wearing a *Jounetsu Sekkyaku* badge. Next, the salesperson will suggest a full look that might completely change the way you think about your style. It is then up to you to take the plunge and buy the whole outfit or just a few select items.

Poster for United Arrows, 2013

UNITED
世界を変える
ARROWS

今年もまた、あなたの世界を変える、情熱接客はじまりました。

1
Go to the United Arrows stores.

UNITED ARROW

ユナイテッドアローズに行く。

2
Find store staffs wearing "Jounetsu-Sekkyaku" pins.

「情熱接客」バッジを付けているスタッフと会う。

3
Spare ten minutes to them.

あなたの10分をスタッフに預ける。

4
Those staffs will bring you a perfect styling,
which will totally alter your thoughton your own fashion.

あなたの世界を変えるスタイリングをスタッフから提案される。

5
Enjoy trying all the clothes!

服を全部着る。

6
Allow the staffs to take a photo of you
in your new look.

世界が変わったことを実感し、写真を撮ってもらう。

7
You will get "JOUNETSU TENUGUI"!

"情熱手ぬぐい"をもらう。

6ᵀᴴ September 2013, Friday ~ 14ᵀᴴ October 2013, Monday

jounetsusekkyaku.com/

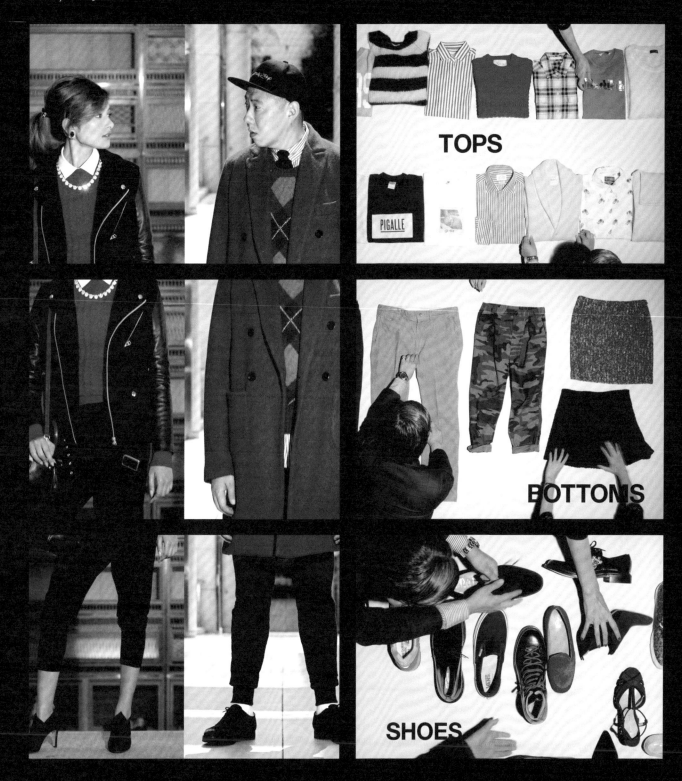

In celebration of these campaigns, which have been held three times from 2012
to 2014, we invited actors and actresses, kabuki actors, models, artists,
comedians, and other well-known personalities to experience our customer
service. We streamed videos and visuals that showcased our salespersons'
commitment in finding an unexpected look that felt totally right. The
campaign may be over, but our passion toward offering the best customer
service remains the same.

Can we offer you a drink?

2014 marked the twenty-fifth anniversary of United Arrows.
We celebrated this milestone with a renovation of UA CAFÉ,
adjacent to the Men's Building of our flagship store in
Harajuku, into the UA BAR.

With the slogan "Tailor-Made Coffee And Cocktails," UA
BAR features a warm, cozy, wooden interior, and offers
a wide selection of drinks ranging from craft beers to
classic cocktails. The micro-roasted coffee is served in
collaboration with Fuglen, a trendsetting café and cocktail
bar first opened in Oslo in 1963. It also offers an extensive
gastro-pub menu that includes steak and rice served on a hot
cast-iron plate, hamburgers, as well as innovative variations
on comfort food like omurice, a fried rice omelet, and
Neapolitan, a ketchup-flavored spaghetti—a favorite all over
Japan.

This unusual collaboration between Japanese and Norwegian
sensibilities create a welcoming environment to visit before,
after, or during shopping at the United Arrows Harajuku
flagship store.

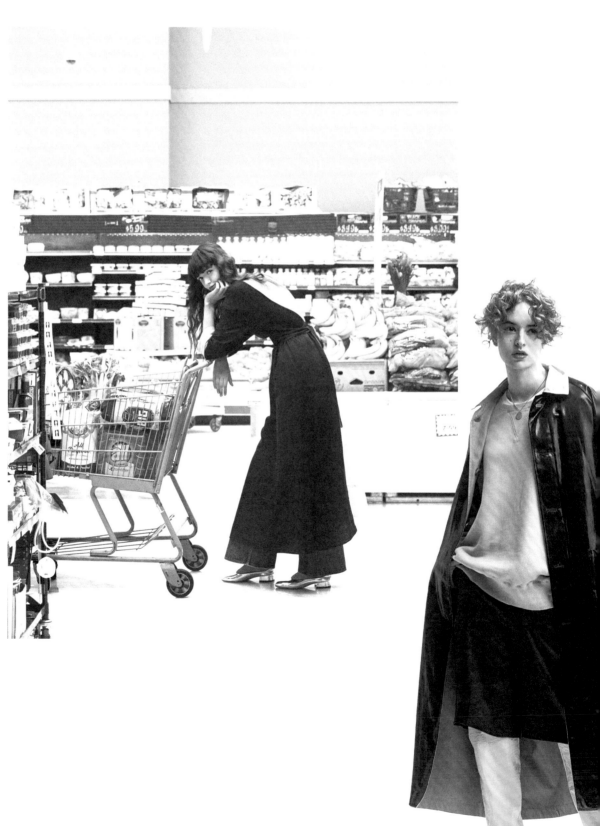

Welcome to Our Family: 6 (Roku)

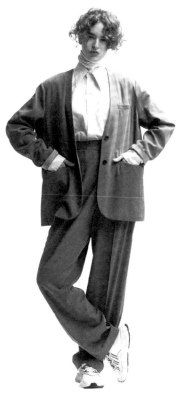

Women's label 6 (Roku) was born out of the Beauty&Youth label in 2013. The number "6" comes from the six elements the brand is envisioned to span: sports, military, ethnic, nautical, work, and school. These elements represent universal themes rooted in styles of vintage clothing. The director of 6 (Roku), Eriko Yoshida, has always enjoyed a "high and low" look. During the phase of her career when she worked as a buyer, she would often wear high-end brands, but combined them with vintage items from her personal wardrobe. Her fashion sense is a good example of a mix of styles, which is the inspiration behind 6 (Roku) and the styling identity that the brand offers.

In 2016, 6 (Roku) opened its first store in the NeWoMAN commercial complex adjoining Shinjuku Station. The same year, they opened another store in the Harajuku shopping street, Cat Street. These stores carry 6 (Roku)'s original collection, along with vintage wear and international brands, such as Maison Margiela, that align with the six elements. Today, they still capture the contemporary fashion essence of Tokyo.

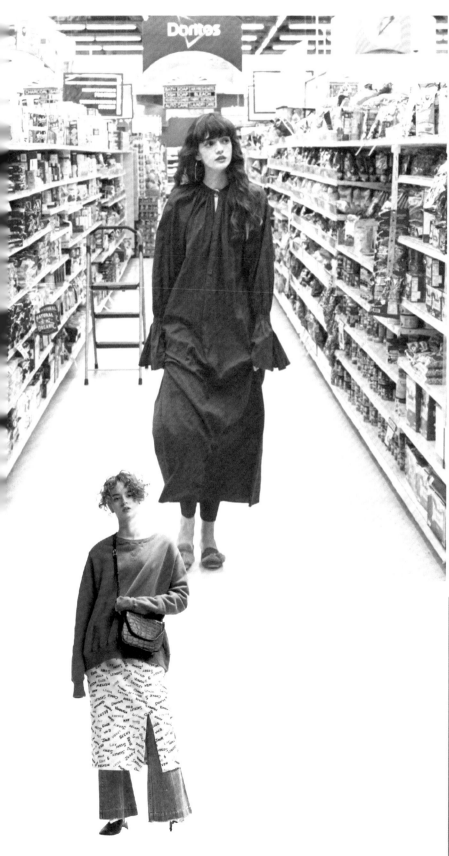

Happy birthday to our new store

On September 20, 2015, the first Green Label Relaxing street-level store opened its doors. The location was Jiyugaoka, which has now become a district in Tokyo where people most want to live. It is just the right distance away from central districts like Shibuya and Shinjuku; it has plenty of greenery, fine stores, good restaurants, and quality housing. On weekends, it attracts many families for strolls. Blending right into this atmosphere, the Green Label Relaxing store offers styles that match the diverse lifestyles of families and both male and female customers. The store hosts various events that bring the community closer. Among them, a workshop in candle arrangement during the Christmas holiday season, and a "photo spot" inside the store to celebrate Halloween.

We Learn from Nature

Hanaiku by Green Label Relaxing is a regular event focusing on ecology.
Bringing parents and children together to learn about flowers, we hope
to bring awareness about the future of our planet and the future of
our children. Roughly translating to "education about flowers," the
name *Hanaiku* is a neologism modeled on a pre-existing term, *shokuiku*,
meaning "education about eating." Children are invited to create a
bouquet from an assortment of flowers and leafy plants. Then, children
are taught the names of the plants, their scents, while also learning
that plants need water and light to live, just as we do. The aim is
that these children will grow into adults with compassionate hearts
who cherish nature and other living beings.

**Ikumi Kitagawa,
Sales Associate
Green Label
Relaxing,
Kawagoe Store**

May I help you?

Homemakers lead very busy lives! I confirmed that fact firsthand when I had children myself. Being a mother makes you so busy that it pares away everything nonessential from your life. It makes you determined to get things done efficiently and productively. If you have to go to the supermarket to buy ingredients for dinner, you zip straight there and straight back, without any diversions, without stopping by other stores for a little shopping. Eventually, though, one day I realized how much fun and fulfillment I was missing out on in my life without those diversions.

After graduating from college, I worked in apparel retail for many years. But I left the workforce for a while to have kids. Raising kids was really hectic, but once they were old enough for things to become a little bit less hectic, I felt the urge to go shopping, to go out and buy myself some new clothes. To this day, I vividly remember the thrill I felt when I put on a new outfit; it felt like my world had changed. It was at that moment that I realized the power of clothes. When I put on my makeup and a fashionable outfit, I became "more than just a mom." Looking back on the years when I was a stay-at-home mother, I was not meeting up with people very often. That meant I didn't have many opportunities to receive compliments. I had become, in a way, withdrawn… Until fashion gave me a motivational boost. Ever since, I have had a more expansive view of what fashion can do. Dressing fashionably is not just a way to attract compliments from others, but a way to be more yourself—by wearing clothes you like, makeup you like,

a hairstyle you like. It may sound obvious, but these practices are actually a very important part of life: giving yourself a look that you feel good about. And *that* is the essence of fashion.

I've worked in the medical field as well. But what is great about working in apparel is that there are so many possible answers to suit each person's individuality and lifestyle. And the more time that I spend with a customer, the more I can help them to sort out the best of those possibilities. I'm tremendously aware of these possibilities as I work with the customer. I make it a point never to try to present them anything that seems like "the" answer from the beginning. For me, working with customers is not primarily about "selling." Instead, I think about it like this: How can I add value to this person's shopping experience that no other store could give them? When that is the basis of communicating with the customer, there will come a moment when the customer "falls in love" with an outfit and makes a purchase. What can I do that will lead to a customer falling in love with an outfit? Listen to them talk about themselves, get to understand their lifestyle, and show them outfits that will really suit them. As a salesperson, I rely on my ability to listen effectively, speak effectively, and apply my experience effectively. I believe that the nature of the job of selling apparel is to help the customer reimagine how they can look, and how they can feel about how they look… To sell them not only an outfit, but an outfit plus an experience of self-discovery and self-expression.

Office
Hours

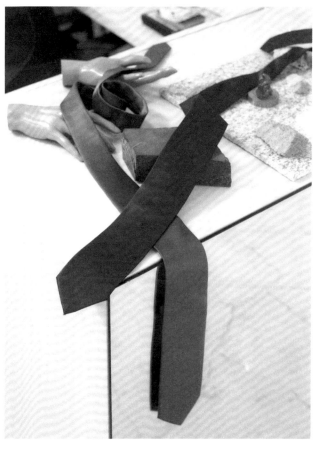

To be both stylish and productive at work
requires a new approach to business clothes.
This is the underlying concept behind the
release of Work Trip Outfits, the latest line
of business suits from Green Label Relaxing.

The name Work Trip stems from the idea of
transforming the daily commute into an
enjoyable travel experience through stylish
suits and fun accessories. Not only are the
suits fashionable, but they are also water-
resistant and machine washable as well. Work
Trip Outfits offers a practical solution that
turns the daily routine into an opportunity
to showcase your style.

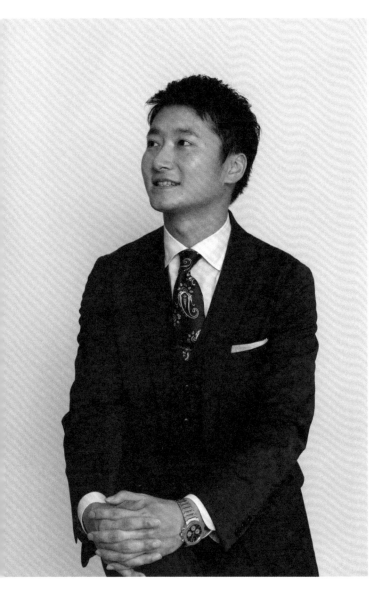

May I help you?

Yuta Tokuyama
Sales Associate, Work Trip Outfits, Yaesu

Have you ever heard of "extreme commuting"? In Japan, it refers to the idea of making the time between when you get up in the morning and when you start your workday as fulfilling as possible. People go sightseeing, camping, hiking, surfing… It can be almost anything. As long as it's out-of-the-ordinary for a workday morning routine, a pre-workday activity has an invigorating effect. The rules are very simple: "Don't be late for work," and "Have fun."

Four years ago, we set up a new label called Work Trip Outfits under Green Label Relaxing that focuses on daily business attire that lets you enjoy being fashionable. I was part of the launch team, and my boss then was the person who introduced me to "extreme commuting." He said that "As long as it fits with your individual lifestyle, you can commute any way you wish."

The message of this brand—that you can wear suits and still show your own sense of style— really resonated with me personally. So, I started getting up earlier in the morning, putting on a suit, and going fishing before heading to work at our shop near Tokyo Station. I got some strange looks from the usual fishing crowd; they were definitely pointing at me and laughing behind my back. But whenever anyone would ask me, "Why are you out here fishing in a suit?" I'd reply, "I work in sales for a fashion brand that promotes commuting to work in style!" And I'd hand them a business card on the spot and explain the brand's concept.

Suits have a very stuffy image, but I'm passionate about making people understand that there is another dimension to the appeal of a suit, besides just being traditional or classic. Of course, I'm well aware that fishing in a business suit is "extreme." Perhaps words are the easier way to convey a brand's concept: "daily business attire that suits your individual lifestyle." But I have always believed that personally living out and embodying the concept of the brand is an absolute must. I'm happy to say that I've been able to introduce more and more of my customers to "extreme commuting" via Instagram!

Can you keep a secret?

The Roppongi Hills United Arrows is our largest flagship store. Using the overall theme of "Bazaar Paranoia," Masamichi Katayama designed the interior. Katayama engages in various projects all over the world, covering fashion boutiques, branding spaces, and planning for large-scale commercial facilities. At the Roppongi Hills United Arrows one finds domestic and foreign designers' brands, as well as our first men's cosmetics collection. Seven rooms reflecting seven different themes line up in the store chaotically, giving the feel of an arcade or a bazaar. Chaotic, but in a good way.

Women's Fitting Room

Entering the women's fitting room feels like stepping in to a spacious walk-in closet. It features a heavy velour curtain, a large mirror, and, above all, a wide space where customers can take their time trying on clothes. Whether shopping for domestic and foreign casual brands for daily wear or checking out dresses and jewelry for special occasions, customers can enjoy a comfortable and unique fitting experience.

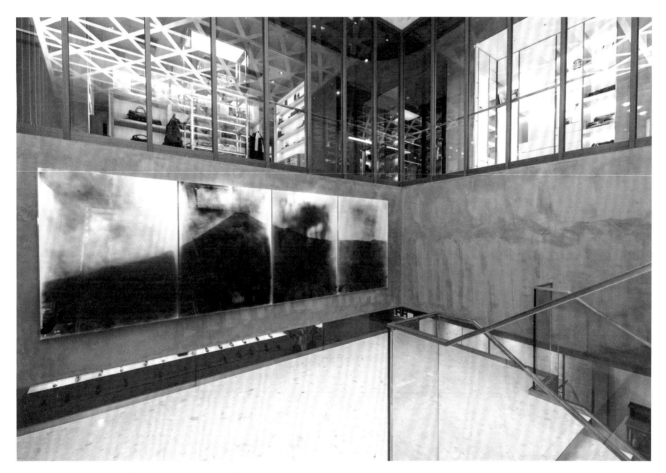

Mt. Fuji Welcomes You

Greeting customers and connecting the first-floor women's section and the second-floor men's section, this photograph was taken by Takashi Homma. After long research, Homma managed to capture Mt. Fuji from a hotel room, bringing the iconic mountain into the store.

Explore Excellent Tailoring and Craftsmanship

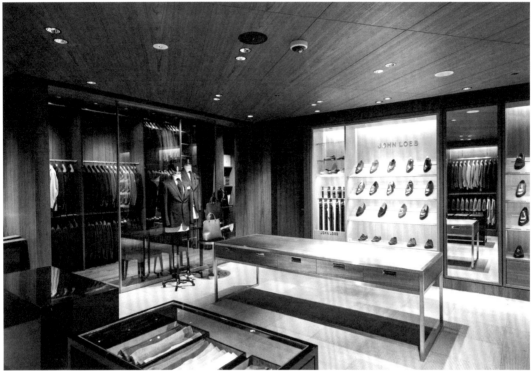

This is the innermost part of the men's section on the second floor. In contrast to the other sections, this space has a classical, calming atmosphere and specializes in men's suits, shirts, ties, and dress shoes. Further back, the stockroom is visible through a window. The effect is almost like a compelling art exhibition for suits. Individual items are displayed in separate corners, enabling a shopper to sense the charm and individuality of each particular style.

Timely Alterations

Adjacent to the suit section is "Shinsaibashi Reform," a clothing-repair shop where specialists can alter the thigh-width and hem-width for trousers, or make finer adjustments like jacket and cuff and width. All staff is highly trained, ensuring that everything will be done to the customer's preference. In addition, any alterations will be completed and ready for pickup on the day of purchase from the Roppongi Hills Store.

248

Where Cats Bring Luck
A row of beckoning cat figurines surrounds the cash register
on the second floor, their right paws raised—a gesture known
to bring good luck and money. Below them is a photograph
of the logo for the Roppongi Shopping District Promotion
Association, designed by art director Kaoru Kasai. The cats
welcome customers, along with the signage from the famous
Roppongi Intersection, a symbol of this area.

A Japanese Treasure

Roppongi hosts the second Junrian store, modeled after the first in Ginza. Junrian perpetuates the classic Japanese standard of beauty, incorporating deep spirituality and an aesthetic sense focused on the highest quality. The store was established by one of the founding members and now honorary chairman of United Arrows, Osamu Shigematsu. Carefully selected items from all over Japan are gathered inside the authentic *sukiya*-style building.

250

**Akiko Degawa,
Sales Associate
United Arrows,
Roppongi Hills**

May I help you?

I work on the floor, and since 2016 I've also been involved in store-focused product planning. In fact, I was involved in designing the jacket I'm wearing today! It's a total original that can only be found at the United Arrows Roppongi Hills store. As a United Arrows salesperson, my job is to provide customers with the highest level of service on the sales floor. There are needs that only people in my position see, and this makes us especially valuable in product planning.

Roppongi is a unique neighborhood. We have a lot of Japanese and international companies, especially IT firms and start-ups. Yet it's also a dazzling entertainment district. Businesswomen come to look for office wear, while other customers want outfits for glamorous events. This combination of needs led to clothes we call "Roppongi Specials." These are clothes that flatter the wearer's femininity regardless of age. I spend every day talking with customers and planning new items for silhouettes that enhance the wearer's personality, and that win compliments from friends and partners.

I've been a sales associate for nearly twenty years, and I've found that our customers shop at United Arrows because they're looking for reliability. People come to the store because they want good communication and a sense of trust and security that you can't find online. Every member of the staff responds to those needs by making genuine, honest suggestions of what they believe is the best solution. The pace of change is so fast in Roppongi that I'm determined to make the United Arrows Roppongi Hills store a place where people can come to relax. It's a combination of the traditional approach at the heart of United Arrows, with the constantly evolving landscape of Roppongi. I'm looking forward to creating new ideas that combine both of those characteristics.

Welcome to Minami-Aoyama

Entrance

H Beauty&Youth opened in Minami-Aoyama in 2016. It proudly features our largest salesfloor area. There, customers can enjoy shopping on the two floors above ground level and the basement floor below, as if they were freely walking between small rooms inside a museum. The interior of the shop offers an urban, chic, and casual style, and the lack of a clear separation between the menswear and womenswear sections creates a gender-free atmosphere. Because no mannequins are installed in the shop, customers can freely imagine their own style. We also propose a mix of both men's and women's items at the sales corner closest to the entrance. Recommended items for each season are also lined up here.

Say Hello To *Mona Lisa*

Works by both domestic and foreign artists are scattered
throughout the store. In one of the fitting rooms on the first
floor, hangs MADSAKI's interpretation of Leonardo da Vinci's
Mona Lisa. After working as a member of the international
artist group, Barnstormers, MADSAKI is now based in Japan
and New York. He is known for using provocative language and
citing classic paintings to make viewers reconsider the value
of art.

T-shirts Instead of Diamonds

One corner on the first floor is made of glass. If this were a traditional
department store, you might find diamonds or other expensive jewelry
displayed here. Instead, this section features T-shirts, which embody
the true nature of a casual store. The lineup of unisex T-shirts that are
selected from brands around the world is itself an artistic composition
unique to H Beauty&Youth.

Bonsai Everywhere

Found as frequently as the works of art
inside the shop are bonsai of various sizes.
These traditional bonsai contrast with the
modern-looking space, and they have come to
be a symbol of H Beauty&Youth. The carefully
pruned trees are replaced with new ones
every two weeks, allowing customers to enjoy
different shapes with each visit to the
store.

At the time of the store's opening in 2016,
there were not a lot of shops selling a wide
range of sneakers in Minami-Aoyama, despite
it being an area with many high-end brands.
Therefore, we set up a corner dedicated
to sneakers near the large window on the
second floor, which can be seen easily from
the shop entrance. Sneakers from Nike,
Adidas, and Reebok are available for men
and women. In keeping with H Beauty&Youth's
core concept of gender-neutrality, the same
designs are on hand in different sizes for
men and women.

The Only Place to Get Sneakers

The Rare Find

Next to the corner for sneakers, there is a row of showcases for
accessories. Among them are valuable vintage watches by Rolex or Cartier,
among other classic brands. After picking out the newest sneaker, a
customer might be surprised to find the perfect vintage watch waiting
nearby. This complementary juxtaposition embodies the idea of creating new
things by learning from the past.

Have a Drink, Take a Break

After browsing the first and second floors of the store,
it might be nice to take a break with a beer or a juice.
Customers can have a drink while waiting for a partner or
friend trying things on in a fitting room; or they can take
their drink with them as they continue to shop. There is even
a refrigerator beside the cashier on the second floor where
a beverage can be stored while the customer shops.

Unusual Greetings

A striking work of art greets customers stepping into the basement floor. Another work by MADSAKI, whose *Mona Lisa* appears on the first floor, this painting is inspired by Rembrandt van Rijn's *The Syndics of the Drapers' Guild*. This work was exhibited as part of the "WANNABIE'S COLLECTION" (a title coined by combining the words "wannabe" and the major auction house Sotheby's). It reflects MADSAKI's belief that "art should be enjoyed more freely," in opposition to the art world's tendency to give the most attention to the most expensive works. Just as H Beauty&Youth places high-end brand items next to vintage goods, MADSAKI's work embraces the attitude that "good things are good."

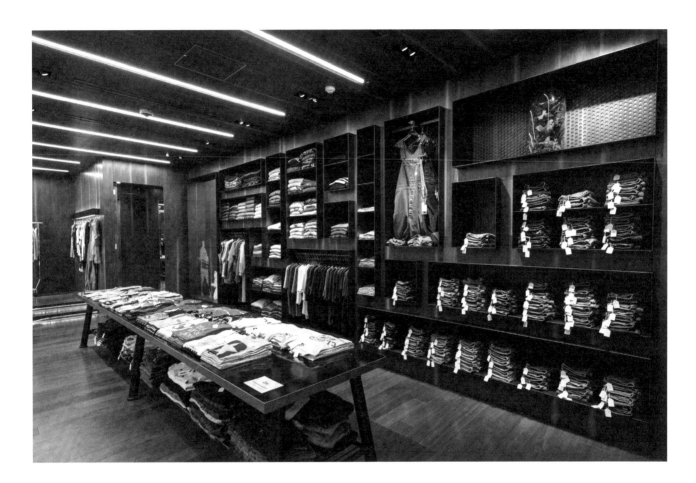

Enjoy the Mix

The direction that the six clothmakers in
MADSAKI's painting are looking toward is the
space for secondhand items that were chosen
in collaboration with domestic dealers. In
shops where usually only new products are
displayed, we deliberately located this
secondhand section in one of the main areas
so that customers can enjoy original styling
—mixing high-brand items or incorporating a
vintage item with a casual look.

Rie Morioka
H Beauty&Youth

May I help you?

I used to think that "living life with style" was something
that only people with plenty of money could do. I thought
that style was something way out of my reach. To be honest,
there was a time when my life was the opposite of stylish:
I had moved away from home, was living off ready-made
meals from the convenience store, and eating snack food
for breakfast. But that changed after I moved to Tokyo and
started working at the United Arrows Shibuya Cat Street store
and the H Beauty&Youth store (where I work now). Working in
those stores gave me a new perspective. Even compared with
other United Arrows stores, those two draw a lot of customers
who know how to pick their own clothes. At first that made me
think, "I'm not really needed by customers like these," so I
acted very self-effacing. But then one day I got into a very
lively conversation with a certain customer—a very stylish
customer, who hadn't even come by the shop to buy anything—
but just came to enjoy the atmosphere. That conversation
ranged beyond clothes, because the customer seemed to be
interested in food and other subjects as well. I remember
wondering to myself, "How does this person wear just a Hanes
T-shirt and make it look so cool?" That encounter got me
thinking. I came to the realization that this individual
wasn't basing their fashion choices merely on the price of
things, but on how an item suited their personal sense of
style. I thought to myself, "So that's what it means to 'live
life with style.'" Ever since then, I've had a different
philosophy and attitude toward fashion.

Once I became conscious that I also could "live life with
style," I started regularly going to a florist and getting
flowers to decorate my apartment. A friend of mine worked
there, and whenever I stopped by, I would see her interacting
with customers. She loved talking about flowers; if the
customer showed the slightest interest in one, she would
offer helpful suggestions about it: "Here's a good way
to arrange this flower!" "This one also looks nice when
it's dried!" Her stream of ideas and advice expressed her
genuine love of flowers. It dawned on me that it's much more
enjoyable to buy flowers from someone who loves them. My
friend was guiding her customers toward "living life with
style" through flowers. That realization was a turning point
for me. I started guiding my customers toward "living life
with style" too—through fashion.

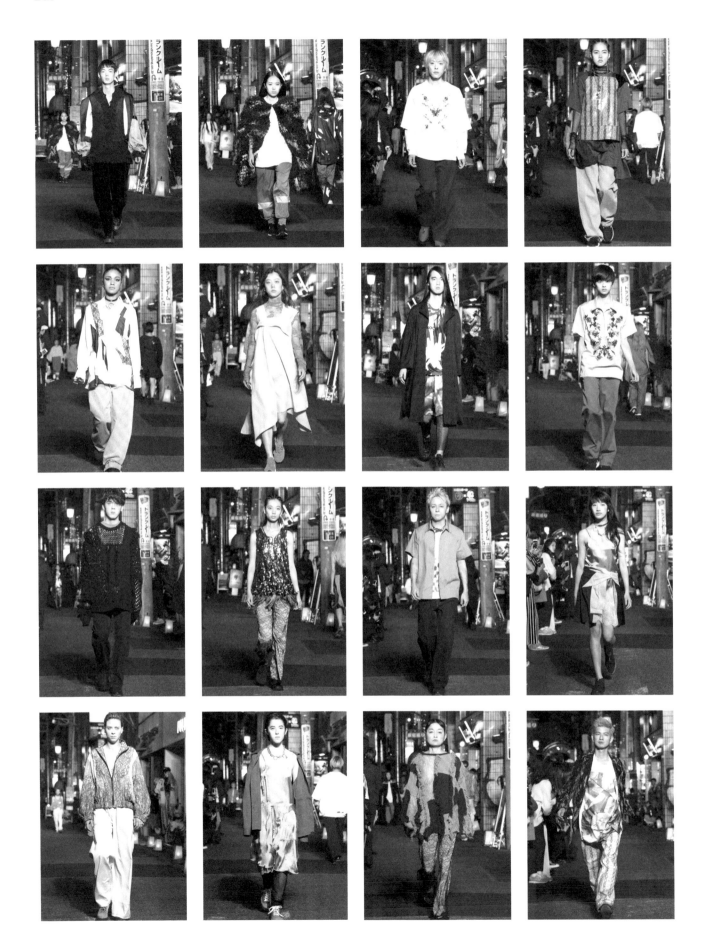

Koché Comes to Harajuku Street

"I want to do a show in Japan." Koché was established by Christelle Kocher in Paris in 2014; her wish was granted by H Beauty&Youth.

In 2016, H Beauty&Youth was the first to bring Koché to Japan, establishing a pop-up store. It also supported Koché's participation in Amazon Fashion Week Tokyo Spring/Summer 2017. The venue was Tonchan-dori in Harajuku, a street crammed with Japanese izakaya, restaurants, vintage stores, and convenience stores. Koché took over the entire street, holding an unannounced show that still drew over a thousand industry professionals and passersby.

Koché revolves around the concept of "couture to wear," and the skills and craftsmanship Kocher honed at such brands as Dries Van Noten, Bottega Veneta, and Chloé were on full display in a collection that mixed elements of street and casual—at a venue that perfectly blended Japanese history and urban style. Kocher's lifelong respect for Japanese designers and her one-time desire to study in Japan was reflected in the perfect choice of Tonchan-dori. Street photographer Rei Shito has an in-depth understanding of Tokyo's models and fashionistas and handled the casting of the Japanese models, while others came from Paris. Kocher herself cast amateur models off the street of Tokyo to walk the runway.

The show closed with a spectacular finale by Ambush designer YOON: the models paraded along Tonchan-dori holding lanterns. The casting, location, and styling showed an extraordinary synergy between Japan and Paris that drew international attention. Koché's diverse mix of style and culture still resonates with the value of H Beauty&Youth.

Welcome to our family: Bractment

The brand name Bractment derives from "bract," the term for a leaf containing a bud that has evolved and grown to the point that it may be mistaken for a flower itself. Bractment offers a well-balanced combination of refined styles within a basic look, for both male and female adults. The assortment of items reflects a specificity extending to the finest points in all aspects of the materials, details, colors, patterns, and even silhouettes.

BRACTMENT

For dress shirts, a fixture of men's fashion, we selected fabric from Thomas Mason, a long-standing British manufacturer of shirt fabric. While retaining the classic texture of the fabric, we updated the style by going with a roomy "loose-wide" specification for the width. The shirts are an indispensable addition to the Bractment wardrobe of wear for both formal and casual occasions.

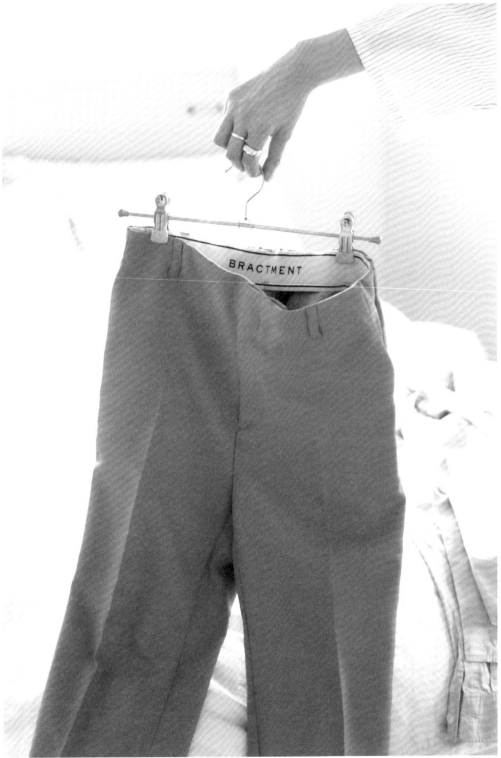

Bractment's pressed slacks manage to have both just the right
stiffness needed to maintain a beautiful silhouette and a
soft flexibility for ease of wear. One key element is the
waist elastic, which bears the logo and is an innovation.
With this, we achieved a comfortable fit without detracting
from the appeal of these elegant slacks. They come in a
variety of colors, ranging from standard to more nuanced
hues. Customers can pick their perfect color for each season.

All the Way from Paris

**Greetings from
Christophe Lemaire
and Sarah-Linh Tran,
of Lemaire**

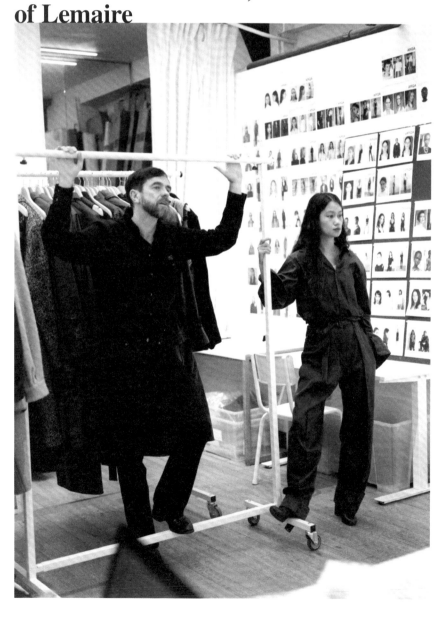

Christophe Lemaire says, "Style is a way of life, and dressing up is a language. Just as the way you talk, walk, and move, I believe that the way one dresses is a way of expressing a personal opinion on life, as well as expressing a set of attitudes and views. Clothes are part of the quality of life. In French, this is called savoir-vivre." The role of fashion in Lemaire's vision resonates strongly with United Arrows. This is why they are such an important partner for us.

A teacher of United Arrows, in a sense, Lemaire opened
a pop-up shop on the second floor of the United Arrows
Harajuku location for three weeks in 2018. It featured the
Fall/Winter 2018 collection, as well as the collaborative
capsule with United Arrows, Lemaire and United Arrows. All
items, such as coats, shirts, and pants, were made using
Japanese fabrics and production techniques.

As Lemaire said, "We are very proud of this collaboration.
I'm very happy to have obtained this new idea of clothing
from Japan, especially the mix of wool and linen." Sarah-
Linh Tran who, with Christophe, helms the Paris-based
brand adds: "The architecture of the Harajuku flagship
store was also fascinating. I remember thinking: How can a
building with so many windowpanes feel so warm? I remember
the kimono section for men, with large wooden drawers
hiding beautiful traditional fabrics, and a man trying on
a luminous cream lamb's wool turtleneck. It was a wonderful
atmosphere, with a tranquility that felt like home."

Later, they both sent a joint message to United Arrows:
"In our creations, we believe it is important to rethink
our relationship with clothing and accessories, while at
the same time pursuing the essential meaning of fashion.
What can be done in the transition to consumerism on a
more global scale? We believe that United Arrows will
adapt to the new rules and challenges of the future. And
at the same time, we believe that they will strive for the
sophistication and attention to detail that is typical
of United Arrows, and the services that they provide to
customers who demand quality."

Making New Italian Friends

Prato, Italy, one of the world's most famous regions for woolens, is also the home of FAbRICA, which crossed paths with Green Label Relaxing in 2019. FAbRICA uses traditional techniques that showcase the unique texture of wool, creating a fabric that is both soft and sturdy. While tradition is at the center of FAbRICA's identity, the brand expertly looms cloth that is perfectly suited for modern lifestyles. This approach to manufacturing is an ideal fit for the updated classics that are at the heart of Green Label Relaxing's modern coat designs.

Our Sisters

The brand name Aewen Matoph derives from the ancient Japanese words: *iuen* (elegance) and *matou* (wear). This label features couture, vintage, and basic items built around contemporary trends. It is aimed at women who know what they like and prize originality.

AEWEN MATOPH

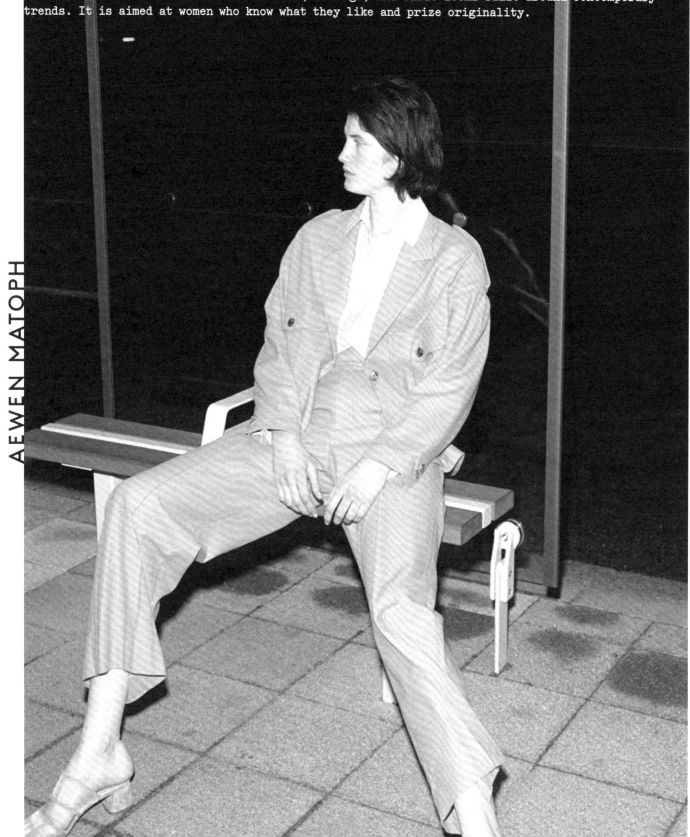

Loeff clothes are all about simple designs that showcase perfectly selected materials sewn to the highest standards. Loeff made its debut in Fall/Winter 2019 as a women's brand, and went on to add men's clothing in Spring/Summer 2020. With its roots in workwear and menswear, the label's philosophy revolves around strength, integrity, and quality. This label offers everyday clothing to be treasured for years.

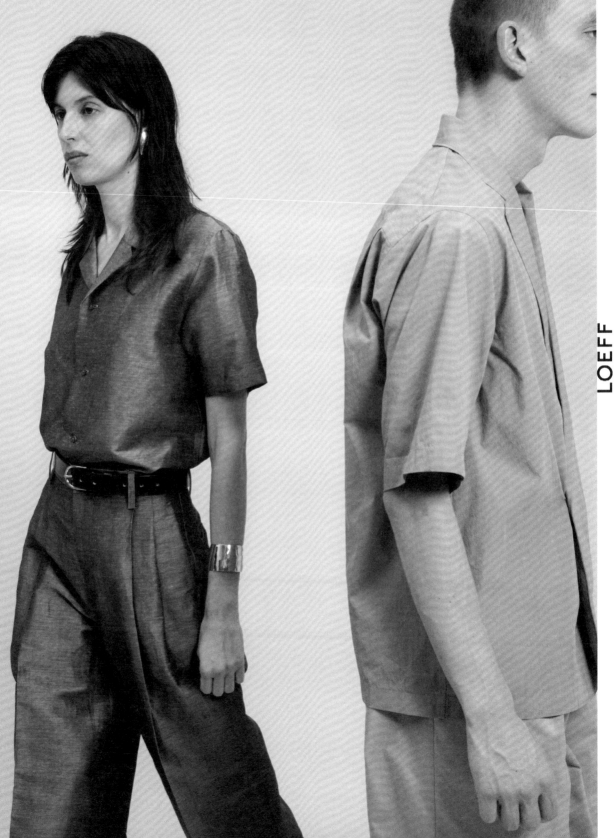

LOEFF

Odette e Odile offers a space where women can explore their personal style while enjoying the busy whirl of everyday life. Inspired by *Swan Lake*, the label's original shoes feature a modern take on the elegant, intellectual elements of classic French fashion. The brand also offers select shoes and items from all around the world. Each piece is engineered to bring a rush of pleasure and confidence to its owner.

Odette e Odile

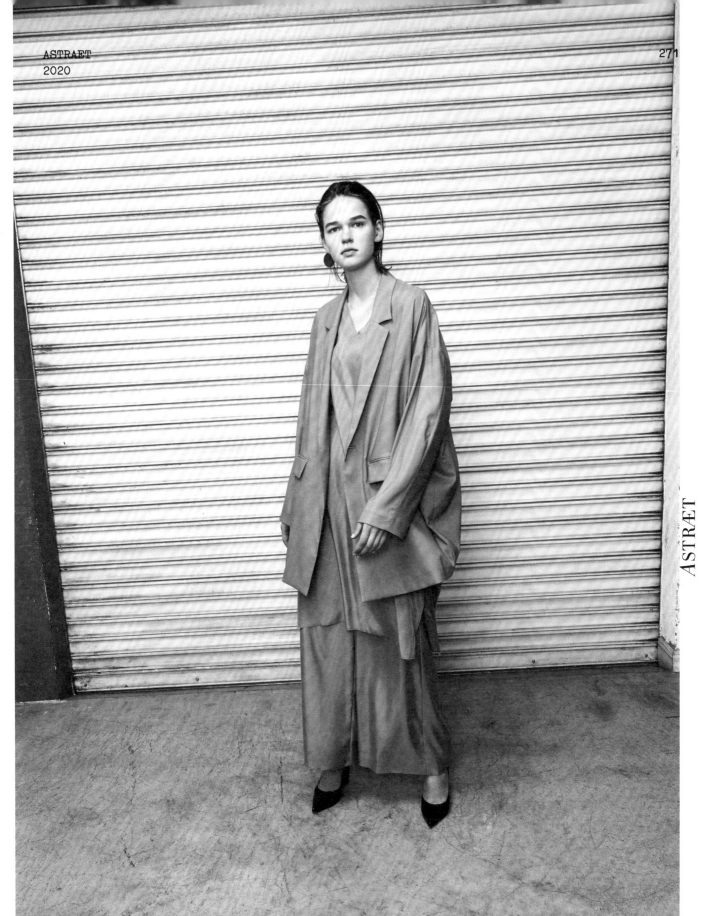

"Astraet" is the Old English word for "street." This brand offers modern updates on classic standards, alongside seasonal collections that examine the latest trends through the Astraet lens. Items combine traditional values with cutting-edge design, revealing a modern, sophisticated aesthetic.

Gentlewomen's Club in Minami-Aoyama

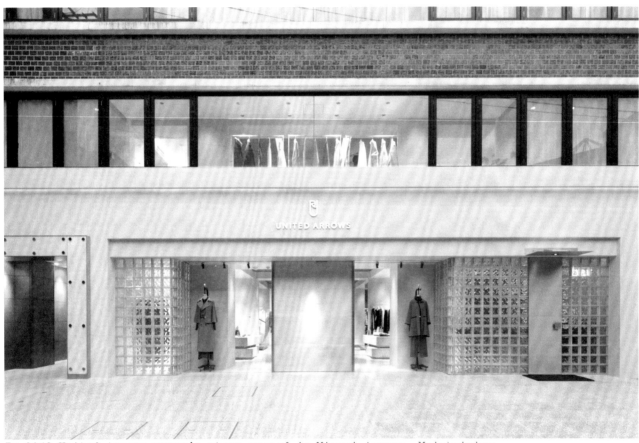

In 2019 United Arrows women's store opened in Minami-Aoyama. Maintaining the core concepts of simplicity, quality, and attention to detail, it was named flagship store for the women's collections. Select items from United Arrows' own labels (Astraet, Aewen Matoph, and Loeff) as well as Japanese brand HYKE and international brands (such as Maison Margiela) can be found on both floors. Each piece is carefully chosen to appeal to women with exceptional taste in fashion and lifestyle goods.

Natural light floods in through glass-block walls, spotlighting items in the store at different times of the day. Teppei Takeda's vivid and impressionistic portraits adorn the walls while clean marble floors highlight the simple, elegant interior.

After shopping, visitors can stop by UA Bar Aoyama, which is located next door. It features a bubbly menu of cocktails, champagne, and sours that can't be found at UA Bar in Harajuku. The bar also serves delicious coffee sourced from Leaves Coffee Roasters of Kuramae, Tokyo.

Here's to Our Relationship!

Rimowa for United Arrows (2006-Salsa White), (2007-Classic Flight)
These Rimowa suitcase models have been available since 2004, and the two variants pictured here are special-order ones that had sold out directly after hitting the market. The white Salsa was created in 2006 with the sentiment that the white color of the suitcase would change with the person who used it on their travels. In 2007, the Classic Flight series was specially ordered in black and went on sale in Japan for the first time. The dials and other parts were altered to meet the specifications of United Arrows, and a removable handle cover was installed using dead-stock leather from the Freudenberg Group to make an especially fine piece of luggage.

G-Shock for United Arrows (1996)
United Arrows was the first select shop to enter into a collaboration with Casio. The watch in the photo is a special-order model commemorating that special moment. Based on the AW-500—declared by Casio's engineers to be the world's strongest analog model and to never have its time hands dislodged—this model's rear face, buttons, and time hands are colored in United Arrows orange. It has a stylish and subdued design. This watch enjoys outstanding popularity even among the analog G-Shock series, with lines forming on the day it was released to the market. This is an unforgettable product for United Arrows, as it became the launchpad for subsequent collaborations with other companies.

Johnstons for United Arrows (2015)
Founded in Scotland in 1797, Johnstons is a maker
of scarves and stoles of the finest materials, like
cashmere and vicuna. The scarf from Johnstons is the
item par excellence for winter. The specially ordered
model in the picture uses the United Arrows House
Check, sanctioned by the Scottish Register of Tartans,
and is a large-size stole. Made using the brand's key
colors—brown and orange—it is yet another expression
of traditional sensibility.

Comme des Garçons Shirt for United Arrows
(2011)
In 2011, Hirofumi Kurino of United Arrows
collaborated with the magazine BRUTUS to
create a limited-edition shirt, and chose
Comme des Garçons Shirt as a partner. At
first glance, they seem like simple white
shirts; however, they have superb details.
On closer inspection, you'll see that they
are a rare kind of shirt with a patchwork of
four kinds of the finest shirting material.

Charvet and Eric Bergère for United Arrows (2011)
Eric Bergère has worked as artistic director
for brands such as Hermès and Lanvin, and this
collaboration saw him with the French shirtmaker,
Charvet. This western shirt is a special item made
possible through a collaborative project with the
magazine *BRUTUS* in 2011 and was sold exclusively
online. This fine shirt is the product of the unique
sensibilities of Bergère and Charvet. Indeed,
despite Charvet's long history, this collaboration
was one of the first with an outside designer.

Duro Olowu for District (2007)
This is a 2007 collaboration with Duro Olowu, a designer who
has received considerable acclaim from the well-heeled women
who patronize his boutique in London's tony St. James's.
Duro, who specializes in the use of graphical prints and
patchwork with African motifs, as well as camouflage and
animal patterns, applied vintage material and designed unique
men's shirts that combined striped material with contrasting
panels. These shirts exhibit a refined showiness that seems
to both conceal and expose the playful mind of the designer.

Barbour for Beauty&Youth (2013)

The Barbour brand is the embodiment of the British outdoor lifestyle. The oiled-cloth waterproof jacket is a standout staple of the brand; combining versatility and durability, the item is rightfully an outerwear masterpiece. Beauty&Youth made a special order for a short-spec Bedale in 2013. A navy blue collar sits atop the brown body, with a tattersall from Moon used for the backing. Beauty&Youth gave the jacket an update, giving it a chic, subdued look that allows for the flexibility required for a transition from the outdoors into the city, and greater visual impact is achieved by the contrasting body and collar.

John Lobb for United Arrows (2002 & 2019)

United Arrows fell in love with the techniques of John Lobb, a legend in English footwear since the 1990s, and has been a tireless advocate for the brand since. And as if to express the intimacy and durability of their relationship, John Lobb has continued to provide the same United Arrows exclusive model since the 1990s. The RIO, which went on sale in 2002, has been special ordered and comes in three colors—a rare green, navy blue, and red. On the right in the photo is the handsomely skin-stitched, semi-square toe loafer—the Ashley—a singular model currently available through custom order only.

Vans × Harris Tweeed for Beauty&Youth (2013)
These Vans, bearing a crazy pattern with each
shoe made of a different woolen fabric, are a
collaboration with Beauty&Youth. A monotone
base textile from Harris Tweed in Scotland was
used for the shoe top. It's a playful design
that combines differing patterns on each of the
parts. Though based on skateboard shoes, these
Vans sport an elegant look.

UCLA for Beauty&Youth (2019)
This is a limited supply T-shirt crafted
by Beauty&Youth to commemorate the 100th
anniversary of the founding of the University
of California at Los Angeles. The T-shirt
sports the university's bear mascot, Joe,
and comes in the school's colors of UCLA
blue or UCLA gold. This T-shirt has an
embossed printed design using both flocky and
silkscreen printing techniques.

Coleman for Beauty&Youth (2020)

This is a collaborative endeavor with the American outdoor brand Coleman, and has been a continuing project of Beauty&Youth. 2020 marks the ninth year Beauty&Youth has been selling these collaborative items, which, aside from the chair and mini table pictured, include a tent, a wagon, a cooler, and a lantern. The items pictured come in a solid gray and a refined blue, and are suited for a variety of contexts, from a beach resort to glamping to the park, or even your veranda at home. This is a collaborative lineup of staple items that change in color, pattern, and style, and is offered to people of all ages.

Paraboot for Beauty&Youth (2017)

With special orders dating to the early 2000s, Paraboot is now a familiar shoemaker to Beauty&Youth. These remarkable "crazy-pattern" shoes, ordered in 2017, combine four types of materials on the staple Chambord: grain leather, smooth leather, glass leather, and suede. This special-order item is the kind of Beauty&Youth item that displays a playfulness on otherwise staple items.

New Balance for United Arrows (2018)

The relationship with New Balance goes back to the founding of United Arrows. Across thirty-two years and countless collaborations, it is no exaggeration to say that for United Arrows sneakers are synonymous with New Balance. Among the various projects was model 990 V4, created to commemorate the first made-in-the-USA pair. It is a noteworthy and classic combination of nylon mesh on the top with suede. The suede is an antique white, which is extremely close to a bright white, and the nylon mesh is a pure white, giving the shoes a clean and fresh look. The words "United Arrows" are emblazoned on the insole, and the shoe comes with a special garment bag printed with the names of both brands.

Red Wing for Beauty&Youth (2019)
Red Wing is a pioneer in work boots. The model in the photo
is based on the simple plain toe, and uses thick suede with
all black right down to the outsole. Increasing the number of
eyelets by one gives the boot a handsome look. These boots are
a commemorative model specially ordered by Beauty&Youth to
celebrate the thirtieth anniversary of the founding of United
Arrows, and they have been arranged to coordinate in an urban
setting while retaining their durability achieved through the
Goodyear welt manufacturing process.

Keith Haring for Beauty&Youth (2013)
Keith Haring epitomized the art scene of
1980s New York. Fans of this pioneer in pop
art among the staff of Beauty&Youth were
brought together to create these shirts to
showcase his work in a highly collectible
item. For Beauty&Youth, Keith Haring remains
an important cultural icon linking art with
fashion.

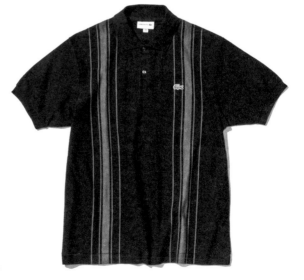

Vainl Archive x Lacoste for Beauty&Youth (2019)
Beauty&Youth put in a special order for the
Lacoste staple polo shirt L1212 to create the
Vainl Archive, and the result is something
completely unexpected. Parallel to the somewhat
loose silhouette of the polo shirt are lines
(and a color scheme) unique to Vainl Archive,
which at once complements and subverts the codes
of Lacoste.

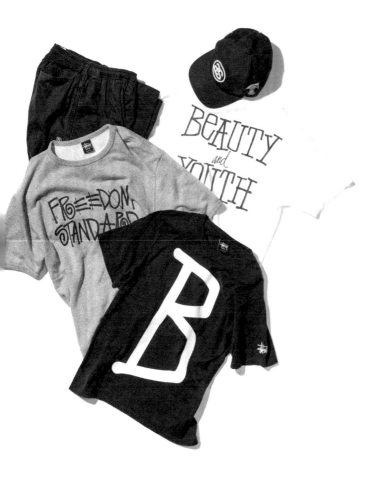

Stüssy for Beauty&Youth (2014)
The capsule collection of Beauty&Youth, which welcomed Stüssy as a partner, commemorated the 25th anniversary of the founding of United Arrows. These items bear Stüssy's trademark SS-Link, and the words FREEDOM STANDARD, a concept design of Beauty&Youth—with both being printed in the unique Stüssy font. This line of items, which combine the oversized specs familiar to Stüssy and Beauty&Youth's signature navy blue, provides it an air of refinement along with a street-savvy feel.

Auralee Converse Beauty&Youth (2018)
Right around the time Auralee—the label founded by Ryota Iwai—announced their move from Tokyo to Paris in 2018, Beauty&Youth launched a triple collaboration with them and Converse. The All Star served as the foundation for the project. The shoes hold a neon-colored ankle patch inspired by the Converse archive of the 1980s, and the top of the shoes have a canvas fabric that uses rare Finx cotton. The outer case has also been finished in a retro style giving it the Auralee look.

To Our Thirty Years, and to the Many More Years to Come!

United Arrows has invited seven professionals from different fields to talk about their practice, share their personal experience, and imagine the future of fashion. By gathering all this knowledge, we hope we can inspire creatives, artists, entrepreneurs, and professionals of all kinds, to thrive and create long-lasting stories. We want those ideas to be shared, discussed, and enjoyed. This is to our thirty years, and to the many more years to come.

Adrian Joffe, CEO of Dover Street Market

Jean-Claude Colban, Director of Charvet

Zengoro Houshi, 46th-Generation Proprietor of Houshi Ryokan

**Nick Knight,
Photographer,
Founder and
Director of
SHOWstudio.com**

**Tetsuya Abe,
CEO of Ikeuchi
Organic**

**Ramdane Touhami,
Owner of Officine
Universelle Buly 1803**

**Asa Ito,
Director of the Future of
Humanity Research Center**

Adrian Joffe, CEO of Dover Street Market on the Essence of Fashion

"We are only interested in creation and new things."

If given the chance to open their own shop, most people would want it to be like Dover Street Market. The variety of clothes, the way in which items aren't confined to a certain category; the ever-changing window displays and the ever-surprising installations and events. There is something exciting about simply entering the shops—and this excitement might be the very essence of fashion. DSM is a place that transforms creation into value; when talking to CEO Adrian Joffe about the shops, we don't just talk about clothes—we talk about what it takes to bring the essence of fashion to everyone.

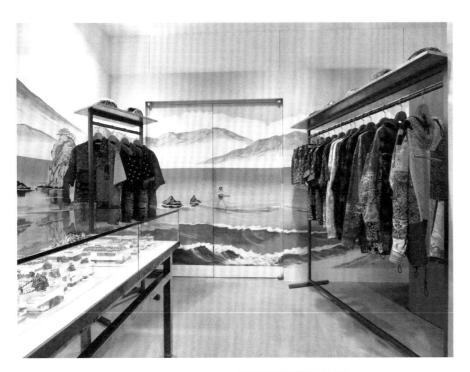

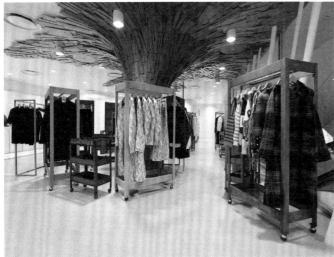

Dover Street Market Ginza

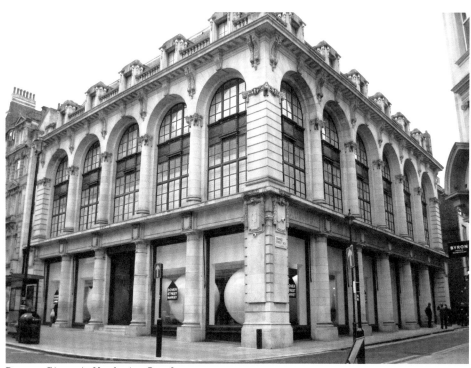

Dover Street Market, London

How would you describe your role at Comme des Garçons?

In a few words, I take care of everything outside Japan
about Comme des Garçons and Dover Street Market. To give you
specific examples, I oversaw the opening of DSM in London in
2004, and supervised the launching of the Comme des Garçons
T-shirt concept "Play" and its wallet line.

How did you come up with the concept of Dover Street Market?
We all remember the "guerilla shops" that first introduced the
concept of the pop-up shop.

DSM was the opposite of the guerrilla shop concept. We opened
at a time when this was the trend, so a lot of people thought
DSM was part of it. This may bring confusion. The intention
behind DSM London was to open a permanent flagship store for
Comme des Garçons when the franchise for Comme des Garçons
with Browns came to an end. We wanted something special, so we
came upon the idea of sharing our space with others, bringing
different visions together to create a completely new retail
experience: an anti-department store, anti-flagship feeling.
The DSM idea of "beautiful chaos" followed quickly.

This idea of "beautiful chaos" can also be taken as an answer
to the online shopping habits of today. Online, customers can
easily and quickly shop from one brand to another.

Naturally, we firmly believe in the unique experience that
only physical stores can bring. For us, online shopping is
just an extra service to support the live shopping experience
and immediate interactions. When visiting our shops, we want
our customers to have a nice, uplifting, and stimulating time.

The shops are also a great way to meet a lot of new designers
and create a sense of community among customers. What are you
looking for when you buy into a brand: are you more attracted
to young designers or established brands?

We always look for fearless originality, hard and dedicated
commitment, as well as rebellious spirit. Along the way, we
had the chance to meet all kinds of wonderful creative people
and established places and spaces where we can work together
in synergy, by mere example or through actual teamwork.

This seems to extend to the staff, who usually engage in
meaningful conversations with customers. What makes a good
sales associate?

Individuality, diversity, confidence, creativity, freedom of
expression, ability to communicate each in their own way… are
traits that we value and try to encourage.

Do you follow any particular rules for your shop display?
What was the most memorable artist collaboration for DSM shop
windows?

Definitely no rules, except being creative and well-
conceived. Nothing gratuitous or forced. I can't say which
one was best. It is not our custom to judge and give a
top ten. All of them were different and gave us something
different. The one I enjoyed the most perhaps was the
collaboration with Ai Weiwei.

There are DSM shops in Tokyo, New York, Singapore, Beijing,
Los Angeles, Paris. How does each city influence the making
of a shop, its collection, artist collaborations and interior
design? How important is it for each store to feel "local"?

Every DSM should feel local and respectful of its locality,
all the while sharing the same DNA and values. Like a title
and many different subtitles.

In addition to the shopping experience, how can DSM bring
happiness to people?

By giving people confidence, fashion can be a means of
expression. It can express freedom and encourage liberation.
It's one of the best tools of expressing who we are, who
we want to be, and what our dreams are. That is why at DSM,
we are only interested in creation and new things, because
without that progress is not possible.

What do you want for DSM stores in the next ten years?

Just to strive to be better and newer, constantly changing,
always surprising, always breaking more boundaries and
borders, and most importantly going beyond fashion. Fashion
must not stay in its box.

Dover Street Market, Singapore

Dover Street Parfums Market

Jean-Claude Colban on the Future of the Classical Tradition

"What we do today is based on what we did yesterday, and what we will do tomorrow is based on what our customers asked today."

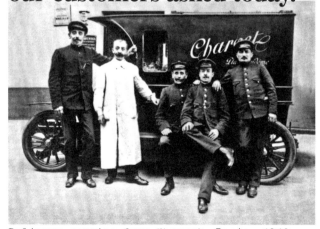

Delivery service from Charvet, Paris, 1910

It isn't an easy task to write about Charvet, the first shirt shop in the world, founded in Paris in 1838. Director Jean-Claude Colban finds it difficult to summarize the brand's long history in a few words. However, Colban definitely has the right words to teach his staff about how to distinguish between colors and fabrics. At United Arrows, we understood that Charvet wasn't just a matter of vocabulary. We first introduced Charvet shirts in 2002 for their quality, their timelessness, and their history. We discuss the changes the shop went through over the years, and how a brand with such history can adapt to modern times.

<u>Charvet is the first shirt shop in the world, founded in 1838.
What is the key to maintaining the business for close to two
hundred years?</u>

The store on 8 place Vendôme was run in a very traditional
manner since the founding. Back then, products were carefully
kept in boxes and brought to customers so the look of the shop
was rather empty and it was not very engaging to the customer.
However, when my father took over the business in the 1960s,
he insisted on creating a direct experience with people and
the products. It was very important that he developed this
experience of a tactile and visual relationship to products.
He also expanded significantly the scope of our collection,
in terms of colors, use of decorative patterns, and also
silhouettes. The 1960s were the time of great change to
Charvet: from very classic French to something more universal,
but with a classic mind.

<u>The idea was to bring customers closer to the product.</u>

Yes, because the shirtmaker's job is to do something which is
very close to the skin. Finger contact, skin contact, smell,
weight, transparency, color, shine, fluidity… all of those
things can only be appreciated by physically interacting
with products. We also increased the color choices too, which
allowed customers to choose from not only one blue but ten.
It allows customers to choose and experience bespoke shirt
making. Choice, custom, bespoke, individualization, is also
the process of selecting. And for selecting you need choice.

<u>You probably have many unusual orders from the customers…</u>

Of course, every request is very specific and I can think of
a handful of customers who have very specific ideas. French
customers can be very specific about blues. American or
Japanese customers will be surprised by all the variations
we have, but some of our French customers are still looking
for the right blue. You see, people think about Charvet
featuring a lot of choice, but we always keep in mind that we
were founded to defer to our customers. That is what keeps us
growing.

<u>That is probably what makes customers come back. They know
that you're learning from them.</u>

There are a variety of reasons people keep coming back. Some
people have a personal or family tradition of visiting our
shop. Other people like to explore: they think of us as some
place where there's always some kind of discovery to be made.
And some people are in a style-defining process. Each visit
is another step forward. Every time they come, people tend to
spend more time in our shop. They've been thinking about their
previous visit, they've been discussing it, they come back for
things we put aside for them. It's a "deepening" process.
I think that's the right word.

It is not only the customer and the products that makes
the store but also the sales associates. They must have
a good understanding of shirt making as well as the
character of each customer.

When it comes to a new sales associate, we first
train them to speak with proper words. So they can
distinguish colors, fabrics, and designs. Catherine
Deneuve once said: "I can distinguish even between
two green peas." That means you need to have the
proper words. We feel that we need to be able to draw
customers' attention to differences. The experience
of choice is an experience of confronting two things.
Learning to describe and to compare is very important.
We also tell sales associates to show our shop around:
a lot of people like to visit, and a lot of people do
not necessarily buy the first time. I don't know about
Japanese, but European and American males like to
buy when they feel comfortable with the product, when
they've mastered the subject. They like to compare
and visit different shops before buying. However, in
our case, you can't experience our products somewhere
else, so you have to let people ask, think, come back,
ask again… You know, it's a process. You also need to give
honest answers. Saying no to a customer who is asking you,
"Do you think it looks good on me?" is very important. It
takes some bravery and it's not easy for a younger person to
say no to an older person. But if you don't give any honest
answers, then what is the point? I think that these are three
important aspects of our customer relationship.

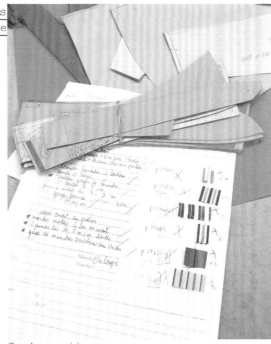

Sewing patterns

Do customers stick to the same sales associate over the
years?

There is a relationship between a customer and their sales
assistant, and it usually lasts. But it doesn't stop there.
There is also a relationship with the patternmaker, and
another relationship with the person who is now in charge of
shipping, doing photographs, handling remote requests. So,
who is upfront might change a little bit, but basically yes,
they keep on relying on the same person. For each order, we
keep little clippings of the selection made and keep it in
a file, so the history is very clear. When we want to make
a new line and we feel that people want something totally
different, we will think of our most daring customers, look
into their personal shopping history and draw inspiration
from it. You see, Charvet doesn't follow one direction:
Charvet is like a whole person, and all the personal
selections from each customer work together.

Place Vendôme, Paris

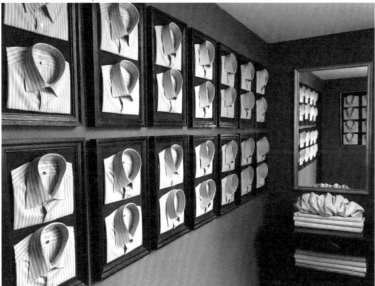

A selection of collars

In the past few years, tired of the low quality of fast-fashion and the new trends they dictate, younger people have been looking into traditional brands and long-lasting products. Do you notice younger customers coming to your shop and if so, how do you adapt to these young customers?

Adapt to younger customers means… It doesn't mean a lot in terms of what we do. I think that if we would be playing the game of trying to be young, it would be cheating. When we adjust, we adjust in ways that are not necessarily trying to be young. Let me share an example. If we are looking at indigo, we naturally have in mind that people who wear indigo and faded wear are typically younger than the people who wear mid-grey. But then we are not going to try to do something like traditional indigo, we are trying to do something that is born out of our tradition and know-how and we are going to mix shades. So, it comes from us. But on the other side, we adjust a lot by a change of lifestyle. For example, there is a lot of reflection today about fabrics and what fabrics are more suitable to the change in lifestyles. Some things are very important, like a fresh interest in some fibers, which were not considered as much as they should be—such as hemp, linen, that sort of thing. And some things are a little bit rubbish, such as new, technical nano-tech finishing, which are supposed to be meeting requests in new lifestyles. So, we adjust in designs, in patterns, but we try to do it in a way that is natural and honest. I think young people are looking for brands they can trust. I think the most important thing is trust. Basically, you are willing to pay a higher price because you have a seal put by some guy, who tells you: "I checked it. I checked it so you can buy it with trust." This is the only meaning of putting your name on a product. You are not going to put it outside, because it is not a social sign, it is just a reassurance you give to whoever buys it. And the younger person has probably less means of checking, so he needs more to rely on suppliers he can trust. I think trust is the key point.

Can tradition be defined by trust?

Not necessarily. When you want to do something new, tradition doesn't play. But yes, tradition means that you've been around, you know what defaults to avoid, how to check, so I guess that's what you mean, yes. We are living in a world where people are taking a lot of shortcuts. And avoiding shortcuts and doing things how they should be done is getting honestly more and more difficult. There is something not nice there, the way processes are disappearing, product knowledge is disappearing, it's a disgrace.

Inside the shop

How does a brand with so much history add new
products and still remain faithful to this tradition?

You know, there was a time in the 1980s, and especially when we
moved into the building where we are now, when we felt it was
appropriate to develop new products, and to start new ideas. For
example, at some point, we decided that we wanted to do leather
goods, such as bags, briefcases, and even suitcases. We worked
with excellent artisans and we came out with a line of suitcases
and cases that were really beautiful. I think it was close to the
best that could be done. But it was not successful. When we showed
it to people, they found it nice but they did not buy it. And we
learned that there is a connection between what you can do and
what people expect you to do. If it comes to buying a suitcase,
you will probably go to a place where you feel it's a specialist,
where you have options. So, at the turn of the century, we really
started focusing a lot on what we felt was our core mission—our
know-how, if you like. Things started to move on from then because
there has been, especially in the last five, ten years, a shift of
lifestyles, and people are expecting our propositions to adapt to
these new lifestyles—and we are going that way. This has brought
up very interesting issues, such as what textiles to use, what
processes to use… It expands gradually and organically from our
core expertise. We don't do, today, what we did ten years ago.
There is a process, we went from step one to step two to step
three. We changed things in the process; we got tired of something,
we kept going on. Our customers, a large part of them, are
individualists. People who want to do their own style. So, we learn
every day from their design ideas. Our best design breakthroughs
are not ours. They come from requests from customers. We are very
keen to say: "The customer is the designer."

Zengoro Houshi on What is Essential to a 1,300-Year-Old Hotel

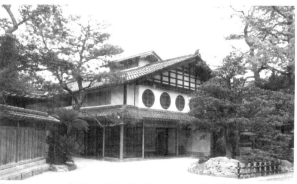

Entrance of Houshi Ryokan, early 20th century

Ishikawa Prefecture, located in the Hokuriku region of Japan northwest of metropolitan Tokyo, is characterized by a climate with distinct changes of seasons. Houshi Ryokan, a traditional Japanese inn, welcomes guests with seasonal dishes in view of a garden where autumn leaves, wintry landscapes, spring cherry blossoms, and the refreshing sensation of a clear stream in summer can be fully enjoyed. Founded in the eighth century, it is thought to be "the oldest hotel in the world," and is still welcoming many guests today. Through flexibility and with a spirit of humility, Houshi Ryokan has overcome numerous challenges over the years. Zengoro Houshi, the 46th-generation proprietor of the ryokan, says, "If there is no change in the concept of a long-standing establishment, the establishment will soon decline."

What is the job of a "Houshi"?

A long time ago, a monk called Taicho Daishi was ordered by the mountain deity Hakusan Daigongen to dig a spiritual spring. He brought a sick person to test its healing powers—which proved successful. Taicho Daishi then commanded his apprentice Garyo Houshi (the founding Houshi) to build a healing hot-spring inn. Since then, the family has taken on the duty of protecting the hot springs for many generations.

So, this ryokan has been around for 1,300 years.

Everyone says, "Thirteen hundred years is amazing!" but 13 years, 130 years, and 1,300 years are not that different. I cherish every day. This is something I've learned from our previous head. Tradition is the accumulation of one day at a time, and is nothing more than the accumulation of reforms. In other words, the ryokan had been in operation for 1,300 years before anyone realized it.

It's very rare for one family to run a business for 46 generations.

The tradition is gone now, but in the past, three generations of family members would share meals together. We teach the Buddha's sermons while eating with the children. I emphasize the important points while eating, so it doesn't get too boring. When children hear these words without paying too much attention, it will eventually nurture their minds. These days, with the increase in nuclear families and dual-income families, not only grandparents, but also parents and children, are often unable to have meals together. In that sense, I think it's getting harder and harder to keep something going for fifty or even one hundred years.

Are there any traditions in the ryokan?

Traditions are naturally created by employees watching, listening to, and imitating the efforts and initiatives of generations of owners and okami (landladies). I believe that traditions come from employees through the accumulation of these actions.

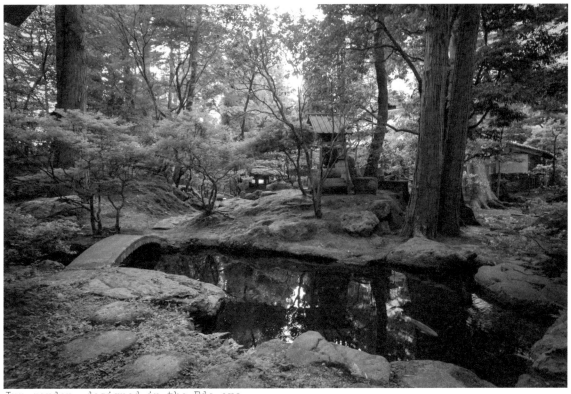

Inn garden, designed in the Edo era

Garden through window of guest room

VIP room designated as a National Important Cultural Property

Guest room

Lobby

What is the secret to the longevity of
Houshi Ryokan?

We are constantly changing and incorporating
new things, while looking at the whole from
a broad perspective. Making something new is
easy, but changing it is very difficult.

Have you ever regretted making changes?

Of course, many times. I learned from an
early age that "ryokan architecture must be
constantly changed" from my predecessors.
The truth is, we have to determine between
what we will change and what not to change,
and that's extremely difficult. There are
many things I've accidentally changed and
I wish I hadn't. When I was young and cared
about being too "old-fashioned," I would go
to Tokyo and bring back what I learned to the
ryokan and try to incorporate many different
things. For example, we built things like
pools, discos, and karaoke bars, but those
things quickly went out of use. All things
can only change either quickly or slowly.
I've learned many times the importance of not
getting caught up in the latest trends, but
finding out what's essential.

Outdoor hot spring, one of the main features of the inn

As the number of overseas customers has increased, have you devised or changed any of your hospitality practices?

As the Chinese proverb says, "If the people near you are happy, the people far away will come." Until now, as long as our important guests, or in other words, the people near us, were happy, the people far away have also come. But now I think that's been reversed, so that if people from afar come and enjoy themselves, those near us will also come. We greet guests when they come talking their own language, albeit with broken pronunciation, and provide them with a cup of matcha green tea to express our gratitude.

The number of long-established ryokan is dwindling, and the tourism industry has not been able to keep up as it has in the past. What do you think is the role of Houshi Ryokan in this context?

If we make no changes just because of the concept of being a long-standing establishment, we will soon decline. We always try new things and remain aware that other facilities have an eye on us. I think it's important for us to tell the next and future generations, "Don't make these mistakes," in order to make connections with them.

What are some of the most memorable words you've received from guests? Please tell us why, as well.

I'll never forget the stern words I received from a guest who said that their own house was much better. In the past, if you went to an inn, you could be satisfied with the food, clothing, and shelter, but nowadays, however, individual lifestyles have improved considerably compared to the past, and guests have more advanced living environments. In that context, in response to the question "Why bother going to a ryokan?" we at a ryokan feel that we have an even greater responsibility to convey a strong sense of Japanese culture and tradition.

Of all the lodgings around the world, what is something you can only experience at Houshi Ryokan?

The hot spring has been welling up for 1,300 years and the garden has been maintained since the Edo period [1603-1868]. I believe that these are things you can experience not by owning a valuable object, but by continuing to hold on to it.

Nick Knight on Magazines, Medium, and Mimicry

Sunday 4th June, 2017

This unique period in our history is forcing so many
changes—the fashion industry is only now catching up to the
possibilities of digital, to which you have been dedicated
for the last twenty years. How does it feel now that
everyone is playing catch-up?

I've been talking this language and trying to make this
a reality for a long time, you're right. For so long, the
business itself was structured so that fashion film just
wouldn't work because the magazines and the catwalks still
held the power. Over the years we have seen a number of
designers going against that…

What do you think about the traditions of our industry? Do
we need to change?

If you separate yourself from the debate a little and ask:
"Well, what's the best way to show fashion?" you wouldn't
come up with the catwalk. If you put that question to a
community of incredibly creative people, one wouldn't
imagine that they would come up with the same answer as
we've had the last seventy years. Our *raison d'être* is to
invent the future. Fashion is a predictive medium, so it's
full of people who want to see something they haven't seen
before! Yet there is this weird anomaly when it comes to
presenting the collections, which are full of new ideas, in
the same way they used to in 1940. That seems a little bit
odd to me.

I'm continually surprised that so many people are resistant
to innovation. This model we're operating on right now
is out of date. Was your decision to launch SHOWstudio a
reaction to this?

Yes. Before the internet, I was trying to crystalize
the idea of fashion film, and I had been filming my
sessions with Yohji [Yamamoto] and Jil Sander since
1988, and I thought, well, here is an interesting
medium, but how can I show people these films? TV was
totally inaccessible and films were hopelessly slow.
The only thing to do was to go directly to an audience,
in the way that Yohji would send out a printed
catalog to people he really admired; I thought I'd
do the same. I'll put my experimental fashion films
on a VHS cassette and send it to anybody I admired,
from architects to artists to politicians. I started
drawing up a list but then it never actually happened!

Two or three years later the internet was formed, so
all of a sudden you had a global distribution platform
for your tapes.

I think we were slightly ahead of our time, and we were
trying to do things the internet hadn't yet managed
to achieve. Our first livestreams were one still

Sunday 6th November, 2016

image that would change after one minute, which isn't really a filmic experience, but it had an interesting presence. It was just the beginning of an idea because I didn't want to do a magazine. I was already doing print work, so this was something new.

What was the first project you put up?

It was a series called *Sleep*, of models sleeping with webcams above their beds. We had a whole floor of the Metropolitan Hotel in London and we set up a studio, hair, and makeup. We dressed the models and then sent them each to their rooms.

It's really interesting to watch it today because of the low-quality image. Through the glitching you get a true sense of the technology of the time, but it also adds an emotional depth. I've always loved lo-fi because you see mistakes. They get lost the more technically advanced things become. The digital tears in the images from that series, when they are printed, look like flecks of gold. They are beautiful. You can revel in and enjoy the patina of digital. My roses too are shot on an iPhone and then printed through an AI, *Sleep, Elise Crombez*, 2001
which gives them this new texture that looks like nothing else. People are always trying to mimic reality and actually you need to push on and find things that are aesthetically different and new. Something that Kanye West once said to me sticks in my mind: "Every mistake is a new opportunity," and that's very much the way I have worked. When things don't turn out the way you think they're going to it gives you an insight you could never have imagined. That's why I'm so interested in CGI and 3D scanning because they show you the world in a way that was previously unavailable.

What did people say when you first launched?

Some people understood it and some people didn't. Bizarrely, the fashion world was very slow to get online and some of the major publications are still trying to catch up. At the time, a lot of them ignored it, as if it were one of my peculiarities. They were a bit dismissive. But other people, like Lee McQueen [Alexander McQueen], the models and hairdressers and the people who worked with me more closely were really excited by it. A lot of the times we were asking people to do things they'd never done before. Like with livestreams, I remember the models telling their families that they were going to be online, so you'd have the models waving at their mums in Australia or North America! They found it kind of thrilling.

I think this idea of having a live audience plays a part—normally the model turns up and there are people on set, but the sense that you are going out in front of a global audience must make a difference?

You perform a little bit more even if it's for 7 or 70,000
people. Early on we never knew who was watching, but it was
never really the purpose to get millions of people to come
and watch. I'm quite happy if one person comes to see; I'm not
doing it to sell anything or to make more money or get more
followers. That has never been the criteria. I'm thrilled if
one million people come and watch, but I'm more thrilled if I
do something good. The work is the thing.

What was the hardest part of SHOWstudio early on?

A lot of it isn't hard because it's incredibly enjoyable and
exciting, which is why I keep shifting the focus to try and
maintain that. To try and do anything really good is hard—it
takes a lot to be able to create something that one is proud
of. It's like mountains, they are always hard to climb. Every
time we start a new project, it's another mountain.

I am sure over the years you have been asked to define what
SHOWstudio *is*—is it a magazine?

It isn't a magazine, a theater play, or an opera—it's all of
those things. We shouldn't try to define it by any criteria
other than what it is, and, in a way, I don't have to define
it because it still exists.

I wonder how you feel about SHOWstudio's role against the
backdrop of print magazines, as they are right now?

In one way I have had a very privileged and lovely
relationship with magazines—they have supported me and
allowed me to do what I do. *Vogue* used to let me broadcast all
their shoots! We had a nice hand-in-hand relationship.
My problem is the corruption within the magazine
system, which I've found frustrating. I remember
working with stylists like Simon Foxton, who would go
to a vintage shop and dye clothes one color and put
them with trousers from one designer and shoes from
another and create a look. That was very nourishing
for the designers themselves because they could see
how people interpreted their clothes, but now that's
changed, as total looks from the catwalks are being
presented back to us, and that's it.

There's very little critique of fashion today.

Some designers have been so lauded that they see
themselves as making visual sculptures or painting,
so, painting anything else on top of a painting is seen
as totally wrong, as it would be to any artist. And
I can understand that philosophy, but I don't think
it's healthy. I think people should be able to see
their work in a way that they can understand it again.
It's why we started the live panel discussions; it's
beneficial for designers to hear from people who

Sleep, Zora Star, 2001

might not like their work—every other creative media, whether it is opera or film or music, has a pretty vicious critical forum. Fashion has bypassed that with this idea that because it is a commercial artform, you cannot criticize it. I don't think that's correct.

I've noticed that there is a new generation engaging in the proper, rigorous critique of fashion on social media, with real passion and care. It's encouraging to see that gaining momentum.

What you're seeing is the end of a system that doesn't work anymore, one where the advertisers have control over the magazines. They cannot control social media, so they have lost their power, their grip. We have a way of talking now that is outside of their ability to censor and control. There's a blossoming of creativity across the internet. It's why I love Instagram because it's a great platform for seeing new talent, people who have created a world for themselves outside of magazines, advertising, catwalks, where they are free to be and do what they want. I started SHOWstudio because a lot of what I was seeing in magazines in the late 1980s and 90s was directed by business; it was becoming very boring. When I started my family in the early 1990s I was very concerned by the social injustice I was seeing in the world around me, and it wasn't being reflected in what the magazines were asking me to do. I needed to find some way of feeling like I was producing images that were really going to matter to my children. I wanted to do work that was socially important and reflected my deep anger at the world around me and also deep joy; but being asked to photograph a beige trouser suit just wasn't cutting it, so I didn't re-sign my American *Vogue* contract. I started SHOWstudio.

How much do you think about the audience, who they are and what they want to see? With a magazine you are always considering a readership that may or may not exist. Online you have a direct connection, an immediate feedback loop.

At the beginning, we realized what we were doing was quite unique, so the feedback was very negligible. Part of my issue with print was I would spend months working on a series of photographs for a magazine like *i-D*, and they would be published, but you would hear nothing back—there was no feedback in that sense. The mute audience wasn't a nice feeling, and although people say we shouldn't care how many "likes" we get, if you ask a musician to perform in an arena with no audience, no one to dance, then you lose something that is the pleasure of performance. So, when we started the site it became clear it was a two-way medium, so as much as we put stuff out, people could comment on it or send stuff in. A lot of the projects in the beginning worked with that; we'd put out films and

Sleep, Natasha Prince, 2001

ask our audience to engage in the creative process and edit them. You can't do that with a magazine. So much of the creative process is about collaboration, so for me, over the years being on set with McQueen, Galliano, or Yohji, it was a privilege to get inside their minds and it's great to be able to share that.

Which is more important, creativity or productivity? By that I mean, is it more vital for us to make more stuff or should we take pause and think before we do?

In one way it's always important to keep on producing and I know a lot of younger image makers that I work with who wait to be asked to do something, and actually, you think, "Just go and do it!" It doesn't have to be the best thing; you just need to get working and start training yourself to see, to understand, to feel. You don't do that by waiting for the phone to ring. When I was younger I would never go out, I was always working because that was what I wanted to do. Every New Year's Eve I was out making a record cover for somebody because that was the epitome of what I wanted to do. I would make sure I started the photograph in the year that was ending and finish it in the year that was beginning. The important thing was creating work, whether it was scratching on a piece of smoky glass or painting lipstick on a mirror. What I think the pandemic has done is force people to reassess, because they are not facing the same set of structures as they were before, so they're thinking about what their work is for and who is seeing it and why they are doing it. There's a lot of reflection going on. We're moving to a totally different evolutionary path, the age of the cyborg and AI. We're entering a new age as a species and leaving the end of the era that we've all based culture on for the last 1,000 years. I feel incredibly alive. And incredibly stimulated.

Interview and words by Dal Chodha

Tetsuya Abe on the Sustainable Future of Cotton

"Just because you want to wear organic cotton clothes doesn't mean you have to eat organic food. We need to allow some margins when judging people's way of life."

In the past few years, many fashion brands have begun producing "sustainable collections" as well as jeans and T-shirts made from organic cotton, making environmental awareness into a fashion statement. But how much is the sustainability pursued by those brands actually contributing to a sustainable fashion industry? How much does consumer choice factor in this process? While the number of brands using organic cotton and promoting their sustainable products grows every year, Ikeuchi Organic is a company that has been producing towels using 100% organic cotton since 1999. Based in Imabari City, Ehime Prefecture, the leading towel manufacturing region of Japan, the company has been in business since 1953, but they are at the forefront of the industry in the sustainable use of organic cotton today. We talked to Mr. Tetsuya Abe, President and CEO of Ikeuchi Organic, about the story behind their organic products.

What made you switch to making towels using 100% organic cotton?

Until 1999, as a towel manufacturer in Imabari, our main focus was producing hand towels for other brands: products with different patterns and colors for each season, designed at the request of the client and not of our own accord. As our company grew, we started to think about focusing on our own products. Keiji Ikeuchi, who now is the owner of the company, was conducting research on cotton. He came to realize that growing cotton based on conventional agricultural methods would have an adverse effect on the environment. That's why he decided to take the plunge and turn to 100% organic cotton production.

Is 100% organic cotton a big change in terms of price and production time?

Yes, of course. Prices went up and we felt that it would have been difficult to keep our clients. So we decided to produce these products under our own brand. That was back in 1999, so just around the time when the

Shimanami Highway connecting the islands of the Seto Inland Sea was completed. Since Imabari is a city of towels and shipbuilding, we wanted to sell towels as a local product at roadside stations.

Sustainability and organic production have come to the forefront of people's minds today. How was it back then?

Only a few businesses were involved in such activities back then, and I think most people only had a vague idea of what it was compared to now. But once we learned that conventional methods would become unsustainable in the near future, there was no turning back. The cotton production process is one example, but durability is also another example of sustainability. This reasoning led us in the opposite direction of what we were doing with the towel handkerchiefs we were making for other brands. We felt the need to make products that would become permanent standard bearers, that could be enjoyed indefinitely, and we felt that their raw materials should be organic.

Ikeuchi Organic factory

How often do you work for other brands now?

We lost some clients, but for those who remained, we switched to organic cotton production in 2013. "Organic" has become a popular word in fashion and manufacturing. However, there is one misunderstanding or misconception that we'd like to clarify. Just because something is "organic" does not give it additional commercial value. For example, organic cotton does not provide any so-called "emotional benefits" of softness or higher quality. In fact, normally, the quality of cotton grown using genetic engineering or pesticides is more stable, it is also better when making shirts and knitwear with silky touch using thinner yarn. Of course, people who are allergic to chemical fibers may appreciate the difference in quality that organic cotton offers, but in general it is difficult to differentiate in terms of usability and comfort.

How can we measure the value of organic cotton?

We should stress the environmental value. In conventional agriculture that uses pesticides and fertilizers, they spray defoliant to remove the leaves in order to speed up the harvest time of cotton. And in the fields where cotton is continuously cultivated using pesticides, the land becomes so depleted that no crops can be grown there again. Since this fact does not relate directly to the customer, it is pretty much our own choice as to how to proceed, but once we learned that this method was not sustainable, we had no choice but to go with organic cotton. The changing of our company name from "Ikeuchi Towel" To "Ikeuchi Organic" reflects this commitment.

If you can't really tell the difference in terms of usability, telling consumers what it means to be organic can be challenging.

For example, we think it would be great if more people who don't have sensitive skin or negative reactions to chemicals could share some sense of why "organic is better than not organic." However, the apparel and textile industries have long maintained a business model driven by oversupply, in which there is no choice other than to lower prices. As long as you are pursuing a business model

All organic cotton is carefully hand-picked

dominated by large quantities or the widest
range, nothing will change. So, in the end,
both the supply side and the consumer side
have to think about who will benefit from
maintaining the status quo. Consumers tend to
choose based on price, but our planet cannot
be sustained unless we think seriously about
how we acquire the things we use. We're at
that stage now.

Each Ikeuchi Organic towel has a QR code,
so you can see where the towel's cotton was
actually grown and what year it was harvested.

Textile products are made from primary
agricultural products, but there are many
"inconveniences" in the manufacturing process
that are usually hidden. However, we believe
the information that doesn't appear on the
label is what's actually more important, so we
show it. The number of people caring for this
information is growing; but interestingly,
older people tend to believe it's better not
to know this information. First of all, if
you do not bridge these divisions, it could
lead to antipathy and polarization. It will be
important to try to bridge this gap in order
to avoid a major disconnect moving forward.

Have we relied too much on cotton?

For example, most chemical fibers are made
from fossil fuels. Fossil fuels are always
hand-in-hand with the risk of depletion, since
there is limited supply. So, sustainability
depends on economic activity. Cotton, on the
other hand, is a plant, so if you maintain
proper soil and water, it will grow and can be
harvested. If you ask me which is better, my
answer would be natural fiber. As for humans
relying too heavily on cotton, I would say
that it is because of the oversupply-based
business model. After all, T-shirts going for
less than 1,000 yen ($10) are too cheap and
would be absolutely impossible for us. There
is some kind of mechanism that makes that
price possible.

People should be aware that cheaper isn't
necessarily better.

Just because non-organic is bad for the
environment doesn't mean the industry will
be able to shift gears overnight. There are
incredibly few places to discuss how to

Most of Ikeuchi's organic cotton is grown in India and Tanzania

narrow the over-expanded business model over
the upcoming years. There is no shortage
of critical opinions regarding what's bad,
but little discussion on what can actually
be done to make things better. From the
viewpoint of organic cotton users like
us, we believe it is crucial for larger
companies to use organic cotton as well, but
with the current business model, that would
necessitate changes in price and production
volume, making such a conversion extremely
difficult.

It's necessary to take action, even bit by
bit. What can be done?

Most companies are working on their quarterly
evaluations. And I think it's necessary that
change starts there. For example, if you
have a product made of organic raw materials
using a sustainable manufacturing process, to
be released as a new product in the spring-
summer season, you can only sell it at a
proper price for a short time. Therefore, if
you judge by the consumption rate, it ends
up looking like the product was a failure.
So, it's important to look at what will
happen from a long-term perspective of five

or ten years, not as an immediate valuation. As with fashion, the same goes with food, where trends come first, but the discussion on how to be sustainable is actually more important.

It may be difficult to tackle this problem immediately.

That is why I think that the consumers' perspective must change. It takes time to educate yourself on this matter and dedicating yourself to a sustainable way of life brings lots of challenges. Just because you want to wear organic cotton clothes doesn't mean you have to eat organic food. We need to allow some margins when judging people's way of life. It's OK to wear organic clothes and eat junk food. I personally haven't made everything in my life organic, either. If you try to do everything at once, your spirit becomes unsustainable, so if the question is what you should prioritize, I would say your spiritual well-being. It is the healthiest option if sustainable efforts become widespread as a result of spiritual enrichment.

You have set a goal of making towels that a baby can eat by 2073.

Yes, it's a catchy expression, isn't it? But what we actually mean is that when choosing organic ingredients, we consider whether the crop has had three years of pesticide-free growth, is fair-trade based, and is a non-GMO species. We are thorough in using only cotton that passes these three criteria. Currently, we source the raw materials used in the warp and weft threads of our towels. However, there is one remaining challenge, which is sewing thread. Sewing threads are sparsely used compared to the warp and weft threads, so the amount needed is quite small. And dying the same number of colors as the towels so as to make it all organic would require a tremendous amount of stock. Therefore, we've set a goal to make the sewing threads all organic so they are totally safe to put in your mouth, by 2073, the 120th anniversary of our founding. For example, in the case of food products, it is obligatory to label products that have been genetically modified. Cotton is a crop that we don't eat, but I hope we'll live in a future society where notifications like "not genetically modified" are common even for non-edible plant-based products. Perhaps in that future, people will look back upon us today and say, "Once upon a time, people were making a fuss about 'organic,' which now goes without saying."

Ramdane Touhami on Small Battles for Big Changes

"One foot in the past, one foot in the future"

Ramdane Touhami is always where you don't expect him. Fashion designer, product designer, and editor, Touhami wears many hats. After revamping the Japanese brand And.A in the 1990s, Ramdane revitalized Cire Trudon—the oldest wax manufacture founded in 1643 and candlemaker to the court of Louis XIV—in 2006. As an editor and publisher, he launched his magazine *WAM*, printed in one of the oldest printing houses in Switzerland. His latest brand, Officine Universelle Buly 1803, brings perfumes, natural beauty treatments, and accessories to his carefully designed shops around the world.

First Officine Universelle Buly 1803 store, Paris

You've been visiting Japan at least once a year since 1995,
for work, research, and leisure—you even lived in Japan for a
few years. Do you still find new things in Japan?

We used to come to Japan in the 1990s to see the future. Now
we come for the past, which is very strange! I have a passion
for Japan. I understand a little bit of Japanese but I don't
use it: when I start using it, I want to be able to talk about
philosophy and the history of Japan [laughs].

How is it to work in Japan?

There is something magical about Japan: it's the quality.
And I believe this quality comes from Shinto [literally
translated as "the way of gods"; Shinto is a religion
originating from Japan, deeply rooted in our relationship
with nature]. You have a word that doesn't exist in French:
honmono (genuine article). In Shinto, bad quality means
"small death." If you think of bad quality, it's called
little death. I guess that's why there is such attention to
good quality here.

Does this way of seeing inspire Buly?

Not only for Buly: for all the things I do. Even before I met
Japanese people, quality was always a big thing. I come from
a very poor family, and the philosophy of my parents was that
"We don't buy a lot, but we buy the right thing." I remember
my father buying a German TV that we kept for 25 years.
There's a lot of things in common with Germany, Switzerland,
and Japan when it comes to quality. You always have in mind
that your reputation rests on quality. I love a country where
you can trust the quality. But when you ask for too much
quality, you lose in flexibility.

How has Japanese customer service inspired Buly?

A lady from the family who does the protocol for the Emperor
came to teach our staff how to do *origata* (traditional
Japanese gift-wrapping etiquette). By the way, do you know
who actually invented gift-wrapping? Bergdorf Goodman!
Originally, it was used in the Emperor's castle; it was also
used in the court of England. But a department store stole it
from the English court, who stole it from the Japanese court.
These ideas of unwrapping and surprising people didn't exist
before a department store used it! You were bringing a gift
that was visible. They added this layer of surprise—and the
Japanese added another layer of art.

Your staff must go through a lot of training. In addition to origata, products can be personalized with calligraphy—quite an unusual way to add a message to a gift. You even offer a postal service with hand-written letters!

Calligraphy service

It is actually more for the staff than the customers: I want people's attitudes about the "staff" to change. When people look at a sales assistant doing calligraphy, they are not just seeing a sales assistant anymore. They see an artist. And the staff becomes proud: they want to stay. All the staff from the other shops want to join Buly just to learn calligraphy. And we are now teaching our staff English and other languages to enrich their working experience and facilitate relationships with customers from all over the world. And I also believe in giving a chance to people: the girl who is number two at Buly right now used to babysit my kids! I gave her a chance. When I tell you that I am not a normal boss, I am definitely not.

This approach to your staff values the work they do.

You have to understand that a long time ago, you used to do a job in this type of career. You were proud to sell in this shop, or to work at this restaurant… Some French brasserie used to have a badge with the number of years a staff member worked there. There is only one restaurant left with this tradition: it is the Brasserie Lipp in Paris. And when staff members retire, they sell this badge for a lot of money because if you had it, you could get a lot of tips. And they used to decide who would replace them. It used to be like that. But today, half of the people working in a restaurant, when you ask them what they do, they will say "I'm an actor, but right now I work in a restaurant," or "I'm an artist, but right now I work in a restaurant." What are you? An artist, an actor? Same for people working in shops. "Normally, I am a fashion designer," or something else. It's very strange. It's the only job in the world that people don't assume. I want my staff to assume. I want to take this job to the next level. When you see someone explaining something about a perfume to you, it's just a salesperson. But when you see this person doing calligraphy, it's not just a salesperson anymore: this person is doing something I can't do, something I respect.

So what is good customer service?

Focused on your customer. Giving your customer a maximum amount of important information, making sure he or she is going to leave your store with knowledge—not just the product, which would be very stupid. There is this fantastic thing we can give to people: "wow." You know what "wow" is? Our job is delivering "wow." If you do a beautiful label,

Officine Universelle Buly 1803 store, Daikanyama, Tokyo

Wrapping inspired by Japanese traditional crafts

clients will say "wow." A good design, "wow." A good sale,
"wow." A good story, a good product, "wow." A good design
for the store, "wow." Our whole life is about delivering
"wow." Most of the time, with online shopping, you never get
"wow." The "wow" will be our savior! We will be saved by the
"wow."

You're just trying to bring the "wow."

Yeah, it's *muzukashii* (difficult)! But when you go to Buly,
in your mind, it's "wow"! In your life, if you have five or
six "wows" per day, you're happy.

When you step in your shop in Paris for instance, it's easy
to get lost in time. The interior features traditional
French woodworking and Pompeiian frescoes. It also has a
café, bakery, and flower shop! But somehow it feels very
contemporary.

You see, it's half modern and half old. Like we say for
Buly: it's one foot in the past, one foot in the future. If
you just do the past, you're dead. Buly is not old. Not at
all. Some of the packaging looks old. But we invented water-
based perfume. We invented so many other technical things!
But we sell them in the old packaging. If you do old for
old, you're dead.

Each shop adapts to their local environment. Your shop in
Paris feels like an authentic French boutique from the 19th
century, but your shop in New York recreates an early 20th-
century art deco style. In Tokyo, your shop in Daikanyama
[a trendy neighborhood in Shibuya Ward] features a unique
design that combines Japanese modern aesthetics and
traditional French style. How do you design your shops?

In Daikanyama, I could not choose between Paris and Japan,
so I split it into two parts. A minimal Japanese part and
an old French part. For the shop in Paris, we did a lot
of research for the fabrics: the wood, the marble… But it
is usually a very quick process. You know how
long it takes me to design a store? Two to ten
seconds. I am not kidding! And I never come back
on the idea. I think the longest thinking I took
was five minutes. It felt very long! I am not a
thinker. I arrive at the right building and I
say to my team, listen: we do glass, we do three
layers of bricks, we do a counter… Maybe we do
a metallic ceiling… I do the drawings like that.
I call my team, they send the plans, and I never
change my mind.

You follow your instinct. Where does this confidence come from?

[Touching his head] This beautiful thing called my brain. Protected by cashmere. Always by cashmere. Colorful cashmere protection. There is a storage place in my head, where I keep all my ideas. And they come out when someone asks me. It's automatic. I think design has to be obvious. Beautiful or not beautiful. Easy. If it's beautiful, I don't have to explain it. You're happy or you are not happy. How did you do that? Not your problem!

Do you find resistance to your ideas when it comes to design?

In Japan, when I suggest new ideas, everything always starts with, "No, impossible." Everything you ask is "no." For me when you say no, my motivation goes higher.

Why do you think Buly is doing so well right now?

It's complicated to do well in this world now. We have no plastic; good quality, good products, good service, and little by little, detail by detail… we grow. Fighting little battles every day. It's actually what I love with a brand like United Arrows… They understand that little details, in the long term, make big changes.

What's your relationship with United Arrows?

I went to United Arrows in Harajuku when Poggy (Motofumi Kogi) was still a sales assistant. It's a brand that, instead of being there for you in one moment of your life, which happens with ninety percent of the other brands, will follow you all your life. To the end! It is a brand that can fit any age, and any budget. That is magic. You can be rich or poor, young or old, and it works. This is the DNA of United Arrows. A little bit like an advertisement for a Swiss watch: "It is not something you own; it is something you pass on to the next generation."

Another sentence that could apply to both Buly and United Arrows would be "Buy less, but buy well."

Just buy better!

Officine Universelle Buly 1803, Paris

Officine Universelle Buly 1803 store, NEWoMan Shinjuku, Tokyo

Asa Ito on Altruism and the Importance of Listening to Each other

"When we listen, we change."

How and where were these clothes made? The perception of sustainability and traceability has a major impact on fashion. Fashion has always been used to assert one's self as a tool for communication. However, fashion now goes beyond superficiality and identity; it includes the idea that understanding how the products themselves are made, and then purchasing and integrating them into one's lifestyle, is important for the planet and for the people who will live one hundred years from now. This is about altruism. Asa Ito is an associate professor at the Institute for Liberal Arts, Tokyo Institute of Technology, and works as the Director of the Future of Humanity Research Center. She is a scholar specializing in art, and conducts interdisciplinary research on art, philosophy, and the body. While her research focuses on individuals with disabilities, we asked her about the concept of altruism.

Please tell us about the Future of Humanity Research Center, where you work as Center Director.

It's a research institute that emerged in February 2020 from the Institute of Innovative Research, Tokyo Institute of Technology, where I work. The institute gathers a diverse set of researchers to ask realistic and essential questions focused on the future of humanity, and engages in a multifaceted exploration of the changes and potentials brought by science and technology, as well as the values that are worth keeping.

You're currently working as the Center Director; did you chose the initial research theme of altruism?

It wasn't only me. Everyone at the Center believed that the altruistic mindset would be a crucial topic in the future, no matter what we thought the future had in store, so we all agreed on that initial research theme.

Altruism is about putting the interests of someone else over your own interests, correct? Did anything about this word ever feel wrong to you?

To be honest, I had always been wary of altruism. I understand that it's good to do things for others, but, at the same time, from my own research, I felt that it can also have a negative effect.

What, for example, could be a bad effect of altruism?

I have been engaged in research on people with disabilities for a long time. For example, this research involved talking to people who were visually impaired or had their limbs amputated, about how they use their bodies, and how they view the world from the perspective of their disability. There are people who have good intentions toward disabled people. They think that they should immediately help those facing difficulties. Of course, we need to offer support to people when they have disabilities, and that's a helpful thing; however, there are numerous cases where this doesn't really benefit the person with the disability.

Some people feel that they should be thanked for offering help.

For example, there was someone who was completely vision impaired. It was about ten years since they lost their vision, but they will say that every day is like riding around on a tour bus. Which is to say, that all of the abled people around are overly helpful. They might say, "There's a step here," or "This is a convenience store." The people around them don't give them a chance to feel the world for themselves. It takes time, but they can gather auditory and tactile information, and they have a desire to imagine what kind of surroundings they are in using their own judgment. All of that becomes narrated for them. It might make it easier for them, but when you imagine what it might be like to ride a tour bus every day, you can understand how bitter they might feel… as if they were tourists being served wherever they go. They also say that they are put into a position to play the part of the disabled person.

All of the challenges they may face are snatched away, one by one?

When someone can't face any challenges, they lose the experience of succeeding at something. This erodes the confidence they have in themselves and they become disheartened. So, in that sense, in my research, I believed that good intention was an impediment. I believed that something as simple as helping someone could, surprisingly, not be for their benefit. At first glance, it appears that people are helping each other, but I felt that these weren't genuine human encounters. So, when altruism was brought up as a keyword for research at the Center, I couldn't think of it in a positive way. But it was also something that I was not familiar with, so I found it fascinating as a research subject.

When we consider the phrase "spare no effort to accommodate everyone," at first it seems helpful; but I have also come to see nothing but rules everywhere. I visited a park recently, and while it was very peaceful, I also recall seeing rules that prohibited children above middle-school age from playing soccer, as well as prohibitions against playing guitar and other instruments. Should we consider this as part of an effort to accommodate everyone? Or is it an infringement on our freedom? Two sides of the same coin, maybe?

These rules come from the demand for a sense of security against the unease toward uncertainty—peace of mind against anything unexpected happening. It's about squashing any uncertainties before they occur. But, on the other hand, there is also the concept of trust. With trust, the individual knows that the other person is different from them, and that things won't always go the way they want them to, and that even if something unexpected happens, there is reassurance that things will probably be fine. In essence, it's letting things be. I've recently actually come to think of peace of mind and trust as opposing ideas. When we go after peace of mind, trust disappears. With the example of the park, going after peace of mind premised on unexpected things as being bad gradually erodes trust, so, ultimately, we will have created a framework to disallow people from behaving any way outside of what we originally designed for. This then causes people to lose spontaneity and freedom, and they come to think that they are not trusted if they go there. Recently, it's been said that most people have a lower sense of self affirmation, and I believe that the demands of society for peace of mind have at least affected this somewhat.

It is important to have peace of mind, but there seems to be no end to it. There isn't such a thing as 100% peace of mind.

There are numerous procedures and processes to attain peace of mind. I think what's actually happening is that people are gradually straying away from what is important to do work that isn't essential. I think altruism is involved in this, but where someone thinks that they actually want to

create clothes for someone, or build a park for children, then there are various hurdles to making that a reality, and the things that are required to do so become complex—causing efforts to gradually stray from the most essential goal of the project. I feel that the whole purpose of doing the work gradually becomes tenuous over time.

Is there ever a time when altruism and business coincide?

It has to be compatible with the economy. As a matter of fact, the most inquiries the Center receives about altruistic research come from the fashion industry. I feel that the fashion world is the realm that is undergoing the most change right now. I think that fashion could be the industry that is most concerned with how to reconcile making money and making a profit with altruism.

Issues regarding labor and the environment are attracting a lot of attention today.

Regarding the issue of labor, the working environments in developing countries like Bangladesh have often been in the news, and those types of factories have repressive and dangerous work conditions—you remember the factory collapsing in Dhaka, in 2013. Behind the act of us purchasing new clothes at low prices there is a harsh reality for the people making them. This is a difficult thing to fathom for someone living in a large city like Tokyo; however, I think that the COVID-19 pandemic gave us important food for thought on how interdependent our world is, how connected we are through the internet, and how much our lives are connected.

Also, in terms of the environment, the UNCTAD has suggested that the fashion industry is the second largest polluting industry next to the oil industry. It was called an environmentally destructive industry, and it became commonly reported that a large portion of the clothes that were actually made were discarded after a season ended. I believe it's within this context that the fashion industry is currently undergoing major changes.

As the director of the Future of Humanity Research Center, Ito held its kick-off meeting outside the Center around a small bonfire with her colleagues; she believes that engaging in "small chats" and listening to each other is one of the keys to active altruism

If the methods used to manufacture goods are made transparent, this gives the consumer a choice in their purchases. For example, if consumers aren't told where the cotton is grown, where the material is made, where the clothes are sown, to determine the price, then it makes it difficult for them to make a decision on their purchases.

Humans have a limited capacity for imagination, so we can't imagine what happens on a global scale. When we're provided an explanation on something, it can sometimes come off as moralizing to us, and we can't really get a feel on things. For example, if we were to feel pain in our own bodies when a forest is cut down somewhere, then everyone could envision that as their own problem. Fashion is subject to trends, and is not necessarily a realm driven by logic. Trends only are manufactured desires put into the market.

So, it's probably important for those who produce and those who purchase to stop and think about things?

For example, the calls to disinfect, or to stay away from crowds are basically a superficial code of conduct we call "new normal." What we need to consider is what's behind; the labels of a "new life" or being a "new human" or having "new fashion." It is important to consider how we might change our value system in the future. It's not so simple as rebuilding, or getting things back to the way they used to be before the coronavirus; I believe this is an opportunity to consider how we might renew ourselves.

I think that we will have to develop and trust both our instinct and senses in conditions that cannot be adequately described by numbers and words. What does refining one's senses mean to you?

It's good to refine one's senses, but it's also fine not to do so. If we hone our senses in a strange way, then we might ultimately cause ourselves unease, so I think it's important to be content, and to be resilient to conditions in which the objectives and goals are not entirely clear. I think being resilient to an uncertain future is becoming sensitive to things as they come

along and following one's instinct. I think it's important to have both qualities—to be unexcitable and to be sensitive.

How can we attain both of these qualities?

At the research center we believe it's not just going to meetings or conferences, but also engaging in small chats. People can grasp at something that someone says and expand on it. I think engaging discussion in both ways is quite important. Like I mentioned before, with altruism there is an aspect of controlling the other, so I think that it is more altruistic to not seek to control, unleash the hidden potential and trust on their self-motivation.

At the Center, we think that altruism can be best likened to a vessel. Vessels are in a "standby" state. When we're spoken to, we do our best to listen and receive what is being said. We don't immediately discard incidental elements from a plan; rather, we nurture them. I think this is the essence of altruism. First, we should listen and create space, shouldn't we?

It seems only normal, but everything starts from listening to what others have to say.

When we listen, we change. With active altruism, the individual acting undergoes no change before and after. This unchanging state is arduous from the perspective of the person with the disability. They simply feel used. If that's the case, then how do we go about changing? Well, the first thing we have to do is to listen carefully. When we do this, we'll notice many things that differ completely from what we thought before. When we begin to see someone's thinking and value their perception, then I think we can truly change.

United Arrows Chronology

1989
- Establishment of United Arrows Ltd., and appointment of Osamu Shigematsu as Representative Director and President (October)
- Start of an agency service for all management and operations related to the opening of stores in Japan by the popular Parisian boutique Marina De Bourbon (November) *Concluded in 1995

1990
- Opening of the first United Arrows store in Shibuya Ward, Tokyo (July)

1992
- Opening of the United Arrows Harajuku, United Arrows' flagship store, in the Harajuku district of Tokyo (October)

1996
- Opening of W-Shock, the first United Arrows laboratory (experimental) store, in the annex of United Arrows Harajuku (March) *Concluded in 1998

1997
- Opening of The Sovereign House, The United Arrows label image store, in the Ginza district of Tokyo (March)
- Opening of the United Arrows laboratory stores Nonsect and Utica in the annex of United Arrows Harajuku (October)

1998
- Opening of the Blue Label General Store in the Harajuku district of Tokyo (July) *Changed to Beauty&Youth United Arrows in 2009; the store closed in 2016
- Opening of the first store for United Arrows Green Label Relaxing (GLR) in the Harajuku district of Tokyo (August); the store closed in 2000

1999
- Start of locations in railway station buildings. Opening of the United Arrows Yokohama in LUMINE Yokohama (February)
- Registration of United Arrows' shares for over-the-counter trading at the Japan Securities Dealers Association (the current JASDAQ) (July)
- Transformation of Utica into Chrome Hearts Tokyo Annex and full-fledged development of business in Chrome Hearts
- Opening of the first Chrome Hearts store in the Aoyama district of Tokyo along with full-fledged development of Chrome Hearts business (December)
- Opening of CYT, a store devoted to casual wear, in Shibuya Ward, Tokyo (October)

2000
- Start of store locations in outdoor malls, etc., such as Gotemba Premium Outlets and Marinoa City Fukuoka (October)
- Opening of the United Arrows Shibuya Koendori store upon renovation of CYT (July)
- Opening of the United Arrows label image store District (DST) in the Harajuku district of Tokyo (September)

2001
- Opening of the first store for Changes United Arrows, a women's store brand, in the Harajuku district of Tokyo (February) *Business concluded in 2007
- Opening of the first store for Another Edition (AE), a women's store brand, in the Harajuku district of Tokyo (February) *Business concluded in 2018

2002
- Listing of United Arrows' shares on the Second Section of the Tokyo Stock Exchange (March)
- Opening of the first store for Tokishirazu (TSZ), a men's store brand, in Shibuya Ward, Tokyo (March)
- Opening of the first store for Odette e Odile United Arrows (the current Odette e Odile (OEO), a women's shoes and bag brand, in LUMINE Shinjuku (September)

2003
- Listing of United Arrows' shares on the First Section of the Tokyo Stock Exchange (March)
- Opening of Rasslin', a new-concept shop taking mixed martial arts and professional wrestling as its main theme, in the Harajuku district of Tokyo (March) *Business concluded in 2003
- Opening of the first store for Drawer, a women's store brand, in the Aoyama district of Tokyo (August)
- Opening of United Arrows Harajuku for Men and United Arrows Harajuku for Women, upon renovation of United Arrows Harajuku, the flagship store (September)*

2004
- Appointment of Tetsuya Iwashiro as Representative Director and President (June)

2005
- Opening of a store on the online sales website ZOZOTOWN (February)
- Opening of the first store for Jewel Changes (JC), a new women's store brand born from Changes United Arrows, in LUMINE Shinjuku (February) *Change of

name to Emmel Refines and rebranded in 2019
- Opening of the first store for Darjeeling Days, a men's store brand aimed at affluent adults, in the Shinjuku flagship store of Odakyu Department Store (February) *Business concluded in 2008
- Acquisition of all the shares of FIGO CO., LTD., which is engaged mainly in import, wholesale, and retail sales of Italian-made bags, etc., for transformation into a wholly owned subsidiary (November)

2006
- Opening of the first store for Façade Green Green Label Relaxing, a GLR spin-off men's store brand, in the Matsuya Ginza store (March) *Business concluded in 2008
- Opening of the first store for Odonata Green Label Relaxing, a GLR spin-off men's store brand, in the Daimaru Umeda Department Store (March) *Business concluded in July 2008
- Separation of United Arrows' business into United Arrows, the dress-fashion arm, and Beauty&Youth United Arrows (BY), the casual fashion arm (September), and opening of the first stores for each in the Yurakucho Seibu Fashion Annex
- Opening of a store for Liquor, Woman & Tears, a men's store brand, in the Aoyama district of Tokyo (September) *Business concluded in 2010
- Start of store operations in Japan for Cath Kidson, a British interior and miscellaneous goods brand, and opening of the first store in the Daikanyama district of Tokyo (September) *Business concluded in 2011

2007
- Start of store development operations for Disney Loved By Nature for UNITED ARROWS, and opening of the first store in the Jiyugaoka district of Tokyo (March) *Business concluded in 2008
- Launch of Liclis, a proprietary online sales website (April) *Closed in February 2008
- Opening of the first store for Sounds Good, a sports store brand, in the LUMINE Shinjuku store *Business concluded in 2009
- Establishment of the subsidiary Perennial United Arrows Co., Ltd., which is engaged mainly in planning and retail sales of women's wear and personal items (August)
- Renovation and reopening of United Arrows Harajuku for Men (September)

2008
- Establishment of Coen Co., Ltd., a
company developing business in the
casual fashion brand Coen (May)

2009
- Appointment of Osamu Shigematsu as
Representative Director, President, and
Executive Officer (April)
- Opening of United Arrows Ltd. Online
Store, a proprietary online sales
website (September)

2010
- Renovation and reopening of United
Arrows Harajuku for Men, and birth of
the United Arrows & Sons floor on its B1
level (April)
- Opening of the first store of The
Airport Store United Arrows Ltd., the
store brand in the airport terminal in
Narita International Airport (July)
- Renovation and reopening of United
Arrows Harajuku for Women (October)

2011
- Opening of itoya with United Arrows,
a corner of collaboration with Ginza
Itoya, a long-standing purveyor of
stationery items, in Hankyu Mens Tokyo,
in United Arrows' first case of licensing
business (October)
- Opening of the first store of The
Station Store United Arrows Ltd., the
store brand in the metro station in the
Omotesando district of Tokyo (November)
- Opening of the first store of The
Highway Store United Arrows Ltd., the
store brand for the expressway service
and parking area corridor, in the Ebina
service area on the Tomei Expressway
(on the side bound for Tokyo) (December)
*Business concluded in 2015

2012
- Attainment of 100 billion yen
(1 billion USD) in consolidated net sales
for the first time (March)
- Appointment of Mitsuhiro Takeda as
Representative Director, President, and
Executive Officer (April)
- Selection for the grand prize in the
commendations for "corporate value
improvement" among listed companies
presented by the Tokyo Stock Exchange
(December)
- Start of the first residential proposal
based on licensing business. Launch of
PROUD with United Arrows, a residential-
space development business based on
joint proposal with PROUD, the housing
series of Nomura Real Estate Development
Co., Ltd. Start of the first residential

proposal based on licensed business
(April)
- Opening of the first store for Monkey
Time Beauty&Youth United Arrows, an
independent store for Monkey Time, a BY
original label, in LUMINE EST Shinjuku
(September)

2013
- Receipt of the Porter Prize, awarded
to Japanese companies and businesses
executing excellent strategies with
originality (November)
- Start of store development operations
in Japan by BY for Steven Alan, a New
York-born select shop. Openings in
LUMINE Shinjuku and other places (April)
- Establishment of the subsidiary United
Arrows Taiwan LTD. for development of
business in Taiwan (August)
- Opening of a United Arrows store in
Taipei as the first store operated
directly by United Arrows outside
Japan (October)

2014
- Opening of the first store for Astraet,
a new business targeting sophisticated
customers, both men and women, in the
Hankyu Umeda Main Store (February)
*Business concluded in 2018
- Opening of the first store for Boisson
Chocolat, a women's shoe brand, in
Funabashi LaLaport TOKYO-BAY (March)
*Business concluded in 2018
- Launch of Bows & Arrows, a men's
label store for placement in department
stores, in the United Arrows business.
Openings in Daimaru Osaka Umeda Store
and Daimaru Sapporo Store. *Business
concluded in 2017
- Opening of the first store for En
Route, a new business revolving around
fashion and sports, in the Ginza district
of Tokyo (September) *Business concluded
in 2018
- Receipt of the Grand Prize for IR
Excellence (November)

2015
- Establishment of the subsidiary Designs
& Co. for development of business, mainly
in planning and retail sales of women's
apparel and accessories (September)
*Dissolution of the company in 2020
- Opening of the first flagship store for
GLR in the Jiyugaoka district of Tokyo
(September)

2016
- Start of independent store development
for Roku Beauty&Youth (the current
Roku), a women's original project label

that made its debut from the BY business.
Opening of the first store in NEWoMan
Shinjuku, in Shinjuku Ward, Tokyo
(April)
- Launch of H Beauty&Youth by BY, a new-
concept store brand for adults with a
preference for casual fashion. Opening
of the first store in the Aoyama district
of Tokyo (April)
- Opening of the expanded United Arrows
Roppongi Hills as the largest flagship
store in Tokyo (September)
- Launch of Work Trip Outfits Green
Label Relaxing, a new-concept store
brand specializing in men's and women's
business attire, newly developed by
GLR. Opening of the first store in the
Yaesu underground mall in Tokyo Station
(September)
- Transfer of the rights & obligations
related to the Chrome Hearts business to
Chrome Hearts JP LLC through a corporate
split

2017
- Consolidation of United Arrows Ltd.
Online Store, the mail-order sales
website operated by United Arrows, and
the brand website (April)
- Consolidation of United Arrows
Harajuku for Men and United Arrows
Harajuku for Women, and renovation and
reopening as United Arrows One

2018
- Launch of RE: Apartment United Arrows
Ltd., the apparel industry's first
made-to-order renovation service for
condominiums, through collaboration in
condominium renovation with GlobalBase
Corporation (January)
- Launch of Lurow Green Label Relaxing, a
women's store brand, by GLR. Opening of
the first store in Atré Kawasaki (March)
- Reorganization of logistic centers and
start-up of a logistics center equipped
with the latest material-handling
machinery in the city of Nagareyama,
Chiba Prefecture

2019
- Change of the JC store brand name to
"Emmel Refines" and rebranding to match
a new way of thinking (March)
- Establishment of the joint venture
Fitom Inc., an application for
virtually trying on apparel and sharing
images (March)

Behind the Closet

CREDITS

PHOTOGRAPHY
ACROSS, PARCO CO.,Ltd. (P88-89), Shunya Arai (P92, 96, 140-141, 144-145, 154, 214, 222, 238, 242, 250, 258), Thierry Bouët (P85), Charvet (P290-295), Silvia T. Colmenero (P74, 77), Stany Dederen (P80-81), Yasutomo Ebisu (P107-111), David Foessel (P289), Osma Harvilahti (P264), Martin Holtkamp (P331-351), Nick Knight / SHOWstudio.com (P302-306), Hirofumi Kurino (P78-79, 82-83), local artist (P162-167, 169-171), Hiroyuki Matsubara (P244-249, 252-257), Naoya Matsumoto (P210-213), Takehiko Murata (P71-72), Ina Niehoff (United Arrows Edition Cover), Mitsuo Okamoto (Rizzoli Edition Cover, United Arrows Edition Back Cover, P265), Toru Oshima (P68, 104-105, 201, 204, 274-281), Mordechai Rubinstein (P156-P157), Masahiro Sambe (P100, 103, 146, 148-151, 152-153, 220, 222-223, 242, 243, 264-265, 268), Yomiuri/AFLO (P86)

ILLUSTRATION
100% ORANGE (P56-59), Taku Bannai (P60-63), Espen Friberg (P139), Stefan Marx (P164-167), Akane Nakajima (P98), Shoji Naoki (P282-283), Ricardo Bofill Taller de Arquitectura (P75), Yuko Saeki (P64-65), Kaoru Sambe (P256-257), Makito Takagi (P90), Yosuke Yamaguchi (P234-235)

PROP
Rio Kamiya (P67), Ryota Nakajima (P67)

ACKNOWLEDGMENTS

CREATIVE DIRECTION
Toru Dodo, Rhino inc., Kaoru Sasaki, Ryo Sudo, Ikuko Watanabe, Koichiro Yamamoto

ART DIRECTION
Yasuki Fujimoto, Naomi Hirabayashi, Kaoru Kasai, Tomohiko Nagakura, Hideki Nakajima, Masaya Takeda, Daisuke Takoshima, Jun Watanabe

PHOTOGRAPHY
Yasutomo Ebisu, m.hasui, Junji Hata, Trevor Hernandez, Aichi Hirano, Steve Honegan, JIMA, Yoshiko Kato, Mark Kean, Yasuhide Kuge, Hiroko Matsubara, Taro Mizutani, Jamie Morgan, Katsuhide Morimoto, Takehiko Murata, Kazuki Nagayama, Jason Nocito, Mitsuo Okamoto, Katsumi Omori, PICZO, Masahiro Sambe, Masafumi Sanai, Masashi Shimizu, Ronald Stoops, Chikashi Suzuki, Shoji Uchida, Isamu Uehara, Shingo Wakagi, WATARU, Osamu Yokonami, Yoshie Tominaga, Masato Yoshikawa

STYLE
Kozue Anzai, Yuriko E, Tamao Iida, Barry Kamen, Sakae Kaneda, Arata Kobayashi, Kenichi Kusuoka, Yuka Maruyama, Yoko Miyake, Hiroshi Morioka, Risa Sato, Naoko Shiina, Lambda Takahashi, Yumi Takashiba, Masahiro Tochigi, Yohei Usami, Kazuko Yamamoto, Mana Yamamoto, Take Yamamoto, YOON

HAIR AND MAKEUP
Jiro Amano, Hiromi Chinose, Karina Constantine, Didier, Louis Ghewy, Inge Grognard, Hanako, Hiroki, Hiroko Ishikawa, Katsuya Kamo, Shinya Kawamura, Masanori Kobayashi, Kenichi Lee, maRou, Jun Matsumoto, Yuki Miyamoto, Yuko Mizuno, Atsushi Moriyama, Akemi Nakadai, Johnnie Sappong, Chie Sasaki, Tomita Sato, TAKU, Koji Tanigawa, Masayo Tsuda, UDA, Satoko Watanabe, Kenichi Yaguchi, Mami Yasuda

PRODUCTION
commons&sense, Shohei Miwa, Tomonori Nagano, Takuya Oikawa, SUN-AD

First published in the United States of
America in 2021
by Rizzoli International Publications, Inc.
300 Park Avenue South
New York, NY 10010
www.rizzoliusa.com

UNITED ARROWS
Copyright © 2021 UNITED ARROWS
Texts: Courtesy of UNITED ARROWS

For UNITED ARROWS:
Creative Director (at kontakt): Takuhito
Kawashima
Editors (at kontakt): Victor Leclercq,
Yoshikatsu Yamato, and Megumi Koyama
Editorial Coordination (at kontakt): Runa
Anzai
Project Manager (at kontakt): Haruki Kanda
Translation Services: Joyce Lam, James
Koetting and Fulford Enterprises, Ltd.

Art Direction and Graphic Design:
Apartamento Studios

For Rizzoli:
Editor: Ian Luna
Project Editor: Meaghan McGovern
Production Managers: Barbara Sadick and
Maria Pia Gramaglia
Copy Editor/Proofreader: Louie Simon and
Tricia Levy
Design Coordination: Olivia Russin and
Eugene Lee
Editorial Coordination: Taichi Watanabe

Publisher: Charles Miers

Acknowledgments:
The Editors and Rizzoli would like to thank
the support of the following individuals
for their invaluable assistance: Shinya
Matsumoto, Junji Yoshida, Daisuke
Kawahigashi, Eiichi Higuchi, Motofumi Kogi,
Omar Sosa, Takuhito Kawashima, Haruki Kanda,
Runa Anzai, Victor Leclercq, Yoshikatsu
Yamato, Megumi Koyama, Melek Kücükaksu, Ángel
Cánovas, and Milla Hincks.

We would like to express our deepest
gratitude to all the contributors, and
especially for the patronage and support
of Mitsuhiro Takeda and Hirofumi Kurino,
without whom this volume would not have been
possible.
— Ian Luna

Printed in Italy

2021 2022 2023 2024 2025 / 10 9 8 7 6 5 4 3 2 1

ISBN: 978-0-8478-978-6968-8

Library of Congress Control Number: 2021930223

Visit us online:
Facebook.com/RizzoliNewYork
Twitter: @Rizzoli_Books
Instagram.com/RizzoliBooks
Pinterest.com/RizzoliBooks
Youtube.com/user/RizzoliNY
Issuu.com/Rizzoli